Art's Prospect

ROGER KIMBALL

Art's Prospect

THE CHALLENGE OF TRADITION
IN AN AGE OF CELEBRITY

Chicago

IVAN R. DEE

The paperback edition of this book carries the ISBN 1-56663-510-1.

Library of Congress Cataloging-in-Publication Data:
Kimball, Roger, 1953–
 Art's prospect : the challenge of tradition in an age of celebrity
/ Roger Kimball
 p. cm.
 Includes index.
 ISBN 1-56663-509-8 (alk. paper)
 1. Art, Modern—19th century. 2. Art, Modern—20th century.
 3. Art criticism—History—19th century. 4. Art criticism—
 History—20th century. I. Title.

N6447.K56 2003
709'.04—dc21 2003053156

For David and Clarissa Pryce-Jones

Contents

Part Three

Preface: Out of the Limelight

I N HIS ESSAY "Tradition and the Individual Talent," T. S. Eliot famously criticized

> our tendency to insist, when we praise a poet, upon those aspects of his work in which he least resembles anyone else. In these aspects or parts of his work we pretend to find what is individual, what is the peculiar essence of the man. We dwell with satisfaction upon the poet's difference from his predecessors, especially his immediate predecessors; we endeavour to find something that can be isolated in order to be enjoyed. Whereas if we approach a poet without this prejudice we shall often find that not only the best, but the most individual parts of his work may be those in which the dead poets, his ancestors, assert their immortality most vigorously.

The same argument goes for other arts. Perhaps the chief virtue of Eliot's essay was to remind us of how superficial and artistically limiting the Romantic cult of novelty can be. The pretense that the traditional is the enemy rather than the presupposition of originality devalues art's chief source of pertinence: its continuity with the past.

Anyone looking for evidence of this does not have far to seek. A quick glance around our culture shows that the avant-garde assault on tradition has long since degenerated into a sclerotic orthodoxy. What established taste makers now herald as cutting-edge turns out time and again to be a stale remainder of past impotence. It is one of history's ironies that Romantic fervor regularly declines into antic murmurs. Most of the really invigorating action in the art world today is a quiet affair. It takes place not at Tate Modern or the Museum of Modern Art, not in the Chelsea or TriBeCa galleries, but off to one side, out of the limelight. It tends to involve not the latest thing, but permanent things. Permanent things can be new; they can be old; but their relevance is measured not by the buzz they create but by silences they inspire.

Art's Prospect: The Challenge of Tradition in an Age of Celebrity is intended as an illustration of these truths. It is composed of reviews and essays, originally written from the late 1980s through early 2003 and mostly revised for this volume. It is not a chronicle but rather a directed sampling, culled and arranged with an eye to illuminating some of the chief spiritual itineraries of contemporary art. Accordingly, this brief book makes no claim to completeness. What I have tried to provide is a collage whose elements, when seen from one perspective, add up to a diagnosis of a malady and, when seen from another perspective, provide hints of where effective remedies can be found. I am under no illusion that this will be a popular book. Many of the figures I criticize currently enjoy semi-beatified status in the art establishment, while many I praise are routinely vilified or effectively ignored. Still, there is something to be said for stepping back from the great media parade of contemporary culture now and

again to point out that many of those proclaimed to be emperors are, in fact, stark naked. By the same token, it is worth calling attention to some of the many talents that, for one reason or another, the celebrity parade decided to pass by without, or with only insufficient, notice.

I AM GRATEFUL to Denis Dutton, editor of Cybereditions, for first suggesting that I undertake this volume and for publishing a paperback and e-book version in 2002, and to Ivan R. Dee, for publishing this revised and expanded edition. I also wish to acknowledge the editors of the several publications where the original versions of these essays appeared: *The Wall Street Journal, The Times Literary Supplement, The Spectator, The New Criterion, National Review, The Public Interest, Modern Painters, Art and Antiques,* and *Museum and Arts Washington.*

Finally, to continue with the theme of gratitude, it is a pleasure to salute David and Clarissa Pryce-Jones, to whom I have dedicated this book. In a letter to his friend Caninius Rufus, the younger Pliny notes that admiration for the ancients had not led him to despise the talents of his contemporaries. He singles out one poet for his "probitate morum, ingenii elegantia, operum varietate monstrabilis." Had Pliny added something about generosity, intellectual courage, and a genius for friendship, he might have been writing about the Pryce-Joneses. They embody the civilizing values that *Art's Prospect* seeks to encourage. Their example gives one hope. I am grateful indeed to count them as friends.

RK
Norwalk 2003

Art's Prospect

Part One

The Museum as Funhouse

FUN HOUSE, n. *A building or an attraction in an amusement park that features various devices intended to surprise, frighten, or amuse.*
—The American Heritage Dictionary

I threw the bottle rack and the urinal into their faces as a challenge, and now they admire them for their aesthetic beauty.
—Marcel Duchamp, 1946

E VERYONE KNOWS that American culture has undergone drastic changes over the last several decades. Perhaps no cultural institution has changed more drastically in that time than the art museum. Forty years ago, the typical art museum was a staid and stately place. Its architecture, often neo-classical, tended to suggest grandeur and to elicit contemplation. Soaring columns and marble halls bespoke an opulence of purpose as well as material wealth. Even museums that departed from the neo-classical model, such as New York's Museum of Modern Art, strove to embody a dignified seriousness about the vocation of art.

At that time, the museum was widely regarded as a "temple of art," a special place set apart from the vicis-

situdes of the quotidian. The decibel level was low, decorum high, and crowds, generally, were sparse. In the culture at large, there was broad agreement that the art museum had a twofold curatorial purpose: to preserve and exhibit objects of historical interest and commanding aesthetic achievement, and to nurture the public's direct experience of those objects. "Art," not "amenity," came first on the museum's menu.

The seriousness of the art museum was a reflection of the seriousness of the art world. If some works of art were deliberately playful or even frivolous, art itself was entrusted with the important task of educating the imagination and helping to humanize and refine the emotions. Accordingly, art museums were democratic but not demotic institutions. They were open, but not necessarily accessible, to all. The bounty they offered exacted the homage of informed interest as the price of participation. Accessibility was a privilege anyone could earn, not a right that everyone enjoyed.

The 1960s put paid to all that. There are still a handful of holdouts: odd institutions here and there that cling stubbornly to the old ways. But the "blockbuster" mentality that began developing in the 1970s helped to transform many art museums into all-purpose cultural emporia. Increasingly, success was measured by quantity, not quality, by the take at the box office rather than at the bar of aesthetic discrimination.

Indeed, as the egalitarian imperatives of the Sixties insinuated themselves more and more thoroughly into mainstream culture, the very ideal of aesthetic excellence came under fire. Adulation, not connoisseurship, was the order of the day. Many commentators—even many artists—rejected outright the pursuit of aesthetic excellence;

they saw it as an elitist holdover from the discredited hierarchies of the past. Others subordinated the aesthetic dimension of art to one or another political program or intellectual obsession. Notoriety, not artistic accomplishment, became the chief goal of art, even as terms like "challenging" and "transgressive" took precedence over "beautiful" and other traditional commendations in the lexicon of critical praise. Art was still a talismanic necessity, the presence of which underwrote an institution's social pretensions as well as its tax-exempt status. But increasingly art functioned more as a catalyst than an end in itself—one attraction among many and not necessarily the most important. The coffee bar or restaurant, the movie theater or gift store or interactive computer center vied for attention. Art merely added the desired patina of cultural sophistication.

The triumph of quantity over quality showed itself in other ways as well. It used to be that art museums were like oases: relatively few and far between. But in the 1960s it became an article of faith in some quarters that anyone could be an artist; it is our misfortune that so many people seem to have believed that dogma. Suddenly there was a Niagara of new art clamoring for attention. Established art museums undertook ambitious building programs to house the stuff; museumless towns and college campuses scurried to remedy their lack. When it came to anything that could be congregated under the banner of "the arts," the watchword was "more is better." Everywhere one looked there was a new or greatly expanded museum or arts center. No self-respecting population dared be without some visible "commitment to the arts." But the curious logic that subordinated aesthetic to political considerations also meant that while possessing a museum became a badge of

social respectability, "respectability" itself had become a deeply suspect idea. Art museums are still monuments to civic pride—and, sometimes, assets to civic coffers. The irony is that today many museums extol values utterly at odds with the civilization that produced and that continues to sustain them.

I HAD OCCASION to ponder all this on a brief trip to the Berkshires with my wife and two-and-a-half-year-old son in the winter of 2001. We stopped off to see MASS MOCA, the sprawling thirteen-acre complex of reclaimed factory buildings in downtown North Adams that only a few years ago was called the Massachusetts Museum of Contemporary Art but is now formally known by its shorter, more chic acronym. The last time I had visited MASS MOCA was in the fall of 1997, some eighteen months before the $31 point-something million project opened to the public. It is an extraordinary site. Twenty-seven buildings, mostly dating from the latter part of the nineteenth-century, huddle next to the south branch of the Hoosic River. A network of courtyards, elevated bridges, and narrow passageways imparts an intimate, village-like feeling to the fenced-in complex, or "campus," as the museum's literature likes to put it. Like many disused industrial sites, those old brick buildings have a peculiar poetry about them, a certain eldritch charm that has partly to do with the site, partly with the broken handsomeness of the ramshackle utilitarian structures, partly with the spectacle of so much human purpose set forth and then abandoned. It has often been suggested that the architecture of such institutions, instinct as it is with the romance of a bygone era, is its most appealing work of art. That is certainly the case at MASS MOCA.

When the electronics company that had last occupied the site decamped in the mid-1980s, it left some four-thousand people—nearly a quarter of North Adams's population—out of work. What to do with the site? Michael Dukakis was then governor of Massachusetts and his "Massachusetts Miracle" was turning out to be about as successful as the famous photograph of him posing in an army tank. Credit for the idea of MASS MOCA must go to Thomas Krens. Mr. Krens has been the director of the Solomon R. Guggenheim Museum and its ever-expanding empire since 1988. But before that he had been the director of the Williams College Museum of Art a few miles up the road from North Adams. Looking for suitable space to exhibit large-scale minimalist art, he was shown the disused factory buildings. It was love at first sight. It was he who first suggested that the site be converted into a mixed-use cultural center. But if Mr. Krens had the original idea for what became MASS MOCA, credit for bringing it into being belongs to Joseph C. Thompson, the institution's director. Mr. Thompson is clearly a patient man, for he guided the project through innumerable delays, setbacks, changes of plans, defections, and funding crises.

In many ways, then, the very existence of MASS MOCA is an example of triumph over adversity. Mr. Thompson and his colleagues must be given high marks for persistence. And it should also be noted that the working-class town of North Adams has rather a lot riding on MASS MOCA. After all, the site occupies about a third of the town's business district. The hope is that by combining the mantra of art with some tony commercial tenants, MASS MOCA might become a profitable tourist attraction, just like Tanglewood down in Lenox. Will it work? There has been some encouraging news. MASS MOCA logged just over one-

hundred-thousand visitors in its first year, commercial rents in the complex have more than doubled, and, as Mr. Thompson observed in an interview, in downtown North Adams there are two cappuccino machines where before there were none. Nevertheless, I remain skeptical. It is understandable that people should flock to a beautiful spot in the Berkshires to listen to performances of the music of Mozart and Beethoven. Will they also rally round in sufficient numbers to visit what is still a pretty grim mill town to look at installations of work by Joseph Beuys and Robert Rauschenberg?

Time will tell. Much will depend upon the economy, and especially on the fate of the high-tech, dot-commie enterprises that MASS MOCA has, in part, hitched its fortunes to. In any event, it is important to distinguish between MASS MOCA's economic prospects and its artistic promise. Virtually every slip of paper emanating from the museum announces that it is "the largest center for contemporary visual and performing arts in the United States." The museum is also fond of describing itself as a "permanent work in progress," "a cultural factory for the twenty-first century," "an open laboratory for the development and presentation of contemporary art," even as "a testing ground to expand and redefine the nature of contemporary art."

The rhetoric is telling. It is not only because it occupies former factory buildings that MASS MOCA describes itself as "a cultural factory." The history of the buildings it occupies happily reinforces a distinctive attitude toward art and culture. It is an attitude that has its roots in a view of art as "cultural production," that is to say, in a Marxist view of art. Something similar must be said about talk of the museum as a "laboratory" and "testing ground" to

"expand" and "redefine the nature of" contemporary art: these are fashionable terms, but not merely fashionable terms. Rather, what they bespeak is an ideological fashion deeply at odds with the traditional view of art and the place of art museums in society. For lack of a more precise term, we might call it a postmodern attitude.

WHAT MAKES IT postmodern? For one thing, there is the pose of daringness that is merely a pose: of risk-taking that is fully indemnified, of avant-garde gestures generously underwritten by grants from the XYZ Foundation, the State of Massachusetts, and concerned citizens in favor of art, a smoke-free environment, and safe sex. You know the sort of thing I mean: certified avant-garde attitudes that also happen to be shared by everyone else in the "arts community."

Something else that makes MASS MOCA an emblematic postmodern institution is its attitude toward the public, which manages to be minatory and welcoming at the same time. It is a delicate balancing act, and it must be said that MASS MOCA does it well. The institution depends for its life blood on community approval and a steady flow of visitors who, though predominantly not at all "cutting-edge" in their artistic or moral views, don't mind thinking of themselves as pretty hip and with it, especially in relation to their neighbors. So the task of institutions like MASS MOCA (like, say, the Whitney Museum or MOMA or the Guggenheim in New York) is to flatter its patrons, make them believe that they are participating in something pretty daring but not *too* daring. It is a textbook case of what Gertrude Stein called the art of knowing exactly how far to go in going too far.

Consider some of the items MASS MOCA has on offer this

season. Most of these exhibit MASS MOCA in its welcoming, affirmative mode. On April 28, fans of the rock group Talking Heads "can celebrate the 20th anniversary of the Heads' seminal album *Remain in Light*" by attending an event at which "a host of celebrated musicians will reexamine this Talking Heads masterwork." Mark your calendars! Then there is "Rich Flavors of the Republic of Georgia" at which one can "dine family-style on delicacies from the former Soviet Republic of Georgia" and then watch the movie *A Chef in Love.* (Those who prefer Indian food can attend "Passage to India" and "dine on sumptuous Indian food" and watch the Merchant Ivory film *Cotton Mary* with Madhur Jaffrey, the cook turned actress.) There is a Brazilian Carnival Dance Party and, on February 2 and 3, Mabou Mines with a "work in progress" called Red Beads, "an operatic brew of music, movement, and modern puppetry" whose story "centers on the myth of the 'feminine mystique' passing from mother to daughter." In January, "Everton Sylvester and Searching for Banjo" returned to MASS MOCA "for an encore evening of cool grooves and hip talk" while in February there opens "Bubbles 'n Boxes 'n Beyond: Swiss and American Comic Art."

What about the—how to put it?—the *art* art? You know, stuff in galleries that you can look at? That is an unforgivably retrograde question to ask about a "permanent work in progress" dedicated to "redefining the nature of contemporary art," but rest assured that MASS MOCA has plenty of that on offer, too. Probably "Bubbles 'n Boxes" will qualify. But that's only incidentally what MASS MOCA is about. Much more typical is something coming in March: the British artist Mona Hatoum, in "her first major exhibition on the East coast for five years," will

show some recent work that "represents familiar kitchen implements. Hatoum," we read, "unsettles our relationship with the comfortable domestic sphere by turning traditional kitchen implements into threatening objects with electrification and dramatic shifts in scale." Frankly, I am glad to learn that Hatoum is moving into the kitchen and out of herself. As far as I know, the Lebanon-born "body-sculptor" is the only artist to be featured on the web site of the British Society of Gastroenterology. She is best known for *Corps Etranger*, a video in which (according to one description) "Hatoum, with the assistance of a surgeon, passed a fiber optic video camera through her body orifices to create a video self-portrait." It's reassuring to know that she has graduated from the speculum to the spatula.

You had to wait until March for Mona Hatoum's latest. But as I wrote you could see dozens of small, cartoon-like paintings by Laylah Ali, a young black artist just hired by the Williams College art department. The paintings depict stylized round-headed figures of one color doing vague but unspeakable things to stylized round-headed figures of another color. These doodles are supposed to "tell stories about violence and its aftermath." In fact, they are a monotonous exercise in racial stereotyping. MASS MOCA describes Ali as "one of the most enigmatic young artists working today," but what is really enigmatic is why the Williams College art department should wish to hire someone who produces such odious, ideologically predictable objects. (Actually, it's not really so enigmatic, as anyone who can pronounce the phrase "affirmative action" knows.)

Artists like Hatoum and Ali are a dime-a-dozen today. What they have to offer is essentially an attitude, not works—or, more precisely, they offer works whose

meaning is exhausted by the attitudes they embody. Such artists are a regular feature of the programs at MASS MOCA, as they are at most other museums of contemporary art today. But by now such work is so predictable that it functions more or less like interior decorating at a place like MASS MOCA. The real action is in more spectacular—well, larger, anyway—installations such as are featured in an offering from 2000 and early 2001: "Unnatural Science," an exhibition of fifteen works that "use the discoveries, inventions, and methods of science as a springboard for fantastic aesthetic and intellectual investigations."

Science is all the rage in the art world today, as it is in certain precincts of the academy. Or, to put it more precisely, what is fashionable is "science" not science. I do not mean the sort of thing that goes on in physics classes or chemistry classes, but the palaver that drifts up from English departments and seminars in "science studies." In other words, the subject is never the truth about the natural world—which after all is what science is all about —but rather the rhetoric, apparatus, and sociology of science.

A good example was "Useless Science," an exhibition that was part of "Making Choices," the second installment of the Museum of Modern Art's series "MOMA 2000" last summer. The great paterfamilias of this sort of art was Marcel Duchamp, who in the 1920s devoted a lot of time to making objects with titles like *Rotary Hemisphere (Precision Optics)* (1925) and *The Bride Stripped Bare by Her Bachelors, Even (The Large Glass)* (1915–23). Like everything Duchamp did, these objects were spoofs: anti-art, anti-science, indeed anti-intellect as only a clever, nihilistic intellectual could be. Duchamp did not have any recognizable politics, apart from a species of impish anar-

chism. But his gestures have been eagerly adopted by generations of left-wing artists and critics who seem to believe that his efforts to bring art and intellectual inquiry to an end were somehow deep critical explorations. The curators of "Useless Science" tell us that the exhibition "explores the theme of pure scientific inquiry from the first experiments in optics by Marcel Duchamp to recent tests of endurance by Matthew Barney." But that's just meaningless artspeak. Duchamp did not make any "experiments" in optics; he played at making experiments. And as for Matthew Barney, the only thing he "tests" is one's credulity.

In a revealing passage, the curators of "Useless Science" speak admiringly of those artists who carry on in "the tradition of pseudoscience" and

> adopt the rigorous discipline of the objective recorder, the patience of the specimen collector, or the logic of the master engineer, not for the sake of finding an answer to a particular biological or technical question, but, certain in the notion that there are an infinite number of solutions to every problem, to test the very methods of scientific inquiry itself.

It is worth pausing to reflect on this remarkable statement. Is it true that there are "an infinite number of solutions to every problem"? Do artists like Duchamp or Man Ray or Max Ernst or Matthew Barney "test the very methods of scientific inquiry itself"? No and no again. Plenty of problems have only one solution—start with the perfectly respectable problem $2 + 2 = ?$ And as for artists testing "the very methods of scientific inquiry itself," simple kindness requires that we pass by in silence.

Among other things, statements like the above—and their name is legion—illustrate the baneful influence of Thomas Kuhn's book *The Structure of Scientific Revolutions*. Since its publication in 1962, this slim book has done an enormous amount to foster happy irrationalism about science, especially among the scientifically illiterate. The damage it has done in the intellectual slums—in sociology, literary theory, etc.—has been incalculable. Kuhn's doctrine that science does not progress toward truth but merely "solves problems" within a dominant "paradigm" has been like manna from heaven for people keen to undercut the authority of science. Conflating the history of science with the logic of science, Kuhn's theory underwrites what we might call a nonjudgmental view of truth. Different scientific paradigms, he tells us, are "incommensurable." We cannot say that one is true and the other false, merely that they are different.

Laura Steward Heon, the curator of "Unnatural Science," is a grateful Kuhnian. In her catalogue essay, she correctly observes that "before Kuhn, science had been seen as the orderly progression of one theory to another until the truth about some phenomenon was established." But now, post-Kuhn, we can rejoice that "different people at different times and places find conflicting but correct answers about the same topic." "Unnatural Science" is in large part an homage to the spirit of Kuhn's theory. Kuhn was fond of asking questions like "what mistake was made, what rule broken, when and by whom, in arriving at, say, the Ptolemaic system?" His idea was that there *was* no mistake, that the Ptolemaic "paradigm" simply had different assumptions about the geography of the solar system from the Copernican paradigm.

This will not do. As the Australian philosopher David

Stove pointed out, most people—most non-intellectuals, anyway—find Kuhn's question almost embarrassingly easy to answer. For starters, there was the mistake of believing that the sun goes around the earth each day. Kuhn's theory holds that in the evolution of science ignorance is not replaced by knowledge, rather yesterday's knowledge is replaced by "knowledge of another and incompatible sort." But what sort of beast is "incompatible knowledge"? As Stove points out, "knowledge implies truth, and truths cannot be incompatible with one another."†

THE KUHNIAN REVOLUTION has enjoyed such wild success partly because it challenges the intellectual authority of science; even more important, perhaps, is its challenge to the political or moral authority of the society that honors the claims of scientific truth. As Ms. Heon observes, "Kuhn unintentionally opened the floodgates for politically driven challenges to scientific findings and methods from the general public." The intellectual merits of those challenges are essentially nil. But they make for an atmosphere of political theater that speaks deeply to the postmodern sensibility. It is that atmosphere—knowing, darkly frivolous, latitudinarian about everything except its own pretensions—that institutions like MASS MOCA exist to nurture and that exhibitions like "Unnatural Science" instantiate.

Consider: in *Room of the Host* we see two-hundred "imaginary zoological specimens" suspended in illuminated glass jars filled with oil and hanging from the ceiling of a darkened room. "Each specimen," we read in some

† See Stove's hilarious and penetrating essay "Cole Porter and Karl Popper: The Jazz Age in the Philosophy of Science" in my anthology of Stove's writings *Against the Idols of the Age* (Transaction, 1999).

accompanying literature, "whirls in its liquid, emitting chirps and snippets of song that stop the moment a visitor approaches." It is invariably the case that whenever any-one in the arts or humanities starts talking about Heis-enberg's uncertainty principle (overused and invariably misunderstood), something has gone terribly wrong. No sooner had I stepped into the room with those creepy chattering jars than it was explained to me that the fact that the blobs in the jars stopped whirling and chirping when one approached was in part an illustration of Heisenberg's gem about the subatomic world. Right. And I am Marie of Roumania.

Or consider *Food Chain*, a work consisting of a series of large, meticulously printed color photographs. The photo-graphs begin by depicting a caterpillar eating a tomato and move on to show the caterpillar being eaten by a praying mantis, which in turn mates with and is devoured by a female praying mantis, which in turn is eaten by a frog. The gruesomeness of the carnage is accentuated by the over-lifesize of the photographs.

In *Slumber* we are presented with the set for a perform-ance piece by Janine Antoni. It consists of a loom, some yarn, a bed and blanket, a nightgown, and an EEG machine. "During the performance," we read,

> Antoni weaves the blanket at the loom during the day and sleeps in the bed, covered by the blanket, at night. While she sleeps, the EEG machine records her rapid eye move-ments (REM), plotting out the patterns of her dreams. When she wakes up, she transfers the record of her REM to a graph and weaves the pattern with strips of her nightgown. The woven pattern is an analogue for her dreams, and weaving is analogous to dreaming. Each nightgown has

been symbolically connected to the place of performance. Most recently she performed *Slumber* in New York, a fashion capital, and had an elegant Christian Dior nightgown, whose tag you can see at the loom end of the blanket.

We are told that "like many feminist artists," Antoni "emphasizes performance and process." But since we are in the *p*'s, what about "unbearable pretentiousness"? Antoni certainly emphasizes that, as well.

The most elaborate installation on view in "Unnatural Science" is the poetically titled *Apparatus for the Distillation of Vague Intuitions* by Eve Andrée Laramée. This is a roomful of what appear to be beakers, condensers, and the like erected on laboratory tables. Some of the glass—much of which is hand blown, all of which is described as "dysfunctional"—is engraved with "text referring to subjectivity, intuition, guesswork, and desire." Measurements are in "handfuls" and "mouthfuls," the imaginary distillate is a "blunder," "misconception," "boo boo," etc. "Laramée," we are told, "uses science to explore the subjective realms of poetry, absurdity, contradiction, and metaphor, realms normally considered the province of art."

Really? How exactly does that impressive construction of glass tubing "explore" the realm of anything, subjective or otherwise? Like several of the items in "Unnatural Science," *Apparatus for the Distillation of Vague Intuitions* was fun to look at. It had the sort of fetching whimsy one associates with a child's playing with a chemistry set. Is that a good thing? Ms. Heon was right to stress the playful nature of the installations in "Unnatural Science," even if some of the play has a distinctly malevolent cast to it.

Our two-and-and-half-year-old son got it immediately. He liked *Vague Intuitions*, was skeptical about *Room of the Host*, and refused to set foot in the gigantic gallery that housed *Überorgan*, a piece that incorporates inflated bladders "as big as buses" and "reminiscent of body organs" that play "layered musical sounds on a 12-tone scale." It was pretty awful. *Überorgan*, though not technically part of "Unnatural Science," exudes the same spirit. How should we understand that spirit? A recent innovation at MASS MOCA is "Kidspace," "both a gallery for exhibiting the artwork of contemporary artists and a studio where children will create innovative artwork of their own." When we visited, an installation of "interactive sculptures" called "Open and Shut: Artists' Doors" was just going up. Among the attractions was a little house in which, when one closed a door, a light might go on and a window would open. Close the window and something else would happen. It was lots of fun and our son loved it. It was just like going to a fun house. The question is: how do the objects on view in "Kidspace" differ from the objects in the art galleries proper—apart, I mean, from the level of pretension with which the latter are presented? It would take a sharp man to tell the difference. Like my son, I believe it's all pretty much the same.

2001

Minimalist Fantasies

All I want anyone to get out of my paintings, and all I ever get out of them, is the fact that you can see the whole idea without any confusion. . . . What you see is what you see.
—Frank Stella, 1966

Minimal works are readable as art, as almost anything is today—including a door, a table, or a blank sheet of paper. . . . That, precisely, is the trouble. Minimal Art remains too much a feat of ideation, and not enough anything else. Its idea remains an idea, something deduced instead of felt and discovered.
—Clement Greenberg, 1967

After all, what is art? That's the big question.
—Leonard Riggio, Dia Arts Foundation

Art is what you can get away with.
—Andy Warhol (attributed)

WHERE IS EVELYN WAUGH when you need him? I mean, where is the satirist with a boot big and swift and hard enough for the collective backside of today's art world? "The hour is come," Sir Walter Scott indited gloomily, "but not the man."

I share that gloom. There is plenty of good art being made now, but most of it goes unnoticed, all but. The big press and the big money tend to line up behind "transgressive" crap (the blasphemy, kinky sex, bodily effluvia brigade) or utterly vacuous crap (the blank canvas, exhibit-my-old-sneaker, I-can-count-to-twenty-million-and-make-you-watch-me-do-it company). Witness the phenomenon of the museum run as a kind of funhouse, described above.

I apologize, by the way, for the word "crap." I think it's undignified, too. I looked around for an alternative that was equally accurate, blunt, and printable. I considered "*merde*," but it seemed a bit pretentious for the matter at hand. "Crap" at least is short, sharp, and expressive. It has the added advantage of being apt: "CRAP, *n*. . . . 3. a. Worthless nonsense," *The American Heritage Dictionary*.

I should also point out that the "or" between "transgressive" and "utterly vacuous" is not what grammarians call a disjunctive "or." There are quite a few enterprising lads and lasses who manage to be transgressive and vacuous simultaneously. Take Matthew "Mr. Vaseline" Barney. He will be forgotten in about twenty minutes, but as I write *The New York Times*'s extraordinary publicity blitz on his behalf is still reverberating (and his occupation of the Solomon R. Guggenheim Museum is still ongoing). In Mr. Barney's work, I think you will admit, the union of banality and ickiness (common parlance for "transgressive") is well-nigh perfect.

HE IS NOT ALONE. I am sure that you can think of eighty-six additional examples—I'm told that experts can do 114—before lunch.

I want to spare you that unpleasantness, however. My point is simply that when it comes to the Art World—to

the congeries of critic-publicists and curator-publicists, museum-director-publicists, publicist-publicists, and artist-narcissist-publicists who set the agenda and spend the money—the front-burner issue is not aesthetic quality but one or another species of trendiness. When exhibitions of Velázquez or Leonardo or some other historical name-brand worthy roll into town, you can reap some reasonably straight oohs and aahs from the arts pages of the *Times* and other finger-in-the-air publications. But let the focus shift to what's happening now and, presto! instant lobotomy and onset of Tourette Syndrome.

Matthew Barney notwithstanding, I suspect that the really nasty stuff is about ready for a rest—not a long rest, mind you, just a bit of a breather while people regroup after the age of Mapplethorpe, Serrano, Gilbert and George, and all the awful stuff that made "Sensation" such a sensation a couple of years ago. (Remember the Madonna covered with pornographic pictures and bits of elephant poop? Wot larks, wot larks. . .) Doubtless there is something even worse going up somewhere even as I write. But for the moment it seems that the limelight has shifted from the overtly repellent to the merely vacuous side of the equation.

What makes me think this? Palpitations at *The New York Times*, in part. I am thinking in particular of "The Dia Generation" by the *Times*'s chief art critic, Michael Kimmelman. This extraordinary, sixty-five-hundred-word effusion—about which more below—plumped up the paper's Sunday Magazine on April 6, 2003. It was followed by another ecstatic piece, which began on the front page of the paper's art section on April 23. The hook for all this publicity is "Dia:Beacon," a new $50 million art museum in Beacon, New York, about an hour north of

Manhattan. Presided over by the Dia Arts Foundation, Dia:Beacon—note the snazzy pomo orthography—opened in May 2003 to a further cataract of fanfare.

Dia:Beacon is the latest effort to enlist art in the cause of urban renewal. You saw the formula at work in MASS MOCA: Take one economically depressed town in or near a scenic spot. Stir in a clump of abandoned commercial buildings, the older the better. Gently whip up local authorities with the promise that a museum of contemporary art will boost tourism, create jobs, and generally add cultural luster to their town. Decorate with a hip director, preferably someone who was a student-friend-assistant of Thomas Krens at Williams College. Let gel with as much foundation and taxpayer money as you can make off with.

DOES IT WORK? As I said in "The Museum as Funhouse," the jury is still out. MASS MOCA, which helped establish the recipe in 1999, has had only modest success. Michael Govan, the current director of the Dia Arts Foundation (and an alumnus of Williams and the Guggenheim), estimated that the museum would create twenty jobs, attract about 100,000 visitors a year, and generate $7.4 million annually in tourist revenue. Maybe.

Doubtless you have heard of the Dia Arts Foundation, though probably it is not in the forefront of your consciousness. It hadn't been in the news much until the *Times* took up its cause. Dia was one of the many potty ideas with roots in the 1960s that didn't get going until the 1970s, and now, like eczema or PCBs, is almost impossible to extirpate. Why "Dia"? It's Greek for "through," as in "Can't you see through this ridiculous sham?" Dia was started in 1974 by a German art dealer named Heiner

Friedrich and his wife, Philippa de Menil. Herr Friedrich supplied the pretension, most of it; Miss de Menil—a daughter of the art collectors Dominique and John de Menil, and hence an heiress to the Schlumberger oil fortune—supplied the money, lots of it. According to Kimmelman, by the mid-1980s, Dia had spent $40 million on 1,000 works of art.

The senior Menils went in for things like shrines to Mark Rothko. The Rothko Chapel at the de Menil Collection in Houston features a clutch of dark-hued abstractions by The Master set in the hushed preciousness of what some press material calls "a modern meditative environment." Indeed. A step or two away from the meditative modernity of the new-age crystals-are-gods crowd, the Rothko Chapel is . . . well, let's call it unforgettable and leave it at that. The senior Menils extended themselves in exquisiteness: elegant architecture, expensive simplicity, the cool, uncluttered look of what might be called Catholic Zen. The younger generation brought this down to earth. They went in for artists like Donald Judd, Dan Flavin, Richard Serra, John Chamberlain, Andy Warhol, Walter De Maria, Robert Smithson, Sol LeWitt, Robert Ryman, Agnes Martin, and Bruce Nauman. Minimalist, mostly, but by turns louder, coyer, angrier, more ironic—minimalism with neon, dirt, rocks, or crushed sedans.

Dia already runs or has run several other galleries and art spaces. It helped start the Andy Warhol Museum in Pittsburgh with a donation of 150 works by Warhol and the Cy Twombly Gallery in Houston with half-a-dozen works. In Manhattan, Dia runs some cavernous galleries (totaling some 38,000 square feet) in Chelsea and—possibly its most notorious undertaking to date—Walter De Maria's *New York Earth Room* (1977) in SoHo.

The New York Earth Room is exactly what its name says: a room in New York filled with earth. Well, not filled, exactly. This "interior earth sculpture" consists of 250 cubic yards of earth—i.e., dirt—spread over 3,600 square feet of floor space at a carefully manicured depth of twenty-two inches. The room, which is regularly cleaned and purged of mushrooms and other organic intrusions, is solemnly chaperoned by a couple of Dia employees who are discouraged from reading lest their attention wander.

Like most of the artists associated with Dia, Walter De Maria might have stepped out of a farce by Tom Wolfe. *The New York Earth Room* is not his only sandbox for Dia. Elsewhere in Manhattan is *The Broken Kilometer* (1979). I can't improve on Dia's official description: "500 highly polished, round, solid brass rods, each measuring two meters in length and five centimeters (two inches) in diameter. The 500 rods are placed in five parallel rows of 100 rods each." As Frank Stella said of his own work— more on that in a moment—"what you see is what you see." And then there is *Lightning Field* (1977), De Maria's site-specific effort near Quemado, New Mexico. *Lightning Field* consists of four hundred stainless-steel poles, twenty feet long, two inches round, which are arranged in a mile-long, kilometer-wide grid in that desolate Western fastness. Dia spent $1 million on *Lightning Field*, which may help explain why they claim it is "recognized internationally as one of the late-twentieth century's most significant works of art." In case you were thinking of dropping in for a quick look, don't. Overnight reservations (one night only) are required in a cabin that Dia maintains next to the field; "a simple supper (vegetarian) is prepared for you." That meal may seem by-the-by, but it isn't. Everything about Dia is "(vegetarian)."

Dia owns and maintains Robert Smithson's *Spiral Jetty* (1970), a 1500-foot long, 15-foot wide coil of basalt rock and earth in the Great Salt Lake in Utah. Smithson inadvertently built this leviathan when the water level of the lake was unusually low, so the work is now often submerged. Dia also helped with Michael Heizer's *City*, an unfinished (after 30 years) series of huge abstract sculptures in the Nevada desert. "Heizer," Kimmelman reports,

> imagined "complexes," immense mastabas, some a quarter of a mile long, with 70-foot slabs weighing thousands of pounds. He acquired several square miles of remote property, surrounded by public land, two hours into the Nevada desert from the nearest paved road, and he lived for years in a trailer, locked in for half the winter and once going for months seeing only a couple of sheep trailers and a passing pickup truck. Art didn't get much more extreme than that.

Note the word "extreme": it's meant as a term of praise.

Then there is the Dan Flavin Institute in Bridgehampton, New York, which contains nine works in fluorescent lights by Flavin. A typical work by Flavin consists of a handful of standard-issue fluorescent lights arranged in a line. In 1979, Dia spent $5 million to purchase a sprawling disused army base in Marfa, Texas, and help Donald Judd construct a museum for his own work and that of a few artists he especially admired, like Flavin. Dan Flavin liked light bulbs. Donald Judd liked boxes, stacked one on top of another or arranged in a row. At Marfa, he could really let himself go. Until it fell on rocky times in the late 1980s, Dia supplied him with a stipend of $17,500 a month. One result was Judd's *100 Untitled Works in Mill Aluminum*

(1982–86), which are—no surprise here—one hundred large untitled boxes made out of milled aluminum and neatly arranged in two enormous converted artillery sheds.

Friedrich, who was removed as director of Dia in the late 1980s when the Foundation's finances tanked, was never shy about Dia's aspirations. According to Kimmelman, he compared Dia's patronage to that of the Medicis. "Our values are as powerful as those in the Renaissance," Friedrich is quoted as saying. He added that Dan Flavin "is as important as Michelangelo." Think about that the next time you switch on the fluorescent lights in your office.

I OFFER these snapshots of the Dia Foundation's activities as a sort of reality check. Bear in mind the room full of dirt, the steel poles cluttering up the New Mexico landscape, the light bulbs and the aluminum boxes. Think about Andy Warhol—his Campbell's Soup cans and Brillo Boxes, his pictures of Marilyn Monroe and Mao and Jackie Kennedy. Think about *Spiral Jetty*, John Chamberlain and his crushed cars, Richard Serra and his minatory Corten Steel walls. Now think about Michael Kimmelman's assertion that the perpetrators of these objects constitute "the greatest generation of American artists."

> They were the first Americans to influence Europeans. The work these artists made changed, or at least questioned, the nature of art: what it looked like, its size, its materials, its attitude toward the places where it was shown, its relation to architecture, light and space and to the land. The artists even questioned whether art needed to be a tangible object. Minimalism, Post-Minimalism, Earth art, video art, Conceptualism—suddenly art could be nothing more than an idea, a thought on a piece of paper that played in your

head. It could be ephemeral or atmospheric, like the experience of a room illuminated by colored fluorescent tubes.

I described Michael Kimmelman's essay as "extraordinary." As this passage demonstrates, it is extraordinary in approximately the same way that a snake-oil peddler's tales of miraculous cures are extraordinary, i.e., cynical, incredible, and ultimately pathetic.

Kimmelman said early on in his piece that "the history of American art is going to need a little rewriting." Needed or not, rewriting the history of American art is certainly what his essay is about. Let's start with some details. The artists of the so-called "Dia generation" were not the "first Americans to influence Europeans." For better or worse, that trophy belongs to the generation whose achievement Kimmelman is at such pains to depreciate, the generation of "Pollock, Rothko, and de Kooning." In 1958, Alfred Barr organized an exhibition called "The New American Painting," which toured Europe at the same time that a retrospective of Jackson Pollock's work was making the rounds. "The immediate effect of these exhibitions," Hilton Kramer has written, was "to establish the Abstract Expressionism of the New York School as the single most important art movement of its period" in the minds of young Parisians. Annette Michelson, at that time the Paris correspondent for *Arts* magazine, noted in its June 1959 issue that "the one really lively topic of discussion" among Paris artists, dealers, and critics was the new American painting. Barr's show, she conjectured, "might even come to be seen as the 'the Armory Show of post-war Paris.'"

Those acquainted with Kimmelman's other writings on art might be tempted to regard his factual mistake as the

product of simple ignorance. The heady sums of money involved make that very unlikely. Dia's aesthetic may be minimalist, but its pocketbook is maximalist. According to the April 23 story in the *Times*, Leonard Riggio, chairman of Barnes & Noble and now also Dia's Chairman, has given some $30 million towards Dia:Beacon, as well as several art works including Serra's *Torqued Ellipses* (1997), which was on view for over nine months at Dia's Chelsea gallery. The Lannan Foundation has given or lent the new museum another $15 million. When such sums are involved, it is a simple matter to let enthusiasm trump accuracy.

SINCE I STARTED with Evelyn Waugh, I should acknowledge that there is one brilliant moment in Kimmelman's piece that, though inadvertent, is worthy of Waugh at his most comic. It comes in the course of his interview with Leonard Riggio. "I went to Marfa and Roden Crater and visited Heizer in Nevada," Riggio recalls, "and I thought these artists recognized the genius of the average American. Judd built his museum in a little Texas town. [James] Turrell was hiring Native Americans from the area. Heizer was working with local people." In other words, we are supposed to regard Judd's aluminum boxes or Heizer's giant slabs in the middle of nowhere as art for the people, just as Barnes & Noble bookstores are, quoth Riggio, "for average citizens, for the whole of society." It would be an art work worthy of Dia to try out, say, the room full of dirt on a randomly selected group of average citizens. I hope I am invited to witness the result.

Leonard Riggio is not really a comedian, of course. He makes a serious point—a deeply misguided point, I believe, but nonetheless serious—with his assertion that the question "What is Art?" is "the big question." In fact, the last

half century has shown it to be one of the most vacuous questions ever formulated. Whatever interest it might hold for epistemologists, it has proven to be an artistic dead end—worse than a dead end, really, for it has turned out to be an endless maze that leads nowhere.†

Marcel Duchamp posed, and disposed, of the essential issue back in the Teens with his ready-mades: ordinary objects torn out of their quotidian surroundings and exhibited as art. He intended his Dadaist pranks to explode the whole category of aesthetic delectation. But Duchamp underestimated the art world's tolerance for trivialization. What he meant to end art merely led to its ironic depreciation. "I threw the bottle rack and the urinal into their faces as a challenge," Duchamp noted contemptuously in 1946, "and now they admire them for their aesthetic beauty." If a bottle rack or a urinal can be art, well, anything can be. Which means that to say that something is a work of art is to say very, very little. Nevertheless, for many people the word "art" operates like a magic charm: pronounce it and their critical faculties are stunned. They roll over and purr, waving their arms and legs—and wallets—in the air. It is because we have made an idol out of art that we are beset by so many artistic idols.

There was a period, a decade or two ago, when you could hardly open an art journal without encountering the quotation from Frank Stella I used as an epigraph. The bit about "what you see is what you see" was reproduced *ad nauseam*. It was thought by some to be very deep. In fact, Stella's remarks—from a joint interview with him and Donald Judd—serve chiefly to underscore the artistic emptiness of the whole project of minimalism. No one can

† See "Can Art Be Defined?," pages 47–53 below.

argue with the proposition that "what you see is what you see" (the proposition that $a = a$, after all, is unassailable).

But there's a lot to argue with in what he calls "the fact that you can see the whole idea without any confusion." We do not, of course, *see* ideas. Stella's assertion to the contrary might be an instance of verbal carelessness, but it is not merely verbal carelessness. At the center of minimalism, as Clement Greenberg noted in "Recentness of Sculpture" (1967), is the triumph of ideation over feeling and perception, over *aesthetics*. As Greenberg acknowledged, minimalism can bring about "a certain negative gain." It can, for example, lead one to appreciate how "fussy" some earlier abstract sculpture is. By the same token, some minimalist works can bring you up short and make you look at dirt-rocks-trees-boxes-an empty room or whatever with new eyes. It's not every day, after all that you see a field full of steel rods or a huge spiral made of rocks or a picturesque warehouse filled with meticulously fabricated metal boxes. But see them once and you've seen all there is to see. Great art repays renewed scrutiny with new insights, new perceptions. With minimalist art, well, "what you see is what you see": C'est tout, and it's not much. Minimalist art is one-off art.

Besides, there are plenty of engaging visual things that are *not* art: the crab apple tree that is just now flowering outside my study window. How much more interesting it is to look at than a row of boxes by Donald Judd. Would it be even more interesting if some enterprising artist came by tomorrow and declared it a work of art? I might be able to sell it for a handsome price, a prospect which carries its own sort of interest, to be sure, but *aesthetically* it would have remained what it is: a flowering crab apple tree.

At bottom, minimalism is formula art. Just say that

what you propose to exhibit "pushes the boundaries of what counts as art" and you are home free. Minimalism is also, for all its rhetorical boldness, timid art. Its "artistic substance and reality," Greenberg noted,

> turns out to be good safe taste. I find myself back in the realm of Good Design, where Pop, Op, Assemblage, and the rest of Novelty Art live.

Greenberg spoke in this context of minimalism as a kind of "mannerism." It is mannerism for an aphasic, unmannerly age. Minimalism is art whose entire effect depends on walking the tightrope between between art and everything else. It is a kind of cultural circus trick. It was cute when Duchamp did it in the 1910s. It got old fast and now is a cliché employed by artists whose chief talent is for "being artists."

The artists Dia has supported form a disparate group. Not all are minimalists—Warhol, for example, or Chamberlain. But all specialize in art which flirts with what Greenberg called "the look of non-art." They, too—or at least their supporters—thought that "What is art?" was "the big question." In fact, it is the kind of question that, when pursued as a substitute for artistic practice, leads directly to rooms full of dirt and sad fellows living for years in a trailer in the Nevada desert. It also leads to charlatans like Judd, who exploded in a rage when his monthly stipend had to be stopped, and it leads, too, to judgments like Friedrich's that Dan Flavin is "as important as Michelangelo." It leads, in other words, to a view Andy Warhol is said to have endorsed, that "art is what you can get away with."

2003

Betraying a Legacy:
The Case of the Barnes Foundation

After the Donor's death no picture belonging to the collection shall ever be loaned, sold or otherwise disposed of except that if any picture passes into a state of actual decay so that it is no longer of any value it may be removed for that reason only from the collection.
—from the By-Laws of the Barnes Foundation, December 1922

One of the most striking things in America is the Barnes collection, which is exhibited in a spirit very beneficial for the formation of American artists. There the old master paintings are put beside the modern ones . . . and this bringing together helps students understand a lot of things that academics don't teach.
—Henri Matisse, 1930

THE HEADLINE of a 1993 press release from the National Gallery in Washington, D.C., put it with disarming frankness: "World Tour of Great French Paintings from the Barnes Foundation." To be sure, the paintings that were included in that exhibition *are* great. Among the eighty-odd canvases from the Barnes Foundation in Merion, Pennsylvania, that were on view at the National Gallery were masterpieces by Renoir, Cézanne, Seurat,

Matisse, and Picasso, as well as important works by Gauguin, Henri Rousseau, Vincent van Gogh, Chaim Soutine, Amedeo Modigliani, and others. Renoir's *Leaving the Conservatoire* (1877), Cézanne's *The Card Players* (1890–92), Seurat's *Models* (1886–88), Matisse's *Le Bonheur de vivre* (1905–06), *Seated Riffian* (1912–13), and *Merion Dance Mural* (1932–33): these and other works— including the first public showing of a stunning early version of Matisse's dance mural that was only recently discovered in Nice—made the exhibition one of the most spectacular samplings of late-nineteenth- and early-twentieth-century French painting anywhere.

Of course, it all sounds marvelous. Never mind that the installation at the National Gallery was rather sterile: is it not terrific that this was only the first of several stops on a two-year, worldwide, money-making tour that included museums in Paris, Tokyo, and Philadelphia? Think of the crowds: they will almost certainly number in the hundreds of thousands. All those art lovers, hitherto unable to make it to the Barnes Foundation—with its limited hours and out-of-the-way location in a comely suburb of Philadelphia—were at last able to buy a ticket and shuffle past these masterworks *en masse*. (As of this writing, zoning regulations limit the Barnes to 400 visitors a day, three days a week.) Richard H. Glanton, who was then president of the Barnes Foundation, estimated that the tour would bring about $7 million to the Foundation's coffers. (By some accounts, in the end it brought in closer to $16 million.) Was this not a splendid example of shrewd financial management combined with "cultural democracy" in action? The National Gallery wanted you to think so. With some notable exceptions, the press wanted you to think so, too. Likewise the administration of the Barnes Foundation.

But no. The spectacle of the Barnes Foundation under Richard Glanton (who left the foundation under a cloud in the late 1990s) was anything but encouraging. The public-relations *apparatchiks* would have us believe that, after decades of "elitism," the Foundation was finally opening its doors and dispensing its treasures to "the people." In fact, the behavior of the Foundation's trustees, in collusion with several other institutions and individuals, raised a host of troubling questions: questions about the proper place of art and aesthetic values in a democratic society, first of all, but also questions about the future of private philanthropy in this country.

This is hardly the only occasion on which such questions have come to a head. Indeed, the struggle between the prerogatives of artistic excellence and the claims of popular appeal have featured prominently in the recent history of American arts institutions. But the case of the Barnes Foundation adds several new elements to this long-playing drama: a maverick, largely self-taught connoisseur with a genius for business, art, and making enemies; a long and tangled legal battle in which undeclared rivalries have masqueraded as matters of high principle; and, last but not least, large dollops of populist demagoguery.

The protagonist of this saga is Dr. Albert C. Barnes. Born in Philadelphia in 1872, Barnes was brought up in a working-class family, the son of a butcher. He was a talented athlete, boxing and playing baseball semi-profes-sionally to help pay for his schooling. He was also a diligent student, earning a B.S. in 1889 and, from the University of Pennsylvania, an M.D. in 1892 at the age of twenty. After his internship, he traveled to Berlin and Heidelberg to study pharmacology and philosophy. In 1902, he married and, with the German chemist Hermann

Hille, started the company Barnes and Hille, which man-
ufactured a proprietary antibiotic compound called
Argyrol. Especially useful in fighting infant eye infections,
Argyrol was to make Barnes's fortune. In 1907, he bought
out Hille's interest in Barnes and Hille, and the following
year established the A. C. Barnes Company, which
manufactured and marketed Argyrol worldwide.

In addition to his skills as a businessman, Barnes had
prodigious intellectual gifts. The philosopher John Dewey,
a close friend with whom he corresponded and col-
laborated for over thirty years, once remarked that for
"sheer brain power" he had not met Barnes's equal. His
fortune assured, Barnes increasingly turned his attention to
the world of art and ideas. His intellectual tastes, like his
artistic tastes, proved to be daring, individual, and
supremely self-confident. From boyhood, he was fascinated
by American black culture—camp meetings, revivals, and
the like—and he later acknowledged the indelible impres-
sion that black culture had made on his life and outlook.
He also became deeply interested in psychology, including
the startling new methods propounded by Freud and Wil-
liam James. Pragmatism, especially, with its emphasis on
the experiential basis of human values, attracted him.

Barnes began collecting art in the early Teens. At first,
his high-school friend, the artist William Glackens, helped
him buy works. Barnes sent Glackens to Paris in 1912.
Together with the artist Alfred Maurer, Glackens pur-
chased for Barnes works by Cézanne, van Gogh, Picasso,
Renoir, Pissarro, and others. Barnes later traveled to Paris
to make his own purchases from dealers and auction
houses. He eventually assembled one of the most dazzling
collections of modern French painting anywhere in the
world. By the time of his death, in 1951, he had acquired

180 works by Renoir, sixty-nine by Cézanne, sixty by Matisse, forty-four by Picasso, fourteen by Modigliani, twenty-one by Soutine, eighteen by Henri Rousseau, seven by van Gogh, six by Seurat, as well as a handful of Gauguins, Toulouse-Lautrecs, Braques, Monets, Manets, and others.

BUT BARNES'S TASTE was hardly confined to French art. He was also an avid collector of Old Master paintings, American Impressionists, Greek and Egyptian antiquities, intricate wrought ironwork, Native American art, and African tribal sculpture. As one commentator observed, "Barnes was at ground zero of the modern age, founding his museum and school early in the '20s. To a skeptical nation, he championed the new masters from Europe, and he delved deeply enough into their works, theories and lives to confidently present such diverse influences as African sculpture and Baroque dynamos." Altogether, the Barnes collection totals nearly 2,500 works of art.

Interested though Barnes was in art, his first passion was education. Deeply influenced by Dewey's theories on education and democracy, he looked to art and aesthetic experience as a primary, if as yet imperfectly tried, means of educating the human spirit in modern democratic society. In the Indenture of Trust that created his foundation, Barnes noted that he was particularly keen that "plain people, that is, men and women who make their livelihood by daily toil in shops, factories, schools, stores, and similar places," have free access to the sustenance that art offers. As the scholar Richard J. Wattenmaker points out in his excellent essay for the catalogue that accompanied the traveling exhibition of works from the Barnes Foundation, Barnes began by instituting a six-hour work

day at his factory. He installed dozens of artworks at the A. C. Barnes Company and established discussion groups for both white and black workers to ponder the paintings as well as books by Dewey, Bertrand Russell, William James, George Santayana, and others. He started a circulating library and even allowed interested outsiders not associated with the company to attend lectures and discussion groups.

In fact—and this detail is worth bearing in mind—it was out of these informal factory seminars that the Barnes Foundation with its formal roster of classes and research evolved. Convinced that he was on to something, in 1922 Barnes decided to create and endow a foundation "to be maintained perpetually for education in the appreciation of the fine arts." The educational element cannot be overemphasized: the Barnes Foundation was not created as an art museum. On the contrary, Barnes created it "as an educational experiment under the principles of modern psychology as applied to education."

One of the great strengths of Barnes's taste was its breadth. Of course, it is easy to disagree with some of his judgments about particular works or particular artists: but that can be said of any important critic. What matters in a critic are not so much particular likes and dislikes (though the quality of Barnes's collection shows that he did pretty well on this score, too) but the principles of judgment he employs. At the center of Barnes's philosophy was the effort to understand the distinctively *aesthetic* features of works of art no matter what their period or provenance. He sought, as he wrote in *The Art in Painting* (first edition, 1925), the "intelligent appreciation of paintings from all periods of time."

In this, Barnes resembles critics like Roger Fry, who also

attempted to delineate "experimentally" (as Fry put it in his book *Transformations*) the experiences we have "in the face of different works of art of the most diverse kinds." Barnes wished to emphasize the aesthetic qualities of art— the emotional coefficients of line, form, color, texture, and so on. This led him to arrange his collection unchronologically in tableaux designed to highlight the aesthetic, rather than the narrative or thematic, affinities among the works. Many visitors to the Foundation have found this—and the absence of wall labels identifying the works—off-putting. But such were Barnes's strategies to coax students (and visitors) into *looking*. Simple chronological organization and wall labels—to say nothing of that contemporary bane, the "audio tour"—serve to distract the viewer from, well, *viewing*. They encourage him to substitute reading or listening for the harder work of attentive scrutiny. Not that the name of the artist and title of a picture are unimportant; but one should be able to assume that anyone really interested in what he is looking at will go to the trouble to ascertain such historical information beforehand. As Barnes noted in *The Art in Painting*,

> To see as the artist sees is an accomplishment to which there is no short cut, which cannot be acquired by any magic formula or trick; it requires not only the best energies of which we are capable, but a methodical direction of those energies, based upon scientific understanding of the meaning of art and its relation to human nature.

"The meaning of art and its relation to human nature": One should keep this desideratum in mind when the oft-made charge of "formalism" is hurled at Barnes. If by "formalism" one means an abstract inventory of artistic

technique, then Barnes was the opposite of a formalist. As Mr. Wattenmaker notes in his catalogue essay, "What Barnes sought to convey in front of the painting itself, rather than from a reproduction, was a means of sorting out the varieties of human experience embodied in a painting." The term "formalism" is nowadays unthinkingly used as a negative epithet. But it is worth remembering that what separates good works of art from the bad or mediocre is almost always in some sense form, not "content." What makes a depiction of the Virgin Mary or a bowl of irises a great work of art is not the Virgin or the flowers but the handling of those subjects by the artist.

All this is by way of background to the controversy that has swirled around the future of the Barnes Foundation—a controversy in which the touring exhibition of French masterpieces played an integral role. At the center of the controversy is the contention that the Barnes Foundation, while it poses as an educational institution, is "really" an art museum that, in exchange for its tax-exempt status, should be more accommodating to the public. This battle is not new. It began shortly after Barnes's death in 1951 when *The Philadelphia Inquirer*—then owned by one of Barnes's chief antagonists, Walter Annenberg—initiated litigation and an editorial campaign against the Foundation in an effort to transform it into a public art museum. As Gilbert M. Cantor notes in his meticulous and informative book, *The Barnes Foundation: Reality vs. Myth* (1963; second edition 1974), the *Inquirer*'s campaign against the Barnes Foundation "was not a passing fancy but a ten-year program of harrassment which has not ended even today." Mr. Cantor was writing in 1963; all that needs to be emended is the phrase "ten-year."

As owner of *The Philadelphia Inquirer*, Walter Annen-

berg had a large hand in directing the attack against the Barnes Foundation. In this context, it is illuminating to compare Mr. Annenberg's activities as a collector with Barnes's. From the Teens—when it was still unpopular— through the Forties, Barnes collected French Impressionist and Post-Impressionist art: Mr. Annenberg began assembling his collection of Impressionist and Post-Impressionist art in the late Fifties when every museum in the country was clamoring for the stuff. Barnes used his self-made fortune to found an educational institution based on aesthetic principles that he had painstakingly thought through for himself; in the 1970s, Mr. Annenberg offered the Metropolitan Museum of Art in New York some $20 million to establish an educational program that would bear his name, even if it could hardly be said to represent his ideas. Barnes stipulated that the artworks he bequeathed to the Barnes Foundation not be sold, moved, or lent; Mr. Annenberg, when he recently promised to leave his collection of paintings to the Met, stipulated that the works not be sold, moved, or lent. Extraordinary coincidences, to say the least.

ONE OF THE MOST disagreeable features of the effort to destroy the Barnes Foundation has been a campaign of character assassination directed at its founder. This, too, has a long history. Barnes made many enemies. He was aggressive, impatient, and could be overbearing to the point of brutality. He harbored a particular dislike for the academic art establishment, which he regarded as effete, snobbish, and essentially uninterested in the vital aesthetic core of art. (This indeed was one reason that, near the end of his life, he arranged to cede eventual control of the Barnes Foundation to Lincoln University, a predominantly black college in Pennsylvania. Mr. Glanton, incidentally,

served as counsel to Lincoln before being appointed president of the Barnes Foundation.)

Today it is routinely assumed that Barnes was eccentric to the point of irresponsibility. One journalist, writing recently in a major newspaper, described him as "loony." Paul Richard, chief art writer for *The Washington Post*, went even further. In an extraordinarily ignorant article called "An Imprisoned Collection Breathes at Last," Mr. Richard castigated Barnes's view of art as "doggerel-like." Admitting that the Foundation's collection is "among the strongest" American collections of paintings, he nevertheless insisted that it was also the "silliest, and strangest." "Few American museums have ever been as selfish, as scornfully unwelcoming, as is the Barnes Foundation," Mr. Richard wrote, snidely adding that it "isn't really a museum, but a gallery-cum-school for promulgating Barnes-think." In fact, Mr. Richard has it exactly wrong. The Barnes Foundation is not a gallery-cum-school; it is a school whose resources include art galleries. The public has not been given free access to the Barnes Foundation facilities, but then the public is not given carte blanche to wander around classrooms at Yale or Harvard, either. And as for "Barnes-think," well, Mr. Richard gives us a good sense of the quality of his own thinking about art when he goes on to criticize Barnes for acquiring so many Renoirs because Renoir's women "all look much alike." Perhaps Mr. Richard should have taken time out for a course at the Barnes Foundation.

Journalists such as Mr. Richard have unfortunately lent themselves to the attempt to destroy the Barnes Foundation by voiding its charter and forcing it to become a public art museum. As Gilbert Cantor noted in his book, should this effort succeed, it would be "tantamount to

confiscation of an art collection." The ironies are manifold. When he established the Foundation, Barnes wrote that "the purpose of the gift is democratic and educational in the true meaning of those words." Now, under a barrage of populist and anti-elitist slogans, the "true meaning" of democracy and education are rejected for the sake of a grotesque counterfeit.

Before the court granted permission for the world-tour of paintings from the Foundation, Mr. Glanton had proposed selling off various works to finance renovation of the Foundation buildings. So far, that provision of Barnes's trust document has survived the assault. Yet anyone considering the charitable disposition of his own property must be given pause by the cavalier treatment accorded Barnes's Indenture of Trust. The Indenture specifies that "at no time shall there be any society functions commonly designated receptions, tea parties, dinners, banquets, dances, musicales, or similar affairs" held at the Barnes Foundation. But last fall Mr. Glanton gave an elaborate reception and lunch party there at which not only the press but also various society figures, including Mrs. Walter Annenberg, were present. The Indenture specifies that the administration building attached to the gallery "be used as classrooms"—and so it was until Mr. Glanton moved the Foundation's offices into the building, converting Mrs. Barnes's former sitting room into his private office. The Indenture specifically prohibits the "copying of any of the works of art in the Barnes Foundation by any person whatsoever." Barnes was particularly opposed to color reproductions of works of art because they give a distorted impression of the original. And yet the exhibition catalogue, published by Alfred A. Knopf, contains hundreds of illustrations, "154 in full color," as a press release boasts. Another fascinating coincidence:

Samuel I. Newhouse happens to own Knopf and the Newhouse Foundation happened to make a $2 million grant to Lincoln University just before Knopf was granted permission to publish the catalogue. And of course the Indenture prohibits lending any works from the collection: that provision, too, has obviously been egregiously violated.

Albert Barnes gave his fortune to perpetuate the idea that democracy was not inimical to high culture. Mr. Glanton and others are determined to prove him wrong, even if it means making a travesty of his ideas and trampling on the principle of private property. It is disheartening to behold.

1993

Postscript, 2003

THE CONTROVERSY over the Barnes Foundation has not quieted down in the years following the world tour of highlights from its collection. Despite the millions raised from the tour, the Foundation teetered close to insolvency under Mr. Glanton's tenure. The town of Merion, rightly fearing that efforts to turn the Barnes Foundation into what one observer called a "Getty-type commercial museum" would negatively affect the town's quality of life, sought to have the Barnes Foundation abide by its status as a private educational institution (rather than a public art gallery, a permit for which the Barnes Foundation has never secured). In retaliation, Glanton, who is black, played the race card and brought a civil-rights suit against the commissioners and certain residents of town of Merion charging them with "racial bias." Glanton left after the failure of this preposterous suit, but the future of the Barnes is still very much in doubt.

In September 2002, the trustees of the Barnes Foundation petitioned the court to move its collection from Merion to Philadelphia, a move that some observers see as a prelude to the Barnes Foundation being absorbed by the Philadelphia Museum of Art. A year earlier, Kimberly Camp, the current head of the Barnes Foundation, dismissed as "ridiculous" the rumors that the Barnes might move to Philadelphia or ally itself with the the Philadelphia Museum of Art. "I've given it the same fleeting thought as I would to buying a lottery ticket and giving half to the foundation," she said. "It is not practical." Maybe not, but that is precisely what happened to the collection of John J. Johnson. When Johnson (who, coincidentally, was Barnes's lawyer) died in 1917, he left his collection of some 1,000 paintings together with his Philadelphia house to be a museum. After the house was condemned by the city, the collection was transferred—temporarily, it was thought—to what was then called the Pennsylvania Museum of Art. The judge overseeing the operation stipulated that the collection had to be kept separate. All that went by the boards a decade ago when the museum rehung its collection, rolling the Johnson collection into its own holdings.

As of this writing, the Barnes Foundation continues to operate under severe financial constraints. It has begun a fund-raising drive, but, to date, has enjoyed only limited success. "Unique" is an over-used word these days. But it truly does apply to the Barnes Foundation. It would be a pity if this noble, though idiosyncratic, monument to individual genius were forced into the dumbed-down, homogenizing mold into which the art establishment attempts to force every institution. Poor, cantankerous Albert Barnes would be spinning in his grave.

Can Art Be Defined?

CERTAINTY is a marvelous thing. Not only does it provide a useful carapace against the onslaughts of doubt, but it also does wonders for one's self-confidence. It is perhaps the one mental commodity that everyone, admirers and critics alike, will agree that the novelist-philosopher Ayn Rand (1905–1982) possessed in abundance. The attitude must be catching, for her disciples tend to be well endowed with certainty as well.

I thought about this when contemplating the title of Louis Torres and Michelle Marder Kamhi's book *What Art Is: The Esthetic Theory of Ayn Rand* (Open Court, 2000). As the authors note, the title is "a deliberate inversion" of the title of Tolstoy's didactic manifesto *What is Art?* Most readers have found Tolstoy's brief for subordinating art to religion and morality sufficiently, not to say crudely, apodictic. But at least he had the delicacy to cast it in the interrogative.

The authors of *What Art Is* want none of that pusillanimous hesitation. Rand's speculations about art and literature may exhibit some "shortcomings in detail," they tell us. Nevertheless, they argue that "in its fundamental principles" her theory of art is "coherent, substantial, and

valid, constituting a major contribution to the literature on the philosophy of art."

The prospect of an aesthetic theory that is not only "coherent" and "substantial" but also "*valid*" is pretty impressive, not to say intimidating. Of course, "valid" is an equivocal term. It can mean anything from "following necessarily" to merely "sound" or, finally, "compelling." The authors of *What Art Is* do not specify in what sense they use the word. Several things suggest that they presume a fairly high degree of rigor: their decision to italicize the word, the air of impatient certainty with which their discussion proceeds, and their emphasis on the importance of having "*an objective definition*" of art. Indeed, it seems that one of the chief things that attracted them to Rand's aesthetic theory was her willingness to provide such a definition. At a time when there is so much bogus art about, they were grateful to find someone who cut through the morass and could tell them—clearly, without any foolish shilly-shallying—that this here is art while that over there just doesn't make the grade. It is nice work if you can get it.

I will come back to the question of defining art in a moment. First, let me say a few words in general about *What Art Is*. The book was a long time coming: more than a decade, the authors tell us. Their researches over the years turned up a lot of art-world exotica, and they were loath to leave anything out. What began as a series of magazine articles slowly accreted into a five-hundred page book. The main text is about three-hundred pages. This is divided about equally between an exposition of Rand's theory of art and an attempt to apply its lessons to the bewildering world of twentieth-century art. The main text concludes with a chapter on "public implications": government and

corporate support of the arts (the message: Here be monsters), art and the law (free speech, pornography, etc.), and teaching the arts to children (the more traditional the better). This chapter, which I found to be the most persuasive part of the book, is followed by three brief appendices: a list of "some of the alleged forms of art invented since the beginning of the twentieth century" (Pop art, Op art, Body art, etc.), a list of art-world buzz words, and a few pages of examples of how *The New York Times* uses the term "arts" in its cultural coverage. The appendices are followed by just over a hundred-and-fifty-pages of endnotes that qualify, elaborate, or comment on issues raised in the main text. It's a rich, opinionated mélange of a book, full of notes, asides, and second thoughts, but positively steely in its pursuit of its main theme: laying down the law about what does, and what does not, qualify as art.

I suspect that this book had its genesis in two distinct impulses: admiration for the writings of Ayn Rand, on the one hand, and impatience with the contemporary art world, on the other.

The impatience is eminently justified. As one looks around at much of what is adulated as art today, one shuttles between weariness, incredulity, and revulsion. Of course, there is plenty of good art being produced today. But the headlines are mostly reserved for work that is unutterably banal, downright pathological, or, just occasionally, both. Everyone will have his own rogues gallery and catalogue of horrors. Karen Finley, for example, earned her place in the annals of fatuousness by convincing the National Endowment for the Arts to shovel some money her way for an act that consisted of her prancing about naked, smeared with chocolate, while skirling about

the evils of patriarchy. Or consider Matthew Barney, a hot young artist whose oeuvre consists of things like *Field Dressing (Orifill)*, a video that depicts the artist "naked climbing up a pole and cables and applying dollops of Vaseline to his orifices." That description comes from Michael Kimmelman, chief art critic for *The New York Times* who recently declared Barney "the most important American artist of his generation."

Well, you see what Andy Warhol meant when he said that "Art is what you can get away with." The authors of *What Art Is* provide a generous catalogue of such stuff and the commentary it has elicited. Readers familiar with the terrain will not encounter any new horrors: the authors have just paraded the usual suspects to make their point. But most readers are nevertheless in for some surprises. For in their effort to segregate the sheep of art from the goats of non- or bogus art, the authors have discovered many, many herds of goats.

It is quite breathtaking, in fact, to watch as our authors consign virtually all of modernist and post-modernist art to the limbo of non-art. They begin by promising to provide the "ordinary person's" common-sense view of art with "the theoretical justification it warrants." They end up by denying the status of art to virtually every avant-garde movement since the turn of the last century. Pop art, conceptual art, performance art have to go, as does abstract art in its entirety: "the very concept of abstract art," they tell us, "is invalid." Cézanne is not mentioned in this book. Neither is Georges Braque or Matisse. Picasso appears in one footnote. All of these artists took painting a long way toward abstraction, and it would be interesting to know whether our authors thought they qualified as artists. Kandinsky, Malevich, and Mondrian fail to make the grade, as

do Jackson Pollock, Mark Rothko, and David Smith. It's the same in other genres. Schoenberg "was inspired by a misguided desire to expand the expressive range of his art." Merce Cunningham "opened a Pandora's box that had yet to be closed." James Joyce and Samuel Beckett were obscurantist poseurs. And poor John Ashbery "is not a poet at all." Photography, they conclude, cannot really be considered a form of art, nor can architecture. Our authors are correspondingly severe about the critics who championed any of this work. Meyer Schapiro is taken to task for his "spurious elitist perspective," Clement Greenberg for his "subjectivist elitism," Hilton Kramer for his allegiance to "formalist" values. Even Roger Kimball, it pains me to note, is rubbished for "counterfeit elitism," among other sins.

It is easy to sympathize with the exasperation that prompted *What Art Is.* We really do live at a time when *anything* can be be hailed as a work of art. This has naturally led to a proliferation of pretentious and often pathological nonsense in the art world. But in their effort to introduce sanity to the discussion of the art, our authors have vastly overshot the mark. Some of what they criticize deserves all the obloquy they heap on it. But in their pursuit of "an objective definition" of art they threaten to throw out the proverbial baby with the bathwater.

One problem is that art is not susceptible to the sort of definition they seek. Ayn Rand's detractors tend to view her philosophy as an adolescent form of Nietzscheanism—a sort of double adolescence, if you will—but she herself liked to trace her intellectual patrimony back to Aristotle. It is not surprising, then, that our authors frequently cite *The Poetics* in their exposition of Rand's theory of art. Even more pertinent, however, is Aristotle's observation, in

The Nichomachean Ethics, that "the same exactness must not be expected in all departments of philosophy" and that "it is the mark of an educated mind to expect that amount of exactness which the nature of the particular subject admits." Like many important things in life, art cannot usefully be defined. What matters is experience, not a priori prescription. Any true definition of art will have to be so general as to be vacuous.

So it is with Ayn Rand. Her definition of art as "a selective re-creation of reality according to an artist's metaphysical value-judgments" is hardly more helpful than her characterization of art as "the technology of the soul." Kant was right when he noted that

> There can be no objective rule of taste which shall determine by means of concepts what is beautiful. For every judgment from this source is aesthetical, i.e., the feeling of the subject. To seek for a principle of taste which shall furnish, by means of definite concepts, a universal criterion of the beautiful is fruitless trouble, because what is sought is impossible and self-contradictory.

Our authors say a lot of lofty things about art. They tell us that for Ayn Rand "art is a unique means of integrating the physical and pyschological aspects of human existence," that "art is the indispensable medium for the communication of a moral ideal," and so on. The problem is that lots of things that would qualify as art even on their restrictive definition conspicuously lack the Wagnerian density they desire.

Our authors tell us that "if a critical judgment is based on a mistaken notion of the nature of art, as distinct from that of other human endeavors, it necessarily forfeits its

claim to respect or consideration." But in fact, persuasive critical judgments about art rely not upon possession of the correct "formal definition" of art but upon the exercise of taste. This is not to say that judgments about art are purely subjective; but it is to say that the common ground of taste can never be conceptually demonstrated. In Kant's telling formula, in judgments of taste "we woo the agreement" of others by appealing to a common sense we presuppose but cannot prove.

I do not like Andy Warhol or Karen Finley or Robert Mapplethorpe or Marcel Duchamp any more than our authors do. But it is silly to deny that what they produced was art. It just doesn't get us anywhere. This is even true in the case of Duchamp, who intended his Dadaist pranks to undermine the very idea of art. It may be unfortunate that anything can be accorded the status of art in our society. It may token an important spiritual breakdown as well as a massive failure of nerve. But the real issue is not whether a given object or behavior qualifies as art but rather whether it should be regarded as good art. In other words, what we need is not definitional ostracism but informed and robust criticism.

2001

Julius Meier-Graefe
Discovers El Greco

A LL ART CRITICS dream of discovering a great artist. Most of us assume that it is more difficult to discover a great living artist than one safely dead. And perhaps it is. But rediscovering greatness in the face of the neglect of centuries is itself an awesome task. It requires daring, perceptiveness, and not a little luck. In the annals of modern art criticism, few tales of rediscovery are more thrilling than the story Julius Meier-Graefe recounts in *The Spanish Journey* of how he went looking for Velázquez and discovered El Greco instead.

In fact, reading *The Spanish Journey* is likely to be a double revelation. For Julius Meier-Graefe's work is not at all well known today—except, that is, among a select handful of artists and critics. For them, the German-born critic is one of the guiding lights of twentieth-century criticism. His book on modern art, first published in German in 1904 and translated into English in 1908, is an indispensable introduction into the *aesthetic* achievements of modern art from Ingres to Seurat. Although Meier-Graefe began his career in Berlin, where he co-founded the important art and literary magazine *Pan* and helped to organize some of the first exhibitions of the work of Edvard Munch,

he traveled widely and lived in Paris for much of his life. He belonged to what was perhaps the last generation of cultivated Europeans whose true home was not in any particular country but in the great tradition of European art and culture.

Adolf Hitler unwittingly paid tribute to Meier-Graefe's importance in 1937, three years after the critic's death, in the infamous exhibition of "degenerate art" that the Nazis mounted in Munich. The first thing that viewers saw when they entered the exhibition was a large photograph of Meier-Graefe. For the Nazis, Meier-Graefe had committed two unforgivable sins: He praised modern French art; and, as if this were not bad enough, he also wrote some devastating criticism about the work of Arnold Böcklin and other German artists who were close to the Führer's heart. "One cannot," Meier-Graefe concluded, "love both Böcklin and art."

It is important to understand that Meier-Graefe was not a partisan of French art *per se*. For him, genuine artistic achievement transcended all national and racial boundaries. What really mattered in art was international, cosmopolitan, universal; if he praised late nineteenth- and early twentieth-century French art, it was not because it was French but because it was good. Of course, all this further infuriated the Nazis, who insisted that the ethnic and national background of art were important determinants of its quality.

The Spanish Journey is an unusual work of art criticism. It is also passionate and illuminating. First published in 1910 (an English translation appeared in 1926), the book recounts a six-month trip Meier-Graefe made to Portugal and Spain with his wife and two friends in 1908. It is composed partly of diary entries, partly of letters. There is

almost as much about bullfights, gypsy dances, and other local attractions as there is about art.

Today, it may be difficult for us to realize how poorly El Greco was regarded until Meier-Graefe rediscovered him. A biography, in Spanish, had recently appeared when Meier-Graefe made his journey. But outside Spain, El Greco's work was almost completely ignored. As late as 1881, the director of the Prado called El Greco's pictures "absurd caricatures" and regretted they could not be removed to provincial museums. In 1906, the Spanish government considered selling some of his work abroad.

WHEN MEIER-GRAEFE ARRIVED in Spain, he more or less shared this conventional view of El Greco. Writing about his first visit to the Prado, he remarks that "The El Grecos, which one must pass, looked like inebriated phantasies." One of the most fascinating things about this book is the spectacle of the critic struggling with himself: he had always assumed Velázquez was a great artist, El Greco a nonentity: why then did his experience tell him otherwise? One needn't agree with Meier-Graefe about Velázquez to feel the baffling pathos of his encounter with the artist. "From the very first moment in the Velázquez room I felt that something painful and ludicrous was happening. . . . I went from picture to picture, at first very quickly, like counting bank notes, then slowly and more slowly."

He wanted desperately to approve of Velázquez, but it was no good: "It must be something in me. Velázquez! Velázquez!—The very sound of the name conjures forth the conception of unheard-of qualities. Surely it is impossible that the impression of a few minutes can suffice to arrive at certainty. It must be some desire in me or opposition, spleen, lunacy. There have been six great masters in

the world during the last thousand years. He belongs to them."

And just as Meier-Graefe's confidence in Velázquez was eventually shattered, so his opinion of El Greco was eventually transformed. Another amazing thing about *The Spanish Journey* is the record it contains of a great critic's meticulous care and patience in looking at art. Meier-Graefe visited the El Grecos in Spain again and again, going not only to the Prado but also to out-of-the-way churches, monasteries, and private collections. He went to the Escorial palace a dozen times to see *The Legend of Saint Mauritius*, a painting that he finally concludes is "the most beautiful picture of mankind." Here is one passage, written after he had seen the painting five or six times:

> The contrast between plasticity and flat space hardly exists at all in the *Mauritius*. The bodies are more plastic than in almost any primitive. . . . Books could be written about the manner in which this has been achieved. The main motif has once again been based upon an ellipse. The picture is divided diagonally by two ellipses whose simplest form looks something like this: the upper ellipse is drawn by the angels and the clouds, and the lower and much more obvious ellipse by the men, that is to say, by vertical lines. A system of undulating lines divides the lower ellipse in such a way that a loop is formed. These sub-systems approach the horizontal and the vertical, whose directions are decisive in the square formed by the main group. The inexhaustible wealth of this picture depends upon this play of highly Baroque curves with the horizontal and vertical lines. El Greco conceals this mathematical structure because he does not use the same portions of the body for establishing his structural points (as in the much simpler

Crucifixion) but he does so by means of light or dark places, no matter what details furnish them to him. You feel the form, this interpenetration of curves and degrees, without being able to seize hold upon it. In this way the striking movements of the hands become natural, the hands hold the invisible threads of the rhythm of the picture.

In the end, Meier-Graefe famously concluded that "El Greco paints pictures, Velázquez paints scenes." We needn't agree with this judgment. But we can all profit from the painstaking process by which Meier-Graefe arrived at it. If there is one thing above all that Meier-Graefe teaches us, it is the indispensable importance of first-hand experience of art. Finally, what matters in our appreciation of art is not the historical or biographical or political background of art but the way specific art works speak to us when we experience them. Another word for this experience is taste. "Everything else," Meier-Graefe wrote, "is bookkeeping, cookery."

1994

Félix Fénéon Discovers Seurat

A MONG THE MANY curious characters populating the art world in *fin-de-siècle* Paris, none was more curious than the anarchist, aesthete, and art critic Félix Fénéon. Born in Turin in 1861, Fénéon was a mass of complexities, not to say contradictions. He was, first of all, a figure straight from the pages of Baudelaire's "A Painter of Modern Life," a dandy who lavished immense attention on his clothes and *toilette*. Accoutered in top hat and cape, immaculately manicured and clean-shaven except for a tuft-like goatee sprouting from under his chin, Fénéon appeared as the ideal *boulevardier*, one whose "solitary profession," in Baudelaire's words, "is elegance."

At the same time, Fénéon was for several years a civil servant, some said a "model employee," at the War Office in Paris. It was from this decidedly inelegant position that Fénéon established himself as one of the most important editors and critics of his generation. For *La Vogue*, one of the dozen or so magazines that he helped to start and edit, F.F. (as he was known among friends) oversaw the publication of Rimbaud's *Illuminations* and translations of writers as diverse as Dostoevsky, Keats, and Walt Whitman. He was a close friend of many important writers and poets,

including Stéphane Mallarmé and Paul Valéry. Paul Signac and Edouard Vuillard, among others, painted his portrait. Toulouse-Lautrec produced an amusing caricature. Pissarro was something of a confidante. Georges Seurat (who managed only a quick crayon sketch of the critic) was essentially discovered and put on the critical map by Fénéon.

In his domestic life, Fénéon was partly the dutiful son, partly the liberated bohemian. He married the woman his mother had picked out for him, but openly continued a liaison with his mistress in a *ménage à trois* that lasted forty-six years. (An arrangement that did not preclude many other amatory pursuits.) And then there was Fénéon's politics. This "model employee" of the War Office was also a political radical who railed against the inequities of private property and the bourgeois establishment. According to his most recent biographer, Joan Ungersma Halperin, Fénéon was probably responsible for the anarchist bombing of the fashionable restaurant Foyot in Paris in 1894.

It was like something out of Conrad's *Secret Agent*, except that fortunately no one was killed. While he was in prison awaiting trial, Fénéon began translating Jane Austen's *Northanger Abbey*, which he subsequently published. After a spectacular trial, Fénéon was acquitted. (Mallarmé, among others, testified as a character witness.) But the episode brought his tenure at the War Office to a sudden end.

Apart from his curiosity value, Fénéon's primary claim on our attention today is his art criticism, almost all of which he wrote in the decade between 1883 and 1892. He is especially important as the most perceptive and articulate champion of the movement he named in 1886: Neo-Impressionism. As the critic John Rewald observed, Fénéon

"had an instinct for singling out among hundreds of budding talents the two or three which promised genius." His chief discovery was Seurat, whose work he first saw in 1884 at the inaugural Salon of Independent Artists. Seurat was 24 at the time. His single entry was *Une Baignade, Asnières* (1883–84, now at the National Gallery in London). The painting cannot have impressed the organizers of the Salon much, for it was hung next to the refreshment bar. But for Fénéon the work was a revelation. Many years later, Fénéon recalled that 1884 exhibition: "Was the committee of the enterprise ashamed of the canvas? Only a few drinkers whose attention strayed from their beer noticed that a new way to cipher reality had just appeared."

Fénéon did not meet Seurat for the first time until two years after seeing *Une Baignade, Asnières*. By then, he was enraptured with Seurat's blending of classical form and impressionist subject matter. He was especially captivated by the peculiar brilliancy and animation that Seurat achieved in his paintings.

Today, we are apt to describe Seurat as a "pointillist." Interestingly, Fénéon never used the term *pointillisme*. He spoke instead of "a seeding of tiny coloring strokes" [*semis de menues touches colorantes*], "markings" [*ocellures*], a "whirling host of minute spots" [*menues macules*], "tiny pullulating strokes," and "a swarming of prismatic spangles in vital competition for a harmony of the whole." Seurat's paintings are full of life, but an essential component of his work, as Fénéon discerned, was the very *impersonality* of his brushstrokes. "The painter chose this uniform stroke, but the spot itself had no more reality than the stitch in tapestry; it was like substituting a neutral typography—to the benefit of the text—for an affected and immoderate handwriting."

In her biography of the critic, Joan Halperin noted that Fénéon's "aim as a critic was to serve as a conduit between the work of art and the public." To this end, he tried to keep himself out of his criticism and to write in such a way that the work could reveal itself unimpeded *through* his words. His best criticism is highly distilled, impersonal, and evocative, yet it bristles with etymological puns, neologisms, and recondite scientific terms. According to one critic, attempting to translate Fénéon "would be tantamount to rendering a Sung landscape in department store plastic." Nevertheless, even in English we can glimpse something of the passion and accuracy of Fénéon's judgments. Analyzing a small patch of Seurat's great masterpiece *A Sunday Afternoon on the Island of the Grande Jatte* (now at the Art Insititute in Chicago), he writes that "you will find on each centimeter of this surface, in a whirling host of tiny spots, all the elements that make up the tone."

A cyan-blue, brought out [*provoqué*] by the proximity of a plot of grass in the sunlight, accumulates its siftings [*criblures*] towards the line of demarcation, and progressively grows thinner away from this line. At the formation of this plot itself where only two elements, green and solar orange, converge, every reaction dies under the the furious assault of light. Black being a non-light, the black dog is colored by reactions to the grass; its dominant color is therefore deep-purple; but it is also attacked by the dark blue arising from neighboring spaces of light. . . .

The subject: beneath a sultry sky, at four o'clock, the island, boats slipping past its flank, stirring with a casual Sunday crowd enjoying the fresh air among the trees; and these forty or so figures are endowed with a succinct,

hieratic line, rigorously drawn in full-face or in profile or from the back, some seated at right angles, others stretched out horizontally, others standing rigidly: as though by a modernizing Puvis [de Chavannes].

The atmosphere is transparent and uncommonly vibrant; the surface seems to flicker or glimmer.

Fénéon continued to play an important role in the cultural life of Paris after his trial in 1895. For the next decade, he was ensconced at the *Revue blanche*, one of the most important avant-garde literary magazines of the time. And while he never abandoned his radical principles, Fénéon blithely became a dealer at Bernheim Jeune, where he did very well for himself representing such artists as Matisse, Signac, and Bonnard. Fénéon lived on, amazingly, until 1944. But his great moment came in the mid-1880s when for a few short seasons he became Seurat's ideal critic and champion.

1994

Roger Fry

VIRGINIA WOOLF put it with her customary melodrama: "In or about December 1910, human character changed. . . . All human relations shifted—those between masters and servants, husbands and wives, parents and children. And when human relations change there is at the same time a change in religion, conduct, politics and literature." What cataclysm did Woolf have in mind? A war? A revolution? A religious crusade? No. It was an exhibition of Post-Impressionist painting at the Grafton Galleries in London organized by her friend and fellow Bloomsbury figure Roger Fry.

By 1910, when he was in his mid-forties, Roger Fry was a well-known and highly respected painter and connoisseur of painting. He bought pictures for the great industrialist Henry Frick and for Isabella Stewart Gardner. For the previous five years, he had been curator of paintings at the Metropolitan Museum of Art in New York, and had only just returned to London. The writer Desmond MacCarthy, who helped Fry organize that first Post-Impressionist exhibition, called him "the most analytical mind that has been applied to the study of the visual arts." In his memoirs, the historian Noel Annan claimed that Fry "did

for the visual arts what T. S. Eliot and the English faculty at Cambridge were to do for English literature. He drew a new map."

Looking back to 1910 from the vantage point of the Nineties, it is easy to summarize but difficult to appreciate Fry's achievement. His chief accomplishment was to shift attention away from the *anecdotal* or *literary* aspects of art and toward art's formal qualities: line, shape, contour, modelling, color, and so forth. In "Retrospect," an important essay he wrote in 1920 to conclude his book *Vision and Design*, Fry wrote that "I conceived the form of the work of art to be its most essential quality, but I believed this form to be the direct outcome of an apprehension of some emotion of actual life by the artist, although, no doubt, that apprehension was of a special and peculiar kind and implied a certain detachment."

Unlike Victorian critics such as John Ruskin, Fry was interested in art as a repository not of moral wisdom but of disinterested aesthetic appreciation. According to Fry, art's value lay not in apprehension of abstract Beauty but in the communication of a distinctly aesthetic emotion. In "The French Post-Impressionists" (reprinted in *Vision and Design*), Fry noted that

> All art depends upon cutting off the practical responses to sensations of ordinary life, thereby setting free a pure and as it were disembodied functioning of the spirit; but in so far as the artist relies on the associated ideas of the objects which he represents, his work is not completely free and pure, since romantic associations imply at least an imagined practical activity. The disadvantage of such an art of associated ideas is that its effect really depends on what we bring with us: it adds no entirely new factor to our ex-

perience. Consequently, when the first shock of wonder or delight is exhausted the work produces an ever lessening reaction.

Fry's first love was early Florentine painting. And as long as he confined his interest to the Old Masters, his reputation among the old guard was secure. But Fry's taste was adventurous. He wrote admiringly about the aesthetic qualities of certain African and Latin American artifacts that other observers had regarded mostly as anthropological curiosities. Perhaps his biggest revelation came in 1906, when he discovered the painting of Paul Cézanne. With Cézanne, Fry wrote, "the greatest revolution in art that had taken place since Graeco-Roman impressionism became converted into Byzantine formalism."

Fry's discovery of Cézanne led him to other modern French painters and, eventually, to the idea of organizing an exhibition of their work in London. It was Fry, in fact, who hit upon the name "Post-Impressionism" to describe their work. He had thought about using "Expressionism" but decided to stick with "Post-Impressionism" as being "the vaguest and most non-committal." Among the artists he included in the exhibition (which was called "Manet and the Post-Impressionists") were Cézanne, Matisse, van Gogh, Gauguin, Seurat, Picasso, Signac, and Derain.

It was the first time many of those artists had ever been seen in London. Public reaction was swift and extraordinarily brutal. "Pure pornography" was the judgment of one critic. According to Virginia Woolf, many people thought the exhibition was a hoax. A noted doctor let it be known that in his judgment the works on view were products of madmen. An artist that Fry knew shouted "Drink or drugs?" when Fry showed him a painting by Matisse.

Fry did not write an essay to accompany the first Post-Impressionist exhibition. But two years later, when he organized a second exhibition of Post-Impressionist work at the Grafton Galleries, he tried to account for the wave of public indignation that greeted his earlier effort. What the Post-Impressionists were up to, Fry wrote, "implied a reconsideration of the very purpose and aim as well as the methods of pictorial and plastic art." In his view, "the modern movement was essentially a return to the ideas of formal design which had been almost lost sight of in the fervid pursuit of naturalistic representation."

IT WAS NOT surprising that the public, which had come to regard naturalistic illusionism as the chief benchmark of artistic accomplishment, should "resent" art in which such skill "was completely subordinated to the direct expression of feeling." In their different ways, the Post-Impressionist painters sought "to express by pictorial and plastic form certain spiritual experiences," "to find a pictorial language appropriate to the sensibilities of the modern outlook." In a famous passage from "The French Post-Impressionists," Fry explained that these artists

> do not seek to give what can, after all, be but a pale reflex of actual appearance, but to arouse the conviction of a new and definite reality. They do not seek to imitate form, but to create form; not to imitate life, but to find an equivalent for life. By that I mean that they wish to make images which by the clearness of their logical structure, and by their closely-knit unity of texture, shall appeal to our disinterested and contemplative imagination with something of the same vividness as the things of actual life appeal to our practical activities. In fact they aim not at illusion but at reality.

None of the artists that Fry included was an abstractionist. But their work tended toward abstraction. "The logical extreme of such a method," Fry noted, "would undoubtedly be the attempt to give up all resemblance to natural form, and to create a purely abstract language of form—a visual music."

Perhaps human character did not change in 1910, or even in 1912. But public taste underwent a revolution. Even as people ridiculed the exhibitions of Post-Impressionist work that Fry organized, they came in droves to see the work that everyone was talking about. In time, Cézanne and Matisse came to be recognized as great masters because people began to realize that their work communicated an emotional vividness and urgency that was quite independent of "content" or "subject matter." That is to say, they came to see that Roger Fry was right.

1994

Michael Fried Does Courbet

T HE OSTENSIBLE SUBJECT of *Courbet's Realism* is the work of the great French realist painter Gustave Courbet (1819–1877). But what Michael Fried, a much-lauded academic art historian and director of the Humanities Institute at the Johns Hopkins University, has given us is really only remotely concerned with Courbet. His real subject is the perpetuation of a certain florid species of contemporary academic "criticism." Courbet appears merely as the occasion, the raw material, for the exercise of Professor Fried's critical lucubrations.

Not that this comes as a surprise. Anyone who has followed Professor Fried's career knows that he has long since abandoned art criticism per se—criticism whose chief purpose is to understand and illuminate works of art—in order to devote his considerable talents to chic academic theory-mongering.† *Courbet's Realism* is the summary of his efforts in this direction *circa* 1990.

As usual, Professor Fried operates with a formidable

† I go into greater detail about Mr. Fried's pomposities in Chapter 2 of my book *Tenured Radicals: How Politics Has Corrupted Our Higher Education* (revised edition, Ivan R. Dee, 1998).

criticus apparatus, and he has obviously devoted an immense labor to this study. And yet, if one didn't know better, one might think he was attempting a comic impersonation of contemporary academic pedantry. Almost a quarter of the book is given over to notes: long, arcane notes, notes that wander and digress, that include lengthy passages from Hegel and Marx and Walter Benjamin in German, Jacques Lacan in French—notes, in short, that in many cases have absolutely nothing to do with the painting of Gustave Courbet. Near the beginning of the book, Professor Fried tells us that he is convinced that "Courbet himself was largely unaware of the aspects of his work I focus on." And how.

Savor this representative footnote:

> It's tempting to compare the feminization of the phallus/paintbrush in the *Young Women on the Banks of the Seine* with the implied castration of the dead roe deer and indeed of the passive hunter in the *Quarry,* an almost exactly contemporary work. Cf. Jacques Derrida's speculations on the interplay between phallic and floral imagery in the writings of Jean Genet in *Glas, passim.*

It's no use objecting that there is neither paintbrush nor phallus in the bucolic painting of young women by the Seine; nor that *The Quarry* depicts a hunting scene, not a grotesque Freudian melodrama; nor indeed that all such speculation would be utterly anathema to the earthy, conspicuously non-metaphysical, Courbet. For Professor Fried, the fact that a painting's subject is prosaic is only an added spur to his overworked faculty of fantasy.

In the end it is a macabre kind of bookish fantasy, not scholarship, not criticism, that animates *Courbet's Real-*

ism. As such, the book is a veritable inventory of fashionable academic topics and rhetorical tics. Mr. Fried offers a bit of everything: a pinch of deconstruction, a large measure of sexual politics, a positive obsession with issues of power and domination, all mixed and stirred in Professor Fried's deadpan academicese. Did you know that Courbet's realist painting was fundamentally an "allegory of its own production"? That in *A Burial at Ornans* (1849–50) the depicted shovel "May be likened to the painter's brush"? That Courbet had a "propensity for calling into question the ontological impermeability of the bottom framing-edge"? Would you have guessed that Courbet's realist paintings provide "an archetype of the perfect reciprocity between production and consumption that Karl Marx in the 'General Introduction' to the *Grundrisse* posited"? Or that Courbet—yes, Courbet—had latent feminist, indeed, "feminine" tendencies?

In the context of this book, mention of Marx necessarily reminds one of that sage's comment about history repeating itself first as tragedy, then farce. Which prompts the question: has farce or tragedy been the "latent tendency" of Professor Fried's work all along?

1990

Feeling Sorry for Rosalind Krauss

*Art happens, however, to be a matter of self-evidence and feeling,
and of the inferences of feeling, rather than of intellection or
information, and the reality of art is disclosed only in experience,
not in reflection upon experience.*
—Clement Greenberg

He only thought it respectable to talk about their art.
—Rosalind Krauss, criticizing Greenberg

AUTHORS REALLY SHOULD scrutinize publishers' blurbs carefully before allowing them to appear on their books. Although presumably written to flatter and extol, such endorsements sometimes contain uncomfortable truths. Consider, for example, the blurb that accompanies *The Optical Unconscious* (MIT Press, 1994), Rosalind Krauss's latest contribution to the annals of academic art theory. "Rosalind Krauss," we read, "abandons the historian's voice of objective detachment and forges a new style of writing in this book: art history that insinuates diary and art theory, and that has the gait and tone of fiction."

A great deal might be said about that sentence. First,

there is the element of exaggeration. It takes only a quick look at *The Optical Unconscious* for anyone familiar with Miss Krauss's other essays and books to realize that the blurb-writer is, well, stretching things. Little if anything is "new" here, in style *or* substance. Miss Krauss, a founding editor of the ferociously solemn quarterly *October* and lately appointed professor of Art History at Columbia University, has simply returned once again to her favorite themes in this book, themes that have earned her a prominent place in the demimonde of chic academic theorizing.

Billed as "a pointed protest against the official story of modernism," the six, untitled chapters of *The Optical Unconscious* deal with the same knot of ideas that Professor Krauss mooted earlier in *The Originality of the Avant-Garde* and *L'Amour Fou: Surrealism and Photography* (both 1985). Once again she is spooring after (as she put it in *The Originality of the Avant-Garde*) "a demythologizing criticism" that supposedly will "void the basic propositions of modernism" "by exposing their fictitious condition." Max Ernst, Georges Bataille, Marcel Duchamp, Jackson Pollock, and other Krauss regulars are re-enlisted in the project of discrediting—or *deconstructing*—modernism. As before, they are strained through the forbidding argot of the two Jacques—Lacan and Derrida—Melanie Klein, Jean-François Lyotard, Fredric Jameson, Walter Benjamin, et al. "Phallicism," the *informe*, "part-object," the "para-noiac-schizoid scenario of early development," "the mirror stage": all our old friends have come back for an encore.

Professor Krauss even uses many of the same decorations with which she festooned earlier volumes. J.-A. Boiffard's photograph of a big toe, for example, which I like to think of as her mascot, reappears. As does her favorite

doodle, a little graph known as a "Klein Group" or "L Schema" whose sides and diagonals sport arrows pointing to corners labeled with various opposing pairs: e.g., "ground" and "not ground," "figure" and "not figure." Professor Krauss seems to believe that this device, lifted from the pages of structuralist theory, illuminates any number of deep mysteries: the nature of modernism, to begin with, but also the essence of gender relations, self-consciousness, perception, vision, castration anxiety, and other pressing conundrums that, as it happens, she has trouble distinguishing from the nature of modernism. Altogether, the doodle is a handy thing to have around. One is not surprised that Professor Krauss reproduces it many times in her new book.

There is one novelty, though. That is the delicious phrase "the optical unconscious," adopted (with a bow to Fredric Jameson's slogan "the political unconscious") from Walter Benjamin. "*I started calling the hare I was chasing over this historical terrain* antivision," Professor Krauss explains. "*But that* anti *sounded too much like the opposite of a* pro *the all too obvious choice for which would be* pro-text. *Which was not at all the case of what I was tracking. The name that gradually took over was the* optical unconscious."

ONE NEED NOT read far in *The Optical Unconscious* before realizing that Professor Krauss has, with arresting frankness, hit upon the perfect title for her book. Few books claiming to deal with art can be more optically unconscious than *The Optical Unconscious*. Professor Krauss is to be commended for this bit of truth-in-advertising. But why the flurry of italics? This, I believe, is intended to "insinuate" diary, as the syntactically challenged blurb-writer

put it. Much of *The Optical Unconscious*, especially in the first three chapters, is set in italics to give it the aura of a journal entry. Whether we are actually being treated to Professor Krauss's journal entries is difficult to say. One hopes for her sake that we are not.

But all the italics do remind us about her having abandoned "the historian's voice of objective detachment." Impish readers might wish to point out that Professor Krauss, like so many of her academic peers today, has long made it a point of honor to deny that anything like "objective detachment" is possible. So it is difficult to see how at this late date she can really be said to have *abandoned* it. Nevertheless, everyone can agree that *The Optical Unconscious* lacks the quality of "objective detachment." Does that mean that it possesses the "gait and tone of fiction"? If the tread of a hippopotamus is what was meant, then yes, *The Optical Unconscious* has the "gait of fiction." In any event, it certainly possesses another feature often claimed for fiction: any resemblance to real characters or situations is entirely coincidental.

Lest this seem overly harsh, consider how Professor Krauss begins her polemic against modernism. Her book opens thus:

> And what about little John Ruskin, with his blond curls and his blue sash and shoes to match, but above all his obedient silence and his fixed stare? Deprived of toys he fondles the light glinting off a bunch of keys, is fascinated by the burl of the floorboards, counts the bricks in the houses opposite. He becomes the infant fetishist of patchwork.

One writer called Ruskin "the most analytic mind in

Europe," a judgment that Professor Krauss finds laughable. "The most analytic mind in Europe," she scolds, "did not even know how to frame a coherent argument. The most analytic mind in Europe produced *Modern Painters,* a work soon to be known as one of the worst-organized books ever to earn the name of literature." What is true of great artists and writers is also true of great critics: in commenting on them we do not so much judge them as judge ourselves. Professor Krauss cannot forgive Ruskin for lavishing such undistracted attention upon the visual world. She turns one of the greatest critics of the nineteenth century into a figure of fun because he had the temerity to pay attention to what he saw instead of theorizing about it. Ruskin survives undiminished from Professor Krauss's vignettes. Does she?

I start with a square. In its upper right corner I write figure *and in its upper left I write* ground. *I want this square to represent a universe, a system of thinking in its entirety, a system that will be both bracketed by and generated from a fundamental pair of oppositions. This of course* [!] *is the universe of visual perception, the one that is mapped by a distinction between figure and ground. . . .*

Vision as a form of cognition. As a form, then, it reworks the very notion of ground. The ground is not behind; the ground is what it, vision, is. And the figure, too, is reworked. Perception marks this figure that the eye singles out by labeling it "pure exteriority": set off from the field on which it appears, it is even more surely set off from me, the beholder. But cognition—in vision—grasps the figure otherwise, capturing it in a condition of pure immediacy, yielding an experience that knows in a flash that if these perceptions are seen as there, *it is because they are seen by*

me; *that it is my presence to my own representations that secures them, reflexively, as present of myself.*

There are pages and pages of this in *The Optical Unconscious*: Rosalind Krauss talking to herself about herself. It is amusing to contemplate what John Ruskin would have made of it.

There is, however, a thesis lurking behind these soliloquies. Professor Krauss's main idea here—as in other works—is that the standard histories of modernism have, like Ruskin, overemphasized the purely visual and the ideal of artistic autonomy. She proposes to correct the record by reintroducing the dark side of modernism: the libidinous, the chaotic, the irrational, the occluded. To this end she draws heavily on Dada and Surrealism—movements considerably more notable for their proclamations about art than for any art works proper. It is better to get it in her own words, though. For example, in place of Ruskin's exacting practice of self-conscious observation Professor Krauss praises the idea, drawn from Max Ernst, of "mechanical *seeing*," of "an autonomist motor turning over within the very field of the visual. This idea," she tells us, "which would come to operate at the center of surrealism's critique of modernism, contests the optical model's schema of visual self-evidence and reflexive immediacy, substituting for this a model based instead on the conditions of the readymade, conditions that produce an altogether different kind of scene from that of modernism's." We can admit, anyway, that this has precious little to do with modernism.

ONE PROBLEM with Professor Krauss's new history of modernism is that, as history, it isn't very accurate. She presents the idea of aesthetic autonomy as a distinctively

modernist innovation, something that came along with the likes of Ruskin. In fact, the ideal of aesthetic autonomy dates back at least to the mid-eighteenth century. The German philosopher Alexander Baumgarten, who coined the term "aesthetic," wrote in his *Reflections on Poetry* that "the poet is like a maker or a creator. So the poem ought to be like a world," i.e., self-contained, ordered, autonomous. One has no sense, in Professor Krauss's account, that the achievements of modernism have their place in an artistic tradition going back to the Enlightenment and beyond.

Among much else, this ahistorical history of modernism tends to transform everything into a species of caricature. Professor Krauss is only really at ease when she has reduced the subject at hand to a formal schema of some sort. This is one reason that she is so attracted by psychoanalytic theories from those of Freud and Melanie Klein to those of Lacan and Gilles Deleuze. The drastic simplifications presupposed by the rhetoric of "drives" and "stages" and "complexes" has an irresistible appeal for a mind ill at ease with genuine complexity. The down side is that all such speculations are ruthlessly Procrustean: much is occluded in the name of recovering the occluded, not least the emotional pulse and aesthetic texture of art: human, evanescent, real.

What we are left with is a twilight realm in which rootless abstractions war bloodlessly with one another. For example:

> *Would it be possible to modify the L Schema as the basis for mapping a visuality that both subtends and subverts the field of modernist vision in the same way that Lacan's psychoanalytic circuitry erodes the structuralist relations*

from within? For if the mirror relation as it is graphed in the L Schema divides the subject from the unconscious, by driving a wedge of opacity through the diagonal center of the graph, it is nonetheless true that the subject is the effect of the unconscious, or what needs now to be called a "subject-effect."

And here she is on Lacan's notion of "the castrative status of weaning":

Suppose we were to try to graph this relation. We might start by characterizing the primal appearance of the object within the infant subject's perceptual field as the advent of something that separates itself out from a hitherto undifferentiated ground to become distinct as figure. *That object, which is the mother's breast—and by extension the mother—becomes a figure, of course* [of course!], *by dint of its withdrawal from the contiguous field of the infant, by virtue of setting him up no longer as the amorphous and all-inclusive subject of satisfaction but now as the subject of frustration and longing, the subject, that is, of desire.*

This is pretty thin gruel, as Professor Krauss must realize. Like many contemporary academic "theorists," she seeks to compensate for the choking airlessness of such musings by punctuating every observation with a hint of violence or risqué sex. Hence, you see, "the castrative status of weaning." What, after all, can that possibly have to do with modernism? Or art? Or "the visual"? (One might, in fact, want to ask what castration has to do with weaning, but that is for another day.)

Naturally, all this is supposed to be daring and "transgressive." In small doses it can be quite hilarious. The

long-term effect, alas, is tedium. How extraordinary to be told by Lyotard that "Con celui qui voit." (Here's looking at you, kid.) Professor Krauss is obviously deeply impressed by Lyotard's formula, for she repeats it often. "There is," she assures us in one place,

> no way to concentrate on the threshold of vision, to capture something *en tournant la tête*, without siting vision in the body and positioning that body, in turn, within the grip of desire. Vision is then caught up within the meshes of projection and identification, within the specularity of substitution that is also a search for an origin lost. *Con*, as they say, *celui qui voit.*

Some more than others, surely. Still, how amazing that, in simply taking a photograph, Man Ray "enacts the institution of the fetish: the 'glance' that refuses what it sees and in this resistance turns black into white, or rather, insists that black *is* white. In the logic of the fetish the paradigm male/female collapses in an adamant refusal to admit distinction, to accept the facts of sexual difference." Gee. And poor Roger Fry. Like Ruskin, he thought that art had something to do with the way things looked. In lecturing, Professor Krauss tells us, "*Fry places himself in front of the projection screen as he places himself before the chessboard. An eye without a body. Pure giver of form. Pure operation of the law. Pure phallus.*" Pure baloney is more like it.

One gathers that Professor Krauss included so many imitation journal entries in *The Optical Unconscious* partly in an effort to imbue the book with something more personal than off-the-shelf art theory. And there is no reason to doubt that her personality shines through clearly

in those passages. Whether one can really call the result "personal" is perhaps another question. In the end, though, the gimmick of italicized text serves two larger purposes. In the first place, it allows Professor Krauss to avoid responsibility for the ideas she floats. After all, can one really criticize a journal entry, which is addressed primarily not to the public but to the writer's own conscience and memory? And second, it allows her to settle some old scores with unusual malice. Professor Krauss presents her argument with modernism as a brave epistemological-political adventure: she is the daring liberator of thoughts and feelings that have been deliberately neglected by orthodox modernism. In fact, her argument is primarily an argument with a few individuals, chief among whom is Clement Greenberg—yet another critic who, like Ruskin, believes that experiencing a work of art is a prerequisite for critical appreciation and understanding.

Professor Krauss began her career as one of Greenberg's disciples. She wrote her dissertation on David Smith at Harvard under his influence and, later, her essays in *Artforum* bore the stamp of his approach. But that was before Professor Krauss emerged as a minor academic celebrity in her own right. Since then, she has striven to distance herself from Greenberg and everything he stands for. Her rejection of the visual component—in other words, the experiential basis—of criticism is only the latest step in a rebellion that has been unfolding for at least two decades now. We can gauge the pathos of that rebellion by the "gait and tone" of her last chapter.

Professor Krauss begins by recounting her impressions of Greenberg as he appeared recently in a television interview. It is not a pretty picture. She speaks of his "flabby

and slack face," "the domed shape of the head, bald, rigid, unforgiving; and the flaccid quality of the mouth and lips." She also dwells on the "arrogance of the mouth—fleshy, toothy, aggressive." It is an extraordinarily cruel vignette —all the more extraordinary for being repeated, with slight variations, five or six times in the course of the chapter. Among much else, Professor Krauss coyly hints that Greenberg was implicated in Jackson Pollock's psychological crisis in 1951, a crisis that sent him back to drinking, effectively ended his development as a painter, and culminated in his demise in a drunken car crash in 1956. In truth, Greenberg did more than anyone to establish Pollock's reputation. If he judged that Pollock had "lost his stuff" by 1951, that was a judgment that history supports.

As she does with other central figures in the history of modernism, Professor Krauss diminishes Greenberg by caricaturing him. The cartoon character she fabricates could never have become the formidable presence that Greenberg was for decades. Her list of grievances is long, beginning with the fact that, even now, Greenberg is immensely more influential and important than she. Above all, perhaps, she cannot forgive him for insisting that art is a "matter of self-evidence and feeling . . . rather than of intellection or information." Rosalind Krauss knows nothing of "self-evidence and feeling." For her, art unfolds in precincts far removed from the immediate claims of feeling. She criticizes Greenberg for concentrating on the *art* of the artists he knew and wrote about—"He only thought it respectable to talk about their art"—largely, one suspects, because she does not see what all the fuss is about.

It is easy to be exasperated with Rosalind Krauss. She is pretentious, obscurantist, and mean-spirited. Enjoying a

position of great academic respect, she has, through her writings, teaching, and editorship of *October*, exercised a large and baneful influence on contemporary writing and thinking about culture. In the end, however, one's exasperation is likely to be mixed with pity. Here is a woman who has devoted her professional life to art and ideas but who clearly has no feeling for art and for whom ideas are ghostly playthings utterly cut off from reality. In the *Republic*, Plato has Socrates remark that "to be deceived about the truth of things and so to be in ignorance and error and to harbor untruth in the soul is a thing that no one would consent to." No doubt Rosalind Krauss would scoff at the idea of possessing anything so quaint as a soul. But she must, from time to time, wonder what her beloved Lacan and Derrida have to do with life, what her Klein Groups and castration fantasies and "psycho-atmospheric-anamorphic objects" have to do with art. Why, she must wonder, do other people seem to care so much about art and beauty when to her it is all an arid, narcissistic battleground? It is pathetic, really. Her writing and ideas are pernicious, but one cannot help feeling sorry for Rosalind Krauss.

1994

The Achievement of
Clement Greenberg

What counts first and last in art is whether it is good or bad.
Everything else is secondary.
—Clement Greenberg, 1954

T HE ART CRITIC Clement Greenberg died in May 1994
at the age of 85. Although he had written little for
more than two decades, Greenberg remained a contentious
and widely discussed figure in the art world and the world
of academic art criticism until the end of his life. Even in
death Greenberg managed to stir controversy. His obituary
in *The New York Times* rightly occasioned outrage and
indignation among Greenberg's admirers. Obituaries of
course can be many things: instruments of eulogy, myth-
making, solace, revenge. The *Times* reminded us that they
can also be models of ignorance and stupidity. The author
of the obituary began by garbling names: he thought, for
example, that "Theodoros" was the last name of the artist
Theodoros Stamos. He confused *Partisan Review*—for
which Greenberg wrote some of his most important es-
says—and *The Paris Review*: a feat that is more or less
equivalent to confusing *Commentary* with *Cosmopolitan*.
And he produced a grotesque caricature of Greenberg's

ideas according to which Greenberg was supposed to have thought that criticism should equal art as a creative endeavor.

It was bad enough that our paper of record should have assigned the obituary of an important cultural figure to someone who hadn't a clue about his subject or the issues that he wrote about; even worse was the fact that the editors chose to print the resulting farrago of misrepresentations and inaccuracies. Throughout his career, Greenberg battled against the collapse of critical standards. It is a pity that he could not have been present to comment on this egregious example of journalistic incompetence.

Not that the *Times* had a monopoly on bad obituaries. True, its obituary was probably the dumbest to appear in a major newspaper. But for pure malevolence, the sneering attack on Greenberg written by Paul Richard for *The Washington Post* must take the palm. According to Richard, Greenberg was a bit of a hypocrite, spouting Marxist rhetoric but disdaining the taste of masses. Moreover, Richard hinted darkly, Greenberg compromised his critical independence by accepting works of art as presents from artists he admired and wrote about. Even worse, Greenberg was "the narrowest of judges," someone who shamelessly touted his few favorite artists but "caused much pain" to those many he did not like.

What one could not glean from either obituary (or "Appreciation," as the *Post* called Richard's exercise in character assassination) is the fact that many consider Clement Greenberg to be the most important art critic that America has yet produced. To be sure, there have always been plenty of voices raised against Greenberg and his ideas. In the 1940s and 1950s, artists who failed to attract his praise and critics who succeeded in attracting his ire

naturally rebelled against his strictures. In recent years, the attacks have become more virulent, as a wide range of academic critics and their epigones have taken aim not only at Greenberg's judgments but also at the aesthetic and moral values that informed those judgments.

Nevertheless, Greenberg is probably the only American art critic whose achievement places him within shooting distance of such European masters as John Ruskin, Roger Fry, Charles Baudelaire, and Julius Meier-Graefe. (The only other contender, I think, is my colleague Hilton Kramer.) Greenberg's reputation rests chiefly on two things. The first was his early championship of Abstract Expressionism. In the 1940s, when their art first came to public attention, such artists as Jackson Pollock, David Smith, and Willem de Kooning were generally either ridiculed or ignored. Greenberg instantly discerned that something important was going on in their work. A look at the art coverage from the 1940s, in specialized art journals as well as in newspapers and mainstream magazines like *Time*, shows a discipline that was by turns confused, complacent, and moribund. Greenberg's criticism sounded a new and vigorous note. He began writing about and praising Pollock as early as 1943. In 1948, on the occasion of de Kooning's first one-man exhibition, Greenberg famously called him "one of the four or five most important painters in the country."

Such judgments helped to establish the careers of many artists and, by the 1950s when Abstract Expressionism came into its own, to secure Greenberg's own authority as a critic of formidable power and prescience. T. S. Eliot, the critic whom Greenberg admired above all others, once wrote that "the rudiment of criticism is the ability to select a good poem and reject a bad poem; and its most severe

test is of its ability to select a good *new* poem." By this standard, Greenberg passed the most rigorous such test to confront art critics since the Teens. In fact, he passed it again and again in his discriminating reviews for *The Nation* (where he was the regular art critic from 1943 to 1949) and in the essays he wrote from the 1940s through the 1960s for *Partisan Review*, *Commentary* (where he also worked as an editor in the 1950s), Cyril Connolly's *Horizon*, *Encounter*, and other journals.

In a deeper sense, however, it may well be that Greenberg's lasting importance as a critic will be seen to rest less upon his particular likes and dislikes. I believe, in any case, that it will not rest primarily upon his campaign on behalf of Abstract Expressionism, the achievement of which looks smaller and smaller as the years pass. More important was the uncompromising seriousness with which Greenberg pursued his vocation as a critic. This is the second, and more central, thing that has underwritten Greenberg's reputation as a critic: his unwavering allegiance to the cause of high art. From the appearance of his first important essay, "Avant-Garde and Kitsch," in *Partisan Review* in 1939, Greenberg staunchly upheld the prerogatives of high culture against the debasements of popular culture and, especially, the insidious attenuations of "middlebrow" taste.

It is no doubt true that much of what Greenberg attacked as "middlebrow" in the Forties and Fifties looks pretty good by today's standards. But that is partly because today's standards are so low. It is no secret that since the 1960s the attack against high culture has greatly intensified. Today, it is unremitting and practically ubiquitous. In the name of "diversity," institutions that were created to preserve and transmit the monuments of high culture—the

universities, museums, orchestras, and serious publishing houses—have rushed to embrace the demotic imperatives of political correctness and pop culture. It is not too much to say that we have witnessed a wholesale betrayal of culture—precisely by those groups and institutions that have been entrusted with its preservation. In this situation, Greenberg's adamant defense of high art stands as a refreshing alternative to the current morass.

ONE OF GREENBERG'S greatest strengths as a practical critic was his ability to call attention to an artist's faults and weaknesses without failing to do justice to his merits. Indeed, he realizes that it sometimes happens that an artist's merits *depend upon* his weaknesses. Thus he spoke of Delacroix's "indispensable" faults—above all, a certain muddiness in his pictures—and criticized "the practice of wholesale appreciation, which remains the bane of art writing today." Rejection of "wholesale appreciation" gave his criticism a certain severity and appearance of ungenerosity. But it also meant that his praise was worth something. Writing about the poet Randall Jarrell, for example, Greenberg noted that he

> has the talents, the sensitivity, the wisdom and almost everything else that the good fairy can give. He is one of the most intelligent persons writing English at the moment. There is some very profound poetry in this book of his, in the literal sense of that word. But . . . he seems to have a blank personality. He is swallowed up by his gifts. His writing, critical and poetic, for all its brilliance, lacks a core.

These are hard words. But Greenberg was right about Jar-

rell. And one cannot help thinking that the poet, himself a master of the penetrating critical *mot*, would have grudgingly approved of the verdict. At any rate, one is reminded of Jarrell's comment, in a poetry round-up published in *The Yale Review* in 1955, that anyone who reads and writes about many books is bound to be disappointed by how few he likes; "yet really," he continues, "he should be uneasy at liking as many as he does. Posterity won't."

Until quite recently, it has been difficult to take Greenberg's measure as a critic because so little of his work was easily available. Many readers under the age of fifty or so knew him chiefly through *Art and Culture*, the modest selection of essays (many of which were substantially revised) that Greenberg published in 1961. Many others knew of him only through the caricatures put abroad by his enemies. The appearance of Greenberg's collected essays and criticism, edited and introduced by the art historian John O'Brian, has changed that. The first two volumes, containing work that Greenberg published from 1939–1949, appeared in 1987; the concluding two volumes, with work published through 1969, appeared in 1993.

O'Brian is to be congratulated on a fine job of editing. The collected criticism is not quite the complete criticism. O'Brian lists a large handful of reviews, "statements," and translations from the German that he left out. But the series does present the vast majority of Greenberg's work as a critic (excluding his few monographs on individual artists) as well as a useful bibliography of articles on Greenberg. There is also an excellent index to each volume that, given Greenberg's prominent role in New York cultural life, amounts to a summary of important events and figures in the cultural world of the period.

O'Brian's introduction to the first volume contains a good biographical sketch. Greenberg was born in the Bronx to Polish Jewish immigrants, graduated from Syracuse University in 1930, and then spent two and a half years at home learning German, Italian, French, and Latin. He worked briefly in his father's dry-goods business, got married (1934), divorced (1936), and worked as a clerk in a number of civil service posts. He began writing and translating in earnest in the late 1930s, publishing his first piece, a review of a novel by Bertolt Brecht, in *Partisan Review* in 1939. In the first two volumes, anyway, O'Brian is very straightforward and puts his finger on one of Greenberg's chief critical virtues—to wit, that he was "quick to reject what seemed meretricious in contemporary culture."

UNFORTUNATELY, when he came to write his introduction to volumes three and four, which cover the period 1950–1969, O'Brian succumbed to the fashionable bit of left-wing ideological dogma according to which Abstract Expressionism was used by the U.S. government as a weapon in Cold War political maneuvering. I know it sounds fruity. But the idea has been a popular gambit for *bien pensants* academics at least since Serge Guilbaut's book *How New York Stole the Idea of Modern Art* floated the notion in the early 1980s. It is perhaps significant that O'Brian was still teaching at Harvard when he undertook the first two volumes but then went to the University of British Columbia, Vancouver, where Guilbaut presides and is an influential presence. Like most Marxist approaches to culture, the chief attraction of what we might call the Cold War Complex is that it relieves one of the requirement of dealing with art on its own terms. If Abstract Expres-

sionism is at bottom a front for U.S. imperialism, then one needn't worry about comprehending its distinctive aesthetic qualities. For his part, O'Brian is deeply impressed that Greenberg's important 1960 essay "Modernist Painting" was first delivered as a lecture for the Voice of America and that, in 1969, he gave an interview that was disseminated by the U.S. Information Agency. "Even after McCarthyism subsided," O'Brian solemnly informs us, Greenberg

> wrote for a number of periodicals sponsored by the Congress for Cultural Freedom, including *Encounter*. . . . [H]e saw no reason to change his practices after it was revealed . . . that periodicals associated with the Congress of Cultural Freedom had been supported by the CIA through a system of dummy foundations. He remained committed to the Cold War agenda of the U.S. government.

There are several things that can be said about O'Brian's comment. First, how prescient of the Voice of America to pick Clement Greenberg to speak on modernist painting: who could have done it better? And how enlightened the CIA was to support the Congress for Cultural Freedom and, through its auspices, important intellectual journals like *Encounter*! Second, it must be said that in his haste to present Greenberg as a kind of intellectual *apparatchik* for the State Department, O'Brian has blunted his own critical faculties and distorted Greenberg's position.

Consider O'Brian's assessment of "The Plight of Our Culture," the long and important two-part essay about the fate of high culture in democracy that Greenberg published *Commentary* in 1953. O'Brian tells us that Greenberg's earlier "pessimism about the culture of modernity had

given way to optimism." Whereas in essays such as "Avant-Garde and Kitsch" Greenberg had disparaged middlebrow taste, he now, according to O'Brian, did an "about-face" and welcomed it: "Greenberg deduced that the newly dominant culture of the middle classes had the capacity to resist dilution and adulteration by mass culture." And this, you see, was supposed to be part of the U.S. government's effort to co-opt intellectuals and extend U.S. cultural influence.

BUT IS IT TRUE that Greenberg suddenly did an about-face and enrolled himself in the ranks of the partisan cultural optimists? It is true that in "The Plight of Our Culture" he noted that "the good and the bad are mixed." "Middlebrow art, if not middlebrow learning or thought," he wrote, "is not wholly adulteration and dilution." Not *wholly*. But, Greenberg wrote in 1947, "the very improvement of general middlebrow taste constitutes in itself a danger" because it seduces writers and artists into packaging their wares for mass distribution. More and more they are tempted to modify their work not to improve it but to appeal to a larger—which Greenberg assumes will mean a less discriminating—audience.

It is at any rate difficult to agree with O'Brian that Greenberg's assessment of culture became more "optimistic" in the 1950s. In a crucial passage of "The Plight of Our Culture," he writes that

> Middlebrow culture, because of the way in which it is produced, consumed, and transmitted, reinforces everything else in our present civilization that promotes standardization and inhibits idiosyncrasy, temperament, and strong-mindedness; it functions as order and organization

but without ordering or organizing. In principle, it cannot master and preserve fresh experience or express and form that which has not already been expressed and formed. Thus it fails: . . . it cannot maintain continuity in the face of novelty, but must always forget and replace its own products.

These are hardly the words of a cheerleader for middlebrow culture.

At bottom, the failure of middlebrow culture is a function of its lack of vitality. "The middlebrow in us," Greenberg writes,

> wants the treasures of civilization for himself, but the desire is without appetite. He feels nostalgia for what he imagines the past to have been, and reads historical novels, but in the spirit of a tourist who enjoys the scenes he visits because of their lack of resemblance to those he has come from and will return to In his reading, no matter how much he wants to edify himself, he will balk at anything that sends him to the dictionary or a reference book more than once. (Curiosity without energy or tenacity is a middlebrow trait wherever and in whomever it appears.)

One suspects that O'Brian's disappointment with Greenberg has more to do with politics than critical judgment. As Greenberg matured he gradually moved away from the Marxism of his twenties and early thirties. Greenberg cut his teeth on anti-Stalinist Trotskyism that more or less defined the New York intellectuals associated with *Partisan Review*. At the end of "Avant-Garde and Kitsch," he made a reflexive allusion to "capitalism in decline" and assured his readers that "Today we look to socialism *simply* for the

preservation of culture." Citing Trotsky in 1940, he wrote that "in order to keep democracy there must be a socialist revolution. . . . We must choose: either capitalism or democracy." In the summer of 1941, he and Dwight Macdonald published "10 Propositions on the War" in *Partisan Review*, declaring, in one of those statements that seems grotesque with the wisdom of hindsight, that, "*To support the Roosevelt-Churchill war regime clears the road for fascism.*" (Italics in the original.)

POLITICALLY, Greenberg did eventually grow up, however. By 1948, he was describing himself as "an ex- or disabused Marxist." And despite his indulgence in socialist rhetoric, Greenberg always insisted on the relative autonomy of art. "True, I may be a Socialist," he wrote in 1946, "but a work of art has its own ends, which it includes in itself and which have nothing to do with the fate of society." And it is just this, of course, that Greenberg's enemies attack. Trendy academic critics like Rosalind Krauss can't abide Greenberg's emphasis on the disinterestedness of aesthetic experience (what they scorn as Greenberg's "formalism") precisely because it renders art unfit for use as ideological propaganda.

The idea that art, that the life of high culture, has its "own ends" which have "nothing to do with society" is at the center of Greenberg's defense of high culture. Not, of course, that the idea is original to him. It belongs to the tradition of thinking about aesthetics that dates back to the eighteenth century, when the term "aesthetics" in the modern sense was coined. When it comes to art, Greenberg is essentially a Kantian, which means that he stresses the *disinterestedness*, *autonomy*, and *irreducibility* of aesthetic experience. Our appreciation of art is not a means to an

end—liberating the masses, say, or bringing about a revolution in social consciousness. On the contrary, art affords a pleasure that is an end in itself.

There is a sense in which the pleasures Greenberg has in mind are, or at least are related to, very homely pleasures. In a 1959 essay defending abstract art, he extols the humanizing potential of disinterested experience: "I think a poor life is lived by anyone who doesn't regularly take time out to stand and gaze, or sit and listen, or touch, or smell, or brood, without any further end in mind, simply for the satisfaction gotten from that which is gazed at, listened to, touched, smelled, or brooded upon." It is this sort of experience-for-its-own sake that is the common root of the more distilled kinds of experience that Greenberg looks for in art.

To the extent that the experience of art is complete in itself, the critic can do no more than bear witness to the essentially non-verbal quality of his experience. There is, as Greenberg frequently suggests, something *ineffable* about genuine aesthetic experience. He put it succinctly in an interview from 1969:

> Q: Could you clarify the difference between major and minor art?
> A: No. There are criteria, but they can't be put into words—any more than the difference between good and bad in art can be put into words. Works of art move you to a greater or lesser extent, that's all. So far, words have been futile in the matter Nobody hands out prescriptions to art or artists. You just wait and see what happens—what the artist does.

Like Kant, Greenberg denies that the ineffability of aes-

thetic experience means that it is inherently private or subjective. Indeed, part of the reason we care about art is that it affords us the opportunity of sharing in an experience that enlarges and reaffirms our humanity. "There is a *consensus* of taste," Greenberg insists, drawing on a term from Kant's *Critique of Judgment*, but it is not a consensus that can be articulated in propositions. Its meaning depends on first-hand experience, that is, on taste—what Greenberg calls experience that "involves a certain exertion." The cultivation of taste depends upon this exertion, and its absence marks the lassitude that Greenberg abominates in middlebrow culture.

Until sometime in the 1940s, when the avant-garde started becoming a middlebrow caricature of itself, Greenberg sought an antidote to the depredations of middlebrow culture in the avant-garde. In a famous and often-quoted passage from "Avant-Garde and Kitsch," Greenberg speaks of the avant-garde artist as "narrowing" and "raising" art "to the expression of an absolute in which all relativities and contradictions would become either resolved or besides the point."

> The avant-garde poet or artist tries in effect to imitate God by creating something valid solely on its own terms, in the way nature itself is valid, in the way a landscape—not its picture—is aesthetically valid; something *given*, increate, independent of meanings, similars or originals. Content is to be dissolved so completely into form that the work of art or literature cannot be reduced in whole or in part to anything not itself.

This search for an absolute leads naturally to a demand for abstraction, to an art that is autonomous or "purified"

(Greenberg almost always uses the scare quotes) of references to everyday life.

Although we tend to associate abstract art with modernism, Greenberg's emphasis on autonomy and completeness reminds us that his conception of art and aesthetic experience is, notwithstanding the anti-Romantic rhetoric he often indulges in, deeply Romantic. Like many modern anti-Romantics, Greenberg remains a Romantic at heart. Thus he insists that pictorial art "in its highest definition" is "static": "it tries to overcome movement in space or time." "Ideally the whole of a picture should be taken in at a glance; its unity should be immediately evident, and the supreme quality of a picture, the highest measure of its power to move and control the visual imagination, should reside in its unity. And this is something to be grasped only in an indivisible instant of time." In Schiller's phrase, Greenberg looks to art for an experience that can "abolish time in time."

THERE IS, HOWEVER, more to Greenberg's championship of high art than his Romantic conception of aesthetic experience. If we sometimes seek the "instantaneous shock of sight" in our experience of art, we also go to art for something else. Already in "Avant-Garde and Kitsch" Greenberg noted that, in its highest, most potent manifestations, the life of art reached beyond individual experience to embrace the world of high culture as a whole: what he calls in an important footnote the world of "Athene": "formal culture with its infinity of aspects, its luxuriance, its large comprehension."

It is undoubtedly true that throughout his career, Greenberg was a champion of abstract art. "The best of contemporary plastic art," he wrote in 1940, "is abstract."

In 1954: "the best art of our day tends, increasingly, to be abstract." 1959: "the very best painting, the major painting, of our age is almost exclusively abstract." And 1967: "The very best art of this time continues to be abstract." At the same time, Greenberg acknowledged that, with the possible exception of some early Cubist works by Picasso, Braque, and Léger, "nothing in abstract painting . . . matches the achievements of the old masters." If the criterion of aesthetic achievement lies principally in the purity and intensity of the experience art affords, the human meaning of art is something broader.

Many people who know Greenberg's work only through the caricatures produced by his enemies are surprised at the range of his interests. The fact that he could speak well of old-master painting does not accord with their image of desiccated "Greenbergian formalism." Although Greenberg made his reputation primarily as an art critic, he wrote about a great many literary, political, and cultural subjects. In fact, he began his career as a literary critic, writing about such disparate writers as Marianne Moore, T. S. Eliot, Franz Kafka, Randall Jarrell, and Stephen Spender. He wrote about the philosophy of Ernst Cassirer and the treatment of German prisoners of war.

GREENBERG IS OFTEN presented as an aesthete whose view of art is precious, elitist, and impossibly rarefied. I do not believe that these criticisms are the whole story. But it must be said that they are *part* of the story. Greenberg's prose was authoritative but not inviting. He himself spoke of the "flat, declarative way" in which he wrote. He favored the brief review—many of his pieces were only a page or two—and he tended to purge his writing of argument, leaving only the judgments, the conclusions. This gave his

criticism force; it also made it doctrinaire. In fact, Greenberg's criticism often tended toward the dogmatic.

This had two results. On the one hand, it helped to bolster Greenberg's authority. On the other, it opened his work to easy parody, as Tom Wolfe famously demonstrated in his attack on Greenberg in *The Painted Word*. Wolfe's attack was unfair; if it was also hilarious it is chiefly because some of Greenberg's laconic pronunciamentos on "purity" and "flatness" in modernist art lent themselves to caricature. In a footnote that he added to a reprinting of "Modernist Painting," one of his most influential essays, originally published in 1960, Greenberg complained about "constructions of what I wrote that go over into preposterousness: That I regard flatness and the enclosing of flatness not just as the limiting conditions of pictorial art, but as criteria of aesthetic quality in pictorial art."

One problem is that Greenberg's understanding of the development or evolution of modern art invited such misinterpretations. Reading Greenberg, it is not always easy to discern where he thinks that "the limiting conditions" of art leave off and "aesthetic quality" takes over. "The essence of Modernism," he wrote in "Modernist Painting," "lies . . . in the use of characteristic methods of a discipline to criticize the discipline itself." Two years later, in "After Abstract Expressionism"—another influential essay—he declared that "the irreducibility of pictorial art consists in but two constitutive conventions or norms: flatness and the delimitation of flatness." "Essence" and "irreducibility" are not the same as "quality," to be sure; but it is clear that Greenberg is interested chiefly in art that is essential, that is irreducible. What is not always clear is how, on Greenberg's terms, one can distinguish the

achievement of aesthetic quality from the pursuit of purity and irreducibility.

And on the charge of elitism, there can be no doubt that it is in one sense justified. As a critic, what Greenberg cared about above all else was the endless process of sifting good from bad, better from worse. Everything else, he wrote, "is secondary." In another and perhaps deeper sense, however, Greenberg was the opposite of an elitist. For what he sought was not to deprive the masses of art but to maintain the distinctions between better and worse upon which the life of art ultimately depends. Moreover, if he celebrated the disinterested satisfaction of aesthetic experience, he also understood that art was not the whole or even the most important part of life. For example, responding to the controversy surrounding Ezra Pound's award of the Bollingen Prize for poetry in 1948, Greenberg noted "Life includes and is more important than art, and it judges things by their consequences. . . . In any case," he wrote,

> I am sick of the art-adoration that prevails among cultured people, . . . that art silliness which condones almost any moral or intellectual failing on the artist's part as long as he is or seems a successful artist. It is still justifiable to demand that he be a successful human being before anything else, even if at the cost of his art. As it is, psychopathy has become endemic among artists and writers, in whose company the moral idiot is tolerated as perhaps nowhere else in society.

He reiterates this toward the end of the interview that closes the last volume of his collected criticism: "There are, of course, more important things than art: life itself, what

actually happens to you. This may sound silly, but I have to say it, given what I've heard art-silly people say all my life. . . . Art shouldn't be overrated."

Of course it is one thing warn against the dangers of "art adoration" in interviews and occasional comments, quite another to avoid it in one's own practice as a critic. Greenberg did not perhaps always manage to avoid it. Regarding the charge of aestheticism, too, Greenberg is in one sense guilty as charged. The extenuating circumstance is that his aestheticism was in part the price he paid for his championship of high art. The poignant irony is that he came to understand the paradoxical truth that aestheticism is one of the most degrading and insidious enemies of life—and hence, ultimately, of art. Greenberg didn't go in much for religion, but we can be pretty sure that he would have endorsed Dostoevsky's observation from *The Brothers Karamazov* that "beauty is the battlefield where God and the devil war for the soul of man."

1988/1994

Part Two

Paul Gauguin and the
Ideal of the Primitive

T HE MOST SURPRISING THING about the monumental retrospective exhibition of the art of Paul Gauguin that occupied a large part of the Washington's National Gallery in 1988 is that it didn't happen earlier. The corporate-sponsored blockbuster had already been the exhibition of choice for some years by the late 1980s, and one can only guess at the thorny administrative and curatorial difficulties that prevented a full-scale retrospective of so tempting a subject from materializing sooner. Gauguin is custom-made for blockbuster treatment. Like the work of his ill-fated friend Vincent van Gogh—who seems to have a major exhibition mounted for every town he ever graced with his presence—Gauguin's work vibrates with popular appeal. Not only does Gauguin's later painting take a decisive step toward the aesthetic innovations of modernism—flattening out the picture plane, eschewing modeling and shadows, drastically simplifying visual detail—but its bold color harmonies and often exotic subject matter and titles imbue it with hints of a mysterious, "primitive" spirituality that people will line up and wait for.

And then there is Gauguin's biography. Born to a French journalist and a Peruvian mother in 1848, Gauguin's odys-

sey from a bank stockbroker, family man, and weekend painter to the impoverished, syphilitic genius who abandoned his family and livelihood for his art and the elusive promise of bliss in the South Seas is guaranteed to be a large box-office draw. The spectacle of Gauguin's brutally egotistical passion is not perhaps quite so edifying as van Gogh's more selfless spiritual-artistic quest; certainly, van Gogh's having gone mad, having mutilated himself after an argument with Gauguin, and finally having committed suicide provided an incalculable boost to his place in the popular imagination. But Gauguin at least attempted suicide (with arsenic, in 1898), and his peripatetic life, bouts of despair, and rejection of European civilization— not to mention his abundant writings, erotic adventures, and early death in 1903 in the desolate Marquesas— endow his life with plenty of Romantic interest. It is clearly the stuff of myth—or at least of a melodramatic movie, which Hollywood gave us long ago with its 1942 adaption of Somerset Maugham's *Moon and Sixpence* and then again just last year with *The Wolf at the Door*, starring Donald Sutherland as the tormented artist.

At last, AT&T, the chief corporate sponsor of the exhibition, stepped in to fill the breach with "The Art of Paul Gauguin." In its effort to make sure that the exhibition reached out and touched millions, AT&T began its media campaign with an elaborate lunch for several dozen people at the exclusive New York restaurant Le Cirque; the guests included curators from all over the country and Europe, numerous critics, and—standing in for the subject— Donald Sutherland, who assured all and sundry how much playing Gauguin had meant for his own art.

Organized jointly by the National Gallery, the Art Institute of Chicago, and the Réunion des Musées Nation-

aux, and drawing on the expertise of no fewer than four distinguished curators, the exhibition traveled to Chicago and the Grand Palais in Paris. It brought together more than 230 examples of Gauguin's painting, sculpture, drawing, and ceramics. A small number of works from his early Impressionist years were included, but the exhibition concentrated on Post-Impressionist works executed after 1888. With objects drawn from collections worldwide, including some seldom-seen works from museums in the Soviet Union, it was (and remains) the largest exhibition ever devoted to Gauguin's art and the first retrospective of his work in almost thirty years. Together with the accompanying five-hundred-page catalogue, the exhibition offered scholars and the general public an unparalleled opportunity to confront the art of this early modern master first hand.

Unparalleled, but not quite complete. Indeed, the exhibition had some important lacunae. In particular, two masterpieces from Gauguin's late period, *Rupe Rupe* (1899) and *D'où venons-nous? Que sommes-nous? Où allons-nous?* (1897) were missing. *Rupe Rupe* was judged too fragile to travel from its home at the Hermitage in St. Petersburg, and the magnificent (if overly familiar) *D'où venons-nous? Que sommes-nous? Où allons-nous?* ("Where Do We Come From? What Are We? Where Are We Going?"), Gauguin's largest and perhaps his greatest single painting, was likewise judged too delicate to travel from the Museum of Fine Arts in Boston. I have no objection to the decision to withhold these works from the exhibition—in fact, I rather applaud the persons responsible for their courage in resisting the temptation to join in the publicity—but the absence of two such superlative works does create something of a gap at the center of the exhibition.

As Mr. Sutherland's portrayal of the artist reminds us, the hostility of critics and the indifference of the public are essential ingredients of the myth of the blighted Romantic artist that Gauguin both cultivated and suffered from. Like many of his talented colleagues, Gauguin had essentially *no* public during his lifetime, and critics—with only a handful of exceptions—abominated his works. Not that he didn't do everything possible to promote himself. Indeed, as his one-time mentor Camille Pissarro observed bitterly in 1891: "We are fighting against terribly ambitious 'men of genius' who are trying to crush everyone who stands in their way. It is sickening. If you knew how shamelessly Gauguin behaved to get himself elected (that is the word) a man of genius, and how skillfully he went about it!" But it is also true that Gauguin had much to struggle against. For example, in 1891, shortly before he embarked on his first trip to Tahiti, a Belgian critic announced that the extraordinary polychromed carved wood reliefs *Be in Love and Be Happy* (1889) and *Be Mysterious* (1890) were evidence of "the erotico-macabre temperament of a genius of lewdness, a dilettante of infamy who is haunted by vice."

No DOUBT such receptions helped to harden the artist's growing resolve to quit the philistine life that Europe imposed and seek solitude and freedom in some unspoilt corner of the world. But Gauguin's rejection of civilization also sprang from a deeper source. Like so many sophisticated men and women, he indulged in the ultra-civilized pastime of rejecting civilization and idealizing the simple, unencumbered life of primitive man. "I am escaping the artificial, I am penetrating nature," Gauguin recorded soon after arriving in Tahiti for the first time. Nor did his conviction that "When machines have come, art has fled"

abate with the years; "The savage," he declares in a letter written near the end of his life, "is decidedly better than us."

Yet it is worth noting that Gauguin had been an artist for more than a decade before anointing himself a "savage." He began painting in 1874, a year after he married a Dutch woman named Mette Gad. It is perhaps an indication of how conventional his early works were that in 1876 he had a landscape accepted by the jury at the salon while works by Cézanne and Manet were refused. But the aspiring painter soon came under the urbane influence of Degas and, especially, of Pissarro and made rapid advances. By 1879, he was considered sufficiently accomplished to be invited to participate in the fourth annual Impressionist exhibition. And in 1885, with the encouragement of Pissarro, he decided to quit his job and devote himself wholly to art.

Gauguin's work evolved quickly. By the late Eighties, he had moved decisively away from Impressionism towards the denser, moodier, more metaphysically ambitious creations of Synthesist or Symbolist art—an art that, as the art historian Robert Goldwater once put it, seeks not to capture any definite reality but rather to conjure "suggestion through infinite nuance." Already in 1885, Gauguin could write to Pissarro—with whom his relations were deteriorating—that he believed there is "no such thing as exaggeration in art. And I even believe that there is salvation only in extremes." In *Diverses Choses*, notes jotted down in Tahiti in 1896–97, he looks back critically at Impressionism and speaks of the "shackles of verisimilitude" ("shackles" being a term that one frequently encounters in Gauguin's writings), complaining above all that the Impressionists "heed only the eye and neglect the mysterious

centers of thought." "Mysterious centers of thought" be-
came increasingly an issue for Gauguin, who later claimed
that "the essence of a work, insubstantial and of a higher
order, lies precisely in what is not expressed."

As many of the works in this exhibition show, after the
late Eighties Gauguin more and more rejected exact obser-
vation for provocative innuendo, attempting, as his friend
Mallarmé exhorted, to "paint not the thing, but the effect
that it produces." Gauguin came to describe his own tech-
nique as "very fugitive, very flexible, according to my dis-
position when I arise in the morning; a technique which I
apply in my own manner to express my own thought
without any concern for the truth of the common, exterior
aspects of Nature." His advice to a friend can stand as a
version of his artistic credo: "don't copy nature too much.
Art is an abstraction, derive this abstraction from nature
while dreaming before it, and think more of the creation
which will result" than of the model. Such "dreaming
before nature" is epitomized in works like *The Yellow
Christ* (1889), in which praying women in Breton garb
cluster around the crucified Christ in a sharply reduced,
abstract landscape, a landscape whose coordinates have
more to do with the artist's color sense than Calvary.
Visually, the influence of Japanese prints on Gauguin's
work also begins to show itself at this time. It is par-
ticularly evident in paintings like *The Vision After the Ser-
mon—Jacob Wrestling with the Angel* (1888), where the
picture plane, bisected by an apple bough, is dramatically
compressed and we look down into the stylized scene of
religious ecstasy from some indefinite space above.

Of course, any major retrospective provides an apt oc-
casion to reassess the nature of an artist's achievement.
And it is an open question, I think, whether Gauguin's

reputation will fare well or ill in the wake of this exhibition. I have no doubt that superlatives will ring loud and long in the press—AT&T does not offer lunch at Le Cirque for nothing—but the lasting effect of any real reassessment is often not evident until well after the media hallelujahs have died down and more circumspect voices can make themselves heard. Yes, there are some extraordinary works on view: in addition to *Jacob Wrestling with the Angel*, I might mention *Loss of Virginity* (1890–91), *Man with an Axe* (1891), *Manao Tupapao—The Spirit of the Dead Watching* (1892), *Te Arii Vahin* (1896), and *Nevermore* (1897)—all of them arguably masterpieces.

BUT I PREDICT that the exhibition will also leave many viewers chastened about Gauguin. For one thing, his mystical or Symbolist histrionics, repeated again and again here, come to seem like little more than that: histrionics, intellectual embroidery that has little to do with the substance of his art. What is meant to be mysteriously evocative strikes one as contrived—when, alas, it does not strike one as simply comical. Gauguin is a prime example of an artist whose art, when it works, soars high above his ideas, but whose ideas all too often invest his art with a load of pretentious hooey that it only partially survives. It is an adolescent fault, but then Gauguin comes to seem more and more the quintessentially adolescent artist. There is also the problem that Clement Greenberg bluntly identified in 1946 in a review of Gauguin paintings: "Frankly, Gauguin does not draw well enough." Finally, as Greenberg goes on to note, Gauguin "was misled, as many a later artist has been, into thinking that certain resemblances between his own and primitive art meant an affinity of intention and consciousness. . . . The result is

something partly artificial, something that lacks reality, however much genius it shows." The cruel irony, of course, is that in embracing the primitive Gauguin believed he was escaping the complications and bewilderments of his civilized self; instead, he only rendered them more painfully visible.

1988

Vincent van Gogh

WHAT IF Vincent van Gogh hadn't suffered from epilepsy, hadn't cut off part of his ear after a quarrel with Gauguin, hadn't, at the age of 37, shot himself mortally out of frustration and fear of another bout of insanity? Would sensitive adolescents—especially those with an interest in mind-altering drugs—idolize him? Would the philosopher Martin Heidegger have rhapsodized about van Gogh's *Pair of Shoes* (1885), claiming (among much else) that the painting "is the disclosure of what the equipment, the pair of peasant shoes, *is* in truth. This entity emerges into the unconcealedness of its being," etc.? Would advance tickets for this exhibition of seventy paintings from Amsterdam's van Gogh Museum have sold out even before the show opened?

Of course not. Nor would museum guides be able to tell the credulous public that van Gogh is "the most beloved" and "most popular" painter in history. Small still-lifes by van Gogh would not sell for tens of millions of dollars. And van Gogh himself would not have been transformed from an earnest but tortured individual into a famous icon of martyred artistic genius.

There were a small handful of remarkable works in

"Van Gogh's Van Goghs: Masterpieces from the Van Gogh Museum, Amsterdam," the makeshift exhibition, that traveled while the Van Gogh Museum was being refurbished in the late 1990s. All of them are exceedingly well known. Among the notable early works are *The Potato Eaters* from 1885 and that *Pair of Shoes* (also 1885) that so entranced Heidegger; among later works (though early and late for van Gogh encompass only a few years) are *The Harvest* and—one of his most famous pictures—*The Bedroom*, both from 1888 and *Wheatfield with Crows*, van Gogh's last picture, painted in July 1890 shortly before he shot himself.

There are a few other pictures worth mentioning. *An Old Woman from Arles* (1888) is one of the few portraits in this exhibition in which van Gogh seems to penetrate at all deeply into the sitter's character. *Skull of a Skeleton with a Burning Cigarette* (1885–1886) is of doubtful artistic importance but might serve well as an icon in an anti-smoking campaign organized by the former tobacco farm owner, Al Gore. One or two of the several self-portraits has something of the intensity we associate with van Gogh's most famous self-portraits.

But to describe this group of pictures as "masterpieces" is an abuse of language. The two paintings from the collection of the National Gallery in Washington, D.C.—*Girl in White* (1890) and *Roulin's Baby* (1888)—are negligible. And of the 70 items sent from the Van Gogh Museum, most are second- or third-rate pictures.

In 1880, after giving up on careers as a minister and an art dealer, van Gogh announced in one of his celebrated letters to his long-suffering brother Theo (who died a mere six months after Vincent) that he intended to devote himself to painting. Van Gogh was in and out of art schools,

but was largely self-taught. In school at Antwerp he encountered Rubens, whose work he says made a deep impression on him. It is not evident that it made a particularly deep impression on his work. van Gogh's extended sojourn in Paris provided him with his most important schooling. He met, and was influenced by, the work of Pissarro, Seurat, Gauguin, Toulouse-Lautrec, and others. Several of the paintings in this exhibition might be mistaken for imitation Pissarros, Lautrecs, or Seurats—which is hardly surprising, since that is what they in fact amount to.

Seurat may have been particularly important. Much of van Gogh's signature work—the late pictures in which the paint is scooped on to the canvas with a heavy, swirling impasto—are in effect exaggerated, not to say caricatured, pointillist pictures. Van Gogh famously dealt not with a meticulously modulated spectrum of color but with angry swaths of paint in which a few blunt color contrasts carry the emotional weight of the picture. In some few paintings the effect is extraordinary. One sees it emerging here in *The Harvest*, an almost Cézannesque arrangement of color volumes.

VAN GOGH'S EMOTIONAL POWER is visible in raging maturity in *Wheatfield with Crows*. This is easily one of his most terrifying pictures, and it is entirely appropriate that this exhibition should conclude with it. Van Gogh had for several years associated yellow with brightness, love, and salubrious good cheer. Here yellow has been poisoned. A glowering sky presses down on the livid fields, contaminating them with bilious hues of darkness. The flock of crows—black, minatory chevrons—appear as a kind of calligraphy of doom.

Wheatfield with Crows reveals van Gogh at his most poignant. It is unfortunate that the exhibition approaches that precinct of emotional and artistic intensity only rarely. *The New York Times* described it as a "blockbuster." In a certain sense they are right. The crowds are sure to be formidable. Countless van Gogh T-shirts, posters, and placemats will certainly be sold. The *Times* itself certainly helped by placing a mention of the exhibition on its front page along with a big color photograph of crowds gaping at a van Gogh self portrait. If that isn't a first for an art exhibition, it is at least very unusual treatment.

But one cannot help suspecting that a large measure of cynicism went into the organization of this exhibition. The Van Gogh Museum in Amsterdam was closed for renovation from September 1998 to the Spring of 1999. Ergo, a lackluster portion of its collection, spiced up with a few memorable pictures, was sent to the United States to collect some rent.

Maybe this doesn't matter. Maybe the public doesn't care whether the van Goghs that they are presented with as "masterpieces" are mostly journeyman pictures. Maybe the only thing that really matters is being in a room with pictures certifiably painted by the man who was so grotesquely unappreciated by the philistines during his lifetime but who is now bravely championed by every Bob and Carol and Ted and Alice who all own framed posters of his *Sunflowers* and *Starry Night*. Many of us, however, will feel the nausea that van Gogh's nephew, Vincent Willem van Gogh, expressed when he recalled that, when it came to his uncle's art, "at home it was rapture, rapture all the time."

1998

Edward Burne-Jones

ANYONE SERIOUS about culture knows that art unguided by an ideal is likely to be vapid. But it is also true that when art is swamped by an ideal the result is generally kitsch. This happens when an artist is unable to express in an artistically convincing way the ideals he professes. It also happens when those ideals seem more manufactured than genuine. In the former case, the fault is formal; in the latter, it is moral or spiritual.

For many observers, the entire Pre-Raphaelite movement is a vivid illustration of these dangers. There can be little doubt that members of the Pre-Raphaelite Brotherhood, from Millais, Holman Hunt, and Rossetti to Edward Burne-Jones and William Morris were motivated by noble sentiments. But one may wonder whether their art was often up to expressing (as distinct from merely proclaiming) those sentiments. Another question is to what extent their sentiments escape sentimentality—to what extent, that is, they are honest. After all, it is no accident that pre-Raphaelite representations of knights errant and Arthurian damsels are perennially popular among sensitive pubescent females. All that hair, for one thing. And then there is the unremitting quaintness. Seldom have medievalizing ideal-

ism and antiseptic eroticism been so slickly commingled. Can anyone pass through puberty successfully and still take the pre-Raphaelites seriously?

Well, yes. But as the Metropolitan Museum's ambitious retrospective devoted to "artist-dreamer" Edward Burne-Jones (1833–1898) reminds us, it is not easy. In 1908, the German art critic Julius Meier-Graefe, while acknowledging Burne-Jones's "great inventive power," nonetheless noted that "the pictures of all the Pre-Raphaelites look best in reproductions." Perhaps that is not entirely fair. But one knows what Meier-Graefe meant. Many of Burne-Jones's paintings do seem like blow-ups of greeting-card images. Like the other pre-Raphaelites, Burne-Jones seemed to care more about the effect he was creating than the picture he was painting. This I suppose is part of what John Christian and John Wildman, writing in the exhibition catalogue, had in mind when they observed that Burne-Jones possessed an "extraordinary capacity to impose his ideals on his models."

BURNE-JONES ALWAYS sweetened such imposition with an abundance of minutely observed decorative embellishment. But no amount of fussiness—and Burne-Jones could excel in fussiness—can conceal the triumph of illustration over any real engagement with painting. As Henry James put it in a letter, there was in Burne-Jones an "element of painful, niggling embroidery—the stitch-by-stitch process that had come at last to beg the *painter* question altogether." Such comments may make it seem as if James were working up to one of his magisterial dismissals. In fact, James harbored a lively appreciation for many aspects of Burne-Jones's work. But his appreciation was always tempered by a recognition of what we might call the amphibious nature

—half art, half literary spiritualizing—that characterized the work of Burne-Jones and the other pre-Raphaelites.

This tension makes James one of Burne-Jones's most subtle critics. In a comment on the "Picture Season in London" for 1877, James singled out Burne-Jones for highest praise. He then went on to note the inveterate "queerness" of his art and "morbid" tendencies of pre-Raphaelitism generally. Acknowledging that Burne-Jones's painting is preeminently one of "reflection, of intellectual luxury, of aesthetic refinement"—good Jamesian virtues all—he nonetheless can imagine someone objecting that "It is not painting, and has nothing to do with painting. It is literature; it is a superior education, a reminiscence of Oxford, a luxury of culture." In the end, James says, there is much about Burne-Jones's art that suggests "the painter is thinking, not looking."

This is not of course the only ambiguity in Burne-Jones's work. "All his young women conform to [a] languishing type with a strictness which savours of monotony," James notes. "I call them young women, but even this is talking a grosser prose than is proper in speaking of creatures so mysteriously poetic. Perhaps they are young men; they look indeed like beautiful, rather sickly boys. Or rather, they are sublimely sexless, and ready to assume whatever charm of manhood or maidenhood the imagination desires." This a- or pan- or trans-sexual element in Burne-Jones is one of the most potent sources of his popularity, and it has done much, I suspect, to bolster the recent revival of interest in his work among those who prefer the more ornate varieties of sex.

The criticism implicit in James's observations should not be allowed to obscure the admiration for Burne-Jones's that accompanied it. Writing in the early 1880s, James

provided an astute summary that locates the peculiar na-
ture of his achievement. Burne-Jones, James noted, needs

> to be looked at good-humoredly and liberally; he offers us
> an entertainment which is for us to take or leave. . . . He is
> not a votary of the actual, and nothing is easier than to pull
> such an artist to pieces, from the point of view of the ac-
> tual. But the process is idle; the actual does not gain and
> the artist does not suffer. It is beside the mark . . . to say
> that his young women are always sick, for they are neither
> sick nor well. They live in a different world from ours—a
> fortunate world, in which young ladies may be slim and
> pale and "seedy" without discredit.

It's less a matter of "O brave new world," perhaps, than
"to die will be an awfully big adventure." But one sees
what James is getting at—and warning about.

This sumptuous exhibition, which traveled to Birming-
ham and the Musée d'Orsay, certainly gives Burne-Jones
his due. With some 170 items, it provides the viewer with a
large helping of every aspect of this indefatigable and mul-
tifaceted talent. Paintings, watercolors, drawings, tapes-
tries, embroideries, stained glass, ceramic tiles, painted
furniture: Burne-Jones busied himself with all, with varying
success. He was most famous in his time for his allegorical
paintings—*The Beguiling of Merlin* (1874), *Phyllis and
Demophoön* (1870), *King Cophetua and the Beggar Maid*
(1880–84): the very titles are redolent of the never-never
land he wanted his art to inhabit.

Today, with one or two exceptions, Burne-Jones's paint-
ings strike most viewers as precious curiosities: slightly
comical exercises in religiose nostalgia. As this exhibition
reminds us, Burne-Jones was generally at his best when at

his most abstract and decorative. The work he did as chief designer at Morris and Co.—William Morris had been a friend since they were at Oxford together—is among his strongest and most vital. That he really could paint if suitably inspired is shown by two late portraits: one of his long-suffering wife Georgiana, begun in 1883 but never finished to Burne-Jones's satisfaction, and one of his daughter Margaret (1885–1886), later the mother of the novelist Angela Thirkell. Both are remarkable pictures. In most of Burne-Jones's portraits and allegories, the humanity of his sitters is totally submerged beneath an ocean of sentiment. In these two pictures, the humanity of his sitters confidently survives the process of idealization. They show what sort of artist Burne-Jones might have become—had he been content to be an artist instead of an "artist-dreamer."

1999

Gustave Moreau:
Between Epic and Dream

I FIRST SAW the big retrospective of paintings and
drawings by Gustave Moreau (1826–1898) in April,
1999 when the exhibition was in Chicago. I had gone to
the Windy City for a conference about the state of higher
education in America (it's even worse than you thought),
and had availed myself of the opportunity to take my first
serious look at the work of a painter I had always as-
sociated with a certain fin-de-siècle ickiness. I wasn't dis-
appointed. I had only been in the galleries about ten
minutes when a co-conferencee, a well-known philosopher
from California, came breezing through. He paused briefly
in front of a few pictures—ones featuring unicorns, I think,
and apparitions—and exclaimed "Kitsch! It's all just
kitsch!" In front of *Oedipus and the Sphinx* (1864),
Moreau's most famous painting: "God, what kitsch."
Salomé (1876): "kitsch, kitsch, kitsch."

Well, I can't deny it. Almost all of Moreau's work has an
element of kitsch about; his most ambitious work is the
kitschiest of all. The harder he tried, the kitschier he
became. A press release for the exhibition repeated the
standard line on Moreau: that he is "best known for his
mysterious and complex allegorical paintings based on

classical, literary, and biblical sources." But in fact, the German art critic Julius Meier-Graefe was right: Moreau is the French "counterpart" of Edward Burne-Jones. For all his "soul reading," Meier-Graefe noted, Moreau "never succeeded in producing the spiritual in art." He was "a naturalist who never went near nature. He painted still-life pieces of the worst sort, which were only popular because, instead of well-preserved fish and fruit, he used ghosts equally well-preserved." Like Burne-Jones and other members of the Pre-Raphaelite Brotherhood, Moreau went in for slightly cadaverous damsels in medieval garb. There is a noticeable lack of red corpuscles in his figures, especially his men—if there are any men. (Put your hand on your heart and tell me, without looking it up, who is Jason and who is Medea in *Jason* (1863–65): it can't be done.)

Moreau was quite up front about all this. "The meaning of modern art." he wrote, "is altogether in the spirit of the Middle Ages." In his classic book on Symbolist art (1979), Robert Goldwater remarked that "Moreau's recurrent theme, often implied, sometimes made explicit, is a dualistic opposition of matter and spirit."

You said it. At first, you might be tempted to say that Moreau's portrayal of women was ethereal, but in fact it is far too creepy for that. So far as Moreau was concerned, the problem with women was that they had bodies, and bodies can be desirable, and desire leads to all sorts of complications. Much easier to associate women with "unconscious" matter, the "vegetal and bestial," and see them as driven by insatiable, all-devouring lusts. You lose any real women in the process, but you do get weird hothouse figures like the rutting, pert-busted sphinx in *Oedipus and the Sphinx*. (Just what is she doing to Oedipus, anyway?)

Moreau did not have to paint like this. He was trained

in the canons of neo-classicism, and some of his student work is straightforward and technically accomplished. And when he forgot about trying to show allegorical figures being "purified by the Sacred," etc.—which wasn't often— he could produce powerful work. Some of his self- portraits, in particular, are unencumbered by hankerings after "the great mystery." But Moreau was in the enviable position of having a largish independent income, so he did not have worry about making a living. He sold very few of his works. (Though some of the most famous—*Oedipus and the Sphinx*, *Salomé*—are in major museums.) Some he gave away to friends. Mostly he hoarded them. On his death, he bequeathed, God help us, more than 14,000 works to the state along with his house on the rue de la Rochefoucauld, so now we have a Musée Gustave Moreau in Paris, chock full of his stuff.

Moreau once remarked that it was because of his deep meditation on the Renaissance masters that "I manage to express. . . that je ne sais quoi exuded by great works of genius: the Sistine and certain works by Leonardo." Yes, well. For most of us the *quoi* is really not so *inconnu*. Moreau was as popular as he was because he filled a cer- tain spiritual void. In his own day, it was mostly the risqué elements of his pictures that appealed. (What was it about the figure of Salomé that made her so attractive to deca- dents?) Today, it is mostly the hazy, displaced eroticism. Among other things, this helps explain why Moreau is still a big hit with sensitive adolescent girls who, suddenly sub- ject to inexplicable twinges, are grateful for the pretty medieval gowns, the exotic settings, and the unicorns.

Moreau's art is kitsch because the je ne sais quoi he so proudly purveyed is totally fake. Kitsch is manufactured emotion, emotion based on self-deception. This is why it is

so widely reprehended. It is also why it is so widely appealing. As the philosopher Karsten Harries noted in *The Meaning of Modern Art* (Northwestern University Press, 1968),

> The need for Kitsch arises when genuine emotion has become rare, when desire lies dormant and needs artificial stimulation. Kitsch is an answer to boredom. When objects cannot elicit desire, man desires desire. More precisely, what is enjoyed or sought is not a certain object, but an emotion, a mood, even, or rather especially, if there is no encounter with a object that would warrant that emotion. Thus religious Kitsch seeks to elicit religious emotion without an encounter with God, and erotic Kitsch seeks to give the sensations of love without the presence of someone with whom one is in love.

This is Gustav Moreau to a T. And yet it is not easy simply to dismiss Moreau. He made a deep impression on the Surrealists, it is true. But against that damaging acknowledgement we must place the fact that, late in life, he taught at the Ecole des Beaux-Arts and numbered among his grateful students Georges Rouault and Henri Matisse. Which I suppose means that, sometimes, the apple does fall far from the tree.

1999

Undressing the Victorians

Manners are of more importance than law. . . . The law touches us but here and there and now and then. Manners are what vex or soothe, corrupt or purify, exalt or debase, barbarize or refine us, by a constant, steady, uniform and insensible operation like that of the air we breathe in.
—Edmund Burke, "Letters on a Regicide Peace"

The artist used to be at war with the Philistine. Today, for fear of being tainted with élitism or with failing to meet the elementary requirements of the democratic outlook, your intellectual abases himself before the power-hungry world of show-business, or fashion, or advertising.
—Alain Finkielkraut, *The Undoing of Thought*

WHEN "Sensation: Young British Artists From the Saatchi Collection" opened at the Brooklyn Museum of Art in the fall of 1999, the museum thoughtfully included a mock "health warning" with its press material. "The contents of this exhibition," the advisory began, "may cause shock, vomiting, confusion, panic, euphoria, and anxiety."

In fact, what the exhibition (which had originated at the

Royal Academy in London) chiefly caused was an un-
bearable sense of tedium. Sure, there was an outcry about
the several odious objects on view. (Remember the blas-
phemous picture of the Virgin decorated with cutouts from
pornographic magazines and clumps of elephant dung?)
And Rudolph Giuliani, then mayor of New York, gave the
"arts community" its biggest thrill in years by threatening
to withhold city funding if the museum insisted on
showing the Virgin de la merde picture. "You don't have a
right to a government subsidy for desecrating somebody
else's religion," he said at the time. "[I]f you are a govern-
ment-subsidized enterprise, then you can't do things that
desecrate the most personal and deeply held views of
people in society." What a delicious access of indignation
that supplied! For many years now, bourgeois cultural in-
stitutions like museums and theaters have been gratefully
embracing every new "transgressive gesture" as soon as it
rolls off the assembly line. How refreshing, how novel—
how *transgressive* when you come right down to it—to
encounter some old-fashioned moral resistance at last.
Naturally, members of the "arts community" roundly
denounced Mayor Giuliani as a philistine and worse (Nazi
Germany was invoked, as were the interventions of
Senator McCarthy). Secretly, in their heart of hearts, I
suspect they were offering him thanks. In these
latitudinarian days, it's not often that the beautiful people
have the opportunity to indulge themselves in such preen-
ing ecstasies of self-righteousness.

Apart from the gleeful circus of indignation, however,
"Sensation" was not much of a sensation. Oh, there were
plenty of rebarbative things on view: you could tell that the
curators had worked overtime to pique the jaded palates of
a public surfeited on "challenging" art. But was there any-

thing new? Were there any aesthetic innovations? Were there even any novel perspectives or ideas? No, no, and no again. It was the same tired old stuff. Pubescent mannequins studded with erect penises? Been there. Bisected animals suspended in glass tanks? Done that. Even the focus of moral outrage—the sacrilegious Virgin—was hardly more than a reprise of stuff Dalí and other surrealists had paraded half a century ago. In straining for effect, the objects assembled in "Sensation" wound up communicating chiefly the effect of straining.

Still, "Sensation" did harbor two lessons, a moral lesson and a commercial one. The moral lesson centered on the great tedium "Sensation" produced. Here at last was unmistakable confirmation of a strange phenomenon that had been flickering into focus here and there in the art world for some years: that an exhibition or performance can be disgusting without being shocking. The full implications of this development, I believe, have yet to be absorbed. Among other things, it suggests that the whole movement of "cutting-edge" art has entered a terminal phase. Like pornography—from which it is often indistinguishable— contemporary "avant-garde" art is a drearily formulaic, naff, and ultimately desperate enterprise. The stimulus is artificial, the means degrading, the result an exercise in futility. The overall effect is boredom.

CURIOUSLY, the commercial lesson of "Sensation" seems, at first blush, to cut in the other direction. For while the exhibition was a yawn in the gallery, at the box office it really was a Sensation. Like the crowds who congregated with touching anticipation to see the next exotic attraction when P. T. Barnum, overwhelmed with patrons, nailed up a sign emblazoned with the legend "This Way to the Egress,"

the art-going public reported for duty en masse at the entrance to "Sensation."

The great question is to what extent the Barnum gambit is replicable. The jury, I believe, is still out on that one. Even today, probably, there are people who would line up to see so strange a thing as an Egress; and doubtless there are many others eager to share with them their own encounters with that elusive beast. It is clear at any rate that the Brooklyn Museum was wagering that the trick still has legs. Hence its enthusiastic acceptance of "Exposed: The Victorian Nude," which was on view there from September 2002 to early January 2003 after stops at Tate Britain and the Haus der Kunst, Munich. the latest Barnumesque import from Britain. Billed as "the first exhibition to chart the moral and aesthetic controversies about the nude body in English visual culture," "Exposed" has more than a little in common with Barnum's innovative approach to crowd control. For one thing, there is the great discrepancy between expectation and fulfillment. "Exposed" is marketed as this year's sexy art event. The chief publicity image is from *Cadmus and Harmonia* (1877), a little-known painting by Evelyn de Morgan (née Pickering). It's a sort of Botticelli-meets-the-Pre-Raphaelite-Brotherhood production: svelte, leggy nude, posed like the figure in Botticelli's *Birth of Venus* but with the regulation Pre-Raphaelite red hair and an alarming "soulful" expression. You might think that the thirty- or forty-foot snake, coiling up from the damsel's legs, would be grounds enough for alarm, but Harmonia seems to be perfectly at ease with her pet—Nastassja Kinski before her time—since she gently if absent-mindedly presses its head to her breast. The catalogue for "Exposed" features a detail of this picture with a thin paper band positioned carefully across Har-

monia's bosom. To open the catalogue, you have to break the band and expose her nakedness: get it? It's about as exciting as the Egress must have been.

Much of what one sees in "Exposed" is like Harmonia and the paper band. That is to say, there is everywhere the hint, the suggestion, the atmosphere of prurience. It is partly the result of the works on view, but only partly. A lot of it comes from the presentation: the arrangement of works, the accompanying commentary, the whole premise and marketing of the exhibition. (One section is called "Sensation! The Nude in High Art." But what is sensational about nudes in high art?) There are a handful of overtly pornographic works on view in "Exposed"— Aubrey Beardsley's comical *The Impatient Adulterer* (1896), for example, some drawings by Turner of copulating couples, and some photographs by Edward Linley Sambourne. But the real obscenity lies elsewhere. It is grounded largely in the diffuse, hothouse ickiness of eroticized idealism that hovers about many of the works: Ernest Normand's *Bondage* (c. 1895), for example, which depicts the Pharaoh inspecting a possible recruit to his stable of slaves, or Gustave Boulanger's *Phryne* (1850), or John Collier's *In the Venusberg* (1901).

These are seriously bad pictures: cloying, aesthetically static, cringe-making in their combination of coy, sugar-glazed, semi-concealed eroticism and spurious high-mindedness. This is not a novel observation about high Victorian painting. Consider the case of Frederic Leighton, represented by more than a dozen works in this exhibition. Leighton's work was immensely popular in its day. But even at that time some observers grasped the essentially meretricious nature of his work. For example, Henry James, writing in 1882 about Leighton's picture *Phryne at*

Eleusis, noted that "his efforts remain strongly and brilliantly superficial. His texture is too often that of the glaze on the lid of a prune-box; his drawing too often that of the figures that smile at us from those receptacles." The great mystery about artists like Leighton is the source of their charisma. For no sooner are they dead than the spell is broken. Leighton, James wrote, was "one of those happy celebrities who take it out . . . in life." Reflecting in 1897 on the great public funeral accorded to Leighton, and the great public indifference to his work that immediately followed his interment, James asked: "Is the key to the enigma that there was too much noise yesterday, or that there is not enough of it today?" For a hundred years or so, artists like Leighton subsisted in the dignified silence provided by well-deserved obscurity. It is one of the aims of exhibitions like "Exposed" to generate enough noise that no one notices the process of unjustified disinterment they depend upon.

In *The Nude: A Study of Ideal Art* (1956), Kenneth Clark famously distinguished between the ideas of nakedness and nudity. "To be naked," Clark wrote,

> is to be deprived of our clothes and the word implies some of the embarrassment which most of us feel in that condition. The word nude, on the other hand, carries, in educated usage, no uncomfortable overtone. The vague image it projects into the mind is not of a huddled and defenceless body, but of a balanced, prosperous, and confident body.

The curators of and contributors to the catalogue for "Exposed" do not much like Clark's book. His passing allusion to the "great frost of Victorian prudery" is several times cited only to be dismissed. For the governing presup-

position of "Exposed" is that, deep down, the Victorians were just as sex-obsessed as we are only, alas, their moral and religious commitments tended to interfere with their sex lives. This presupposition, elaborated in the menacing strains of contemporary lit crit jargon, imbues the catalogue and other official commentary for the exhibition with an anachronistic aura that is partly noxious, partly just comic. For example, in "The Nude in Nineteenth-Century Britain: 'The English Nude,'" Alison Smith, the exhibition's chief curator, writes that in *Bathers* (1876), a seemingly innocent picture of boys swimming, Frederick Walker was "imagining a male utopia that surreptitiously admitted a homoerotic chivalric gaze, while at the same time honoring a popular pastime." I am not sure exactly what a "homoerotic chivalric gaze" is, but I am confident that Walker's muddy, sentimentalizing effort has nothing to do with a "gaze" of that or any other sort.

One is never far from the jarring effect of anachronism in "Exposed." Of course it is most patent in the catalogue. The vertiginous effect is due partly to the argot, which is wildly at odds with the subject matter. Smith again: "the female nude was assigned to the confined urban context of the studio or bedroom which had so disturbed critics earlier in the century. Designed to illuminate a seamy side of the female nude, such works succeeded in disturbing the idea of the artistic or unified body through a process of fragmentation." But what does "disturbing the idea of the artistic or unified body through a process of fragmentation" have to do with the works on view? What indeed does it even mean?

The element of anachronism is not only rhetorical, however. In "Prudery, Pornography and the Victorian Nude (Or, What Do We Think the Butler Saw?)," Martin

Myrone draws on a pornographic 1993 comic strip in order to drag in Margaret Thatcher and her call for a revival of "Victorian Values." "For its proponents," he explains, "Victorian values stood for cleanliness, hard work, strict self-discipline and economy, and a code of morality centered on 'normal' heterosexual family life." Why the scare quotes around "normal"? Does Myrone believe that there is no such thing as a normal heterosexual family life? Does he believe that the Victorians denied it?

One of the contributors to the catalogue quotes the comment that "The Victorians and sex have been exhaustingly, if not exhaustively, written about." And how. You put down the catalogue for this show feeling very tired. One last example. In "Thoughts and Things: Sculpture and the Victorian Nude," Michael Hatt tells us that

> the question of colouring the nude clearly has ramifications for ideas about gender. The coloured female nude is problematic because it turns the nude into a sign of sexual desire, of base physicality; exactly what the ideal is designed to expunge. Here decorous femininity turns into deviance: the matron is in danger of prostituting herself.

An interesting thought experiment for the ecologically minded: what if academics were forbidden to use the word "gender"? How many acres of wood pulp would we save?

There are a few good pictures in "Exposed." Few of them are Victorian. Indeed, "Exposed: The Victorian Nude" is misnamed. It should had been called "Exposed: The Painful Effort to 'Sensationalize' 150 Anaphrodisiac Pictures, Most of Which Are Victorian." What, for example, is Walter Sickert (1860–1942) doing in a exhibition supposedly devoted to the Victorian nude? Or Gwen John

(1876–1939)? Or William Orpen (1878–1931)? These are not Victorian painters, spiritually or chronologically. And what is the point of the smirking film clips from Pathé Frères, *circa* 1903? What do they have to do with "The Victorian Nude"?

The answer is, nothing. But even to ask that question is to misunderstand the governing impulse behind "Exposed." The Victorian nude was merely the pretext, the occasion for this exhibition. In fact, "Exposed" is almost entirely about pretext. In the first place, a group of (mostly) undistinguished art works is gathered together as the pretext for an exercise in sexual politics and cultural warfare. The curators are not interested in these objects for their aesthetic merits (which is just as well, since considered aesthetically most of what is on view in this exhibition is period-piece kitsch). On the contrary, their chief interest is in spinning a psychodrama about the supposed repression or the inversion or the complications of sex in the Victorian period. The assembled works of art provide the excuse to fight some contemporary ideological battles: battles about the place of sexuality in public life, the ideals of modesty and seemliness, the concept of sexual normality.

In other words, "Exposed: The Victorian Nude" is yet another chapter in the so-called culture wars. Over the past decade or so, it has become increasingly clear that this war is a battle about everything the Victorians are famous for: the "cleanliness, hard work, strict self-discipline," etc., that one of the people responsible for this exhibition spoke of with such contempt. Do those values, those virtues, articulate noble human aspirations? Or are they merely the repressive blind for . . . well, you name it: narrowness, hypocrisy, the expression of a "white, patriarchal, capitalist, hegemonic," blah, blah, blah? As our distance

from the Victorian era grows, we can appreciate more and more what giants they were: intellectual, political, scientific, cultural, and moral giants. They did not, it is true, excel at painting or sculpture. But in virtually every other department of human endeavor, the Victorians are models we dismiss or patronize at the cost of our own diminishment. "Exposed" is almost entirely predicated on such a patronizing attitude (an attitude that is only half-masked by the lurid interest in the sentimental schlock that is Victorian painting). Which means among other things that "Exposed" is yet another attack on the moral, aesthetic, and cultural patrimony that Burke extolled under the name of manners.

Finally, exhibitions like "Exposed" are commercial pretexts for institutions like the Brooklyn Museum, which are devoted to transforming themselves from repositories of our cultural heritage into beacons of trendiness. Like almost every other art museum in the Western world, the Brooklyn Museum is engaged on an ambitious building program. What will occupy its capacious new galleries? Hitherto seldom-seen items from its permanent collection, in part. But also a great deal of contemporary art and many exhibitions like "Exposed." The Brooklyn Museum took "Exposed" in the hope that it would be another "Sensation": a box-office success with an abundance of buzz. Artistic quality enters the equation only incidentally, if at all. As of this writing, the calculation does not seem to be paying off particularly well. Which may mean that what "Exposed" exposes is above all the limits of cynicism in marketing art. Or perhaps it only means that Victorian nudes are just too anemic to function as a crowd-pleasing Egress.

2002

Pissarro's Urbanities

WHEN WE THINK of the great Impressionist painter Camille Pissarro, most of us conjure up the bucolic, painterly images that Pissarro painted in such rural spots as Pontoise and Eragny-sur-Epte. At their best, these shimmering landscapes from the 1870s and 1880s rival those of Seurat, Renoir, and Monet.

It may come as something of a surprise to learn that Pissarro painted more urban scenes than any other major Impressionist. Indeed, in the last decade of his life, from the winter of 1892–93 when he began his series paintings until his death in 1903, Pissarro completed over 300 cityscapes. It is the great accomplishment of "The Impressionist and the City: Pissarro's Series Paintings" to acquaint us with this forgotten and much under-appreciated side of Pissarro's oeuvre. In 1992, a splendid traveling exhibition of sixty late Pissarros opened at the Dallas Museum of Art, revealing a whole new dimension of an artist we might had thought we knew well.

Organized by the artist's great-grandson, the art historian Joachim Pissarro, and Richard Brettell, then director of the Dallas Museum of Art, "The Impressionist and the City" was in every way a triumph. The paintings were ex-

ceptionally well chosen to illustrate Pissarro's guiding aesthetic ambitions in his urban series paintings—a difficult task, since the works have long been dispersed, many to out-of-the-way collections—and were installed with great finesse. The accompanying catalogue, written by Brettell and Joachim Pissarro, expertly traces the genesis and development of the series paintings, setting them into the context of Pissarro's earlier work and the work of his artistic peers.

Born in the Virgin Islands of Jewish parents in 1830, Pissarro—like many painters of his generation—had a brief apprenticeship in the family business. By 1855, however, he had decided against a business career and had settled in Paris, where he encountered the work of Courbet, Delacroix, and Corot.

In fact, Pissarro seems to have encountered and profited from just about every important cultural figure and trend of the age. As a young painter he followed the advice of Corot: paint from nature. He later worked with Cézanne at Pontoise, made prints at Degas's studio, had an extremely productive flirtation with Seurat's Pointillism, consorted with Monet, Sisley, Renoir, and Gauguin. Like many painters, he was invigorated by Daumier's caricatures and swept away by Japanese prints, which were just then becoming widely known in the West. (Hiroshige, he declared, was "a marvelous Impressionist.") In politics, he was instinctively radical. And although he consistently disapproved of violence, he came by the 1880s to espouse a potpourri of anarchist ideas, then much in the air.

Pissarro's declaration of anarchist sympathies has unfortunately led some critics to interpolate anarchist themes into his paintings. Not content with the stunning aesthetic achievement of Pissarro's canvases, such observers have

insisted on discovering political messages there, especially in his portraits of urban hubbub. Pissarro himself seems to have warned against this habit when he noted that "motifs are of secondary interest to me: what I consider first is the atmosphere and the effects." The truth is, Pissarro's paintings have absolutely nothing to do with his politics.

The delicate effects that Pissarro sought to capture required not political commitment but technical mastery and also great patience. The vocabulary of light and weather is large, moody, evanescent. A particularly arresting nimbus, gray and radiant, might hover for an hour or two one drizzling morning over the Gare Saint-Lazare; moments later it would have vanished, dissolved into a dreary blankness.

In order to be able to capitalize on propitious moments whenever they should declare themselves, Pissarro had to work on many pictures at once, and work quickly. The paintings would be in different states of completeness, awaiting the return of a specific atmospheric effect. It is not surprising that Pissarro's dealer, Paul Durand-Ruel, was not always so patient. Perhaps it was Pissarro's deliberateness; perhaps it was his penchant for painting subtle modulations of fog and rain: whatever the reason, Durand-Ruel found himself moved to recommend that Pissarro try making paintings that were "light and luminous and of a selling effect." Pissarro's mastery of that effect became fully evident only posthumously.

In the 1890s, being "modern" was itself an important artistic goal for many writers and artists. The example of Baudelaire is paradigmatic. There was no more modern subject than the city and no more modern city than Paris. The energizing spectacle of Paris—that vast repository of burgeoning technology and bustling humanity—was one of

the two great catalysts of Pissarro's late work. As he wrote to his son Lucian in 1897, "it is not very aesthetic, perhaps, but I am delighted to be able to try to do these Paris streets which are often called ugly, but which are so silvery, so luminous, and so lively and which are so different from the boulevards—it's completely modern!"

If the city provided the right setting for Pissarro's late work, the idea of painting in series provided the central organizing principle. Emile Zola, the great realist novelist and friend of so many Impressionist painters, once defined Impressionism as "nature seen through a temperament." What better way to refract nature through sensibility than to conjugate a particular scene through the seasons, times of day, varying effects of light and weather?

The supreme monument to this defining impulse of Impressionism are Monet's stupendous series paintings, also executed in the 1890s. Pissarro was powerfully impressed by Monet's series paintings (he saw the Rouen Cathedral series, for example, in 1895), but his own series are generally more focused on urban themes and are less personal and contemplative.

In total, Pissarro executed eleven separate series of urban views. They took him to Paris twice (in 1893 and 1903), twice to Rouen (1896 and 1898), twice to Dieppe (1901 and 1902), and once to Le Havre (1903). Quays, boulevards, bridges, city streets thronged with carriages and pedestrians: these are the ostensible subjects of Pissarro's series. Noting what he calls Pissarro's "urban humanism," Mr. Brettell describes the "Rue Saint-Lazare" (1893) as "nothing more or less than the first serious study of traffic in the history of art."

Perhaps it is. Pissarro himself noted with some amusement that the Musée des Beaux Arts had bought two of his

views of Le Havre because they were interested in them "from an *historical and documentary* point of view!" Nevertheless, what one takes away from this marvelous exhibition are not images of traffic or visual reports of specific places but a catalogue of rare and beautiful aesthetic effects. Pissarro made himself a master of grays: of mists and fogs and autumn skies. Look especially at *The Raised Terrace of the Pont Neuf, Place Henri IV: Afternoon, Rain* (1902) or the lavishly Turneresque view of the Pont Boieldieu in Rouen from the Birmingham Museum (1896). "To see clearly" is a phrase one often encounters in Pissarro's writings. His urban series paintings remind us that it is most difficult and also most rewarding to see clearly what reveals itself but fleetingly and in part.

1992

Renoir's Portraits

THE MOST AUDACIOUS exhibition on view in the United States in the spring of 1998 was not in New York but Chicago. And it featured not a trans-sexual "performance artist" doing unspeakable things but the portrait paintings of the great Impressionist master, Pierre-Auguste Renoir (1841–1919). The audacity is of two sorts. One is curatorial. As you enter the handsomely installed exhibition there is a large block of text introducing you to the show. It concludes with a quotation from Renoir announcing that his main ambition is to make "pretty" pictures.

"Pretty" pictures? At a time when art is supposed to be "challenging," "difficult," "in-your-face," "transgressive" —anything but beautiful, please, and certainly never merely pretty—it is a daring gesture to advertise Renoir's heterodox statement. Renoir is still one of the most popular artists who ever lived. But his very popularity has contributed to a steep decline in his critical fortunes. It is extremely easy to sniff at Renoir today, and many obtuse black-clad critics—the same critics who on another day wax ecstatic over the Chapman brothers, Damien Hirst, or Vito Acconci—have taken the opportunity afforded by this exhibition to say disparaging things about Renoir's art.

Not that there aren't legitimate criticisms to be made about Renoir. He was an immensely prolific artist, and if his best works communicate an enthralling melodiousness, he sometimes—and not as infrequently as one would wish—slouches toward a nervous, heavy sugariness. Perhaps this is what Mary Cassatt felt when she complained about a 1912 exhibition at Durand-Ruel: "the most awful pictures . . . of enormously fat red women with very small heads."

I suspect Cassatt would revise her opinion sharply upward could she see the exhibition of Renoir's portraits on view at the Art Institute in Chicago. All the heads in this compact exhibition of sixty-odd paintings are well-proportioned and none of the women are distressingly adipose. In fact, most viewers will find this exhibition a revelation. Renoir's extreme popularity has made his work seem tediously familiar. This familiarity has formed a carapace, concealing a painter of powerful accomplishment and beguiling charm. One of the real accomplishments of this exhibition is to retrieve for us the deep audacity of Renoir at his most ambitious.

What makes that audacity hard for many of us to appreciate is its essentially sunny nature. Renoir's painting is essentially celebratory; he looked upon the world with an "oeil bienveillant," glorying in its sumptuousness. There is great intensity in some of Renoir's portraits, but very little melancholy. The dominant mood is festive: a happy, sociable sensuousness. This side of Renoir is abundantly represented here with such famous pictures as *Dance at Bougival* (1883), *Mademoiselle Marie-Thérèse Durand-Ruel Sewing* (1882), and the Phillips Collection's spectacular *Luncheon of the Boating Party* (1880–81), one of Renoir's greatest masterpieces.

Such pictures will be familiar to many viewers; but seeing them again in this exhibition brings them to life in a new way. Colin Bailey, the curator, has selected works from throughout Renoir's career that show him at his most lucid and harmonious. There is a forceful clarity to Renoir's best work that this exhibition manages to isolate and amplify, with the result that even the most familiar pictures take on a new luminousness, transforming what is undeniably "pretty" into something statelier and more substantial. What Bailey said about Renoir's work in the 1860s holds good for his entire career: "Renoir is a tender Realist, whose observation of aspects of urban and suburban leisure, while keen, is also kind."

There are many highpoints to this exhibition. Other familiar paintings include the commanding *Madame Georges Charpentier and Children* (1878) and *Riding in the Bois de Boulogne* (1873). Among other things, these paintings show that in aiming to make "pretty" pictures Renoir did not necessarily sentimentalize or diminish women through daintiness. Mme Charpentier is sharp, tough, motherly, forbidding yet still gracious, while the depiction of an army officer's wife and her young son riding in the Bois de Boulogne is a picture of extraordinary polish and unsprung tension. In fact, Renoir excelled in portraying frank, competent women: the late, affectionate portrait of his wife and her dog, *Madame Renoir and Bob*, shows a handsome matron in a loose, peasant shift coolly assessing the viewer—as certain of him one feels, as she is of herself. ("My mother," Jean Renoir later recalled, "brought a great deal to my father: peace of mind, children whom he could paint, and a good reason not to go out in the evening.")

There are many delights in this exhibition. There are

also a few surprises. The extraordinary portrait of the dealer Ambroise Vollard dressed as a toreador, for example. Painted in 1912, it was Renoir's last portrait, and one of his greatest. At first it seems almost comical: the distinguished dealer in this decidedly uncharacteristic costume seems slightly preposterous. But there is a ferocity in Renoir's portrayal that animates the picture, giving a solidity and depth far beyond what one at first expects.

Probably the strangest picture on view is *Children's Afternoon at Wargemont*, from 1884, which presents a tableau of a mother and her two daughters. Painted with an unusual flatness and psychological edge, it looks forward to Balthus, minus the explicit pedophilia and voyeurism. It is an extraordinarily arresting, almost creepy painting, and it seemed significant in some elusive way that it should be owned by Nationalgalerie in Berlin.

One of the very greatest pictures in the exhibition is also one of the least well known: Renoir's 1870 portrait of his brother, Pierre-Henri Renoir, from a private collection. There are not many people, I'd wager, who would have guessed that Renoir painted this intense, expressionist masterpiece. There is an unsparing candor—tempered, to be sure, with wry affection—about this dark, lovingly painted portrait that makes it a great rarity in Renoir's oeuvre. It is the kind of picture that brings you up short. It is a beautiful, and beautifully honest, picture. If this is what Renoir means by "pretty," I remember thinking, we need more of it.

1998

Mary Cassatt

I N SOME WAYS it was unfortunate that the single best pic-
ture in the retrospective of Mary Cassatt's work that
made the rounds in 1998 was a portrait of the artist by her
friend Edgar Degas. Painted in the early 1880s, *Mary Cas-
satt Seated, Holding Cards*, shows the artist in her mid- to
late-thirties (she died in 1926), a dark, elegantly-garbed
figure leaning forward, the only articulated thing in a field
of scumbled russets, browns, and gray-white brushstrokes.
Perhaps she is deliberately showing her hand of cards;
perhaps she has lost interest in the game and has inadver-
tently let her hands drop. In any event, her gaze—pensive,
intent, lost in a middle distance beyond the picture frame
—suggests that her mind is elsewhere.

As indeed it might be. Cassatt was just then entering the
period of her greatest work. Born in Pittsburgh in 1844,
the fourth of five surviving children in a rich, cultivated
family, Cassatt had been traveling and studying in Europe
since she was twenty. Her first encounter with Degas'
work—some pastels of dancers—in 1874 was a revelation:
"the turning point in my artistic life," she later described
it.

The admiration was mutual. "She has infinite talent,"

Degas remarked—characteristically adding that "No woman has a right to draw like that." In 1877, he invited her to exhibit with the Impressionists (she was the only American to do so) after her two Salon entries for that year had been rejected. For the next fifteen years or so she produced dozens of fetching pictures that made her—along with that other ex-pat painter, John Singer Sargent (d. 1925)—among the most affectionately regarded American artists of her generation.

Hyperbole is an accepted tool of publicity, and no one will be surprised that the claims made for Cassatt's work in the promo literature that accompanied this exhibition were rather larger than her achievement can support. And given the ideological temper of the day, no one will be surprised, either, that the feminist gambit has been played early and often in the commentary on Cassatt's work. The subtitle of the retrospective—"modern woman"—genuflects firmly in this direction, as do the essays in the catalogue for the exhibition. Likewise, readers who turn to Nancy Mowell Mathews's intelligent biography of the artist (Yale, 1994) will find the feminist gong tapped at regular intervals.

THERE IS SOME justification for this. Cassatt was a crusader for women's suffrage—she even sacrificed friends over the issue. Although many of her most famous—and some of her best—pictures celebrate motherhood, she herself never married, never indulged in any love affairs. She devoted herself to her independence and her work. She was a shrewd businesswoman, buying and selling the art of her Impressionist friends and advising the great dealer Paul Durand-Ruel and the collector Louisine Havemeyer, one of her closest friends.

The "modern woman" motif is designed to build up its

subject. Applied to an accomplished artist like Mary Cassatt, however, it tends to have the opposite effect. We care about Cassatt today not because of her political activism but because she painted some excellent pictures. She was not an artist on Degas's level, or on the level of her close friend Camille Pissarro. Nor is she finally on the level of Renoir, an artist with whom she is often compared. But Mary Cassatt was an immensely gifted painter whose best work is a delight.

This retrospective, organized by the Art Institute of Chicago which owns fifty-odd works by Cassatt, offers a generous, perhaps overly generous, sampling of 90 works by Cassatt. As is so often the case with major exhibitions these days, one feels that the impact would have been greater had the curators been content with a smaller show. Like most artists, Cassatt was often not at her best. And this exhibition—which traveled to the Museum of Fine Arts in Boston, and the National Gallery in Washington, D.C.—has the effect of diluting the vigor of her work with many works that are merely second best.

This is a pity because, at her best, Cassatt is a moving artist, a keen observer of manners. *Five O'Clock Tea* (1880) is a mature society masterpiece, *After the Bullfight* (1873), depicting a matador lighting a cigarette, is an arresting early picture that shows the influence of Cassatt's teachers Gérôme and Thomas Couture. The exhibition also includes most of Cassatt's best known pictures: *The Letter* (1890–91), which brilliantly displays her canny absorption of lessons from the famous 1890 exhibition of Japanese prints in Paris; *Girl Arranging Her Hair* (1886), which was once owned by Degas; and many, many pictures of mothers and infants: in arms, at the breast, stepping into a bath. Taken en masse, these pictures provide a vivid intro-

duction to the liabilities that the merely pretty poses to serious art.

We see just how serious an artist Cassatt could be from a handful of pictures: *The Boating Party* (1894), for example, in which the familiar theme of a child in arms is artistically transformed by Cassatt's astringent yellows and blues and the way she both flattens out the picture's images and introduces a bold foreshortening in the rower's back and left oar. It is interesting to compare the handful of portraits Cassatt did of men—there are a few of her brother Alexander included here—with those she did of women. They are generally affectionate, always competent, but they somehow lack depth and that final element of empathy that imbues a portrait with vitality. Cassatt's portraits of women and of women with children vary widely in quality. Probably the best—the one that comes within close shouting distance of the one that Degas made of her—is *Portrait of a Lady* (1878), a remarkable portrait of her mother reading a newspaper. This symphony of whites and ochres highlighted with touches of red and black is a masterpiece of character observation that tells us as much about the unsentimental core of the artist who painted it as it does about the toughness of the subject it reveals.

1998

Matisse in Morocco

I F YOU HAD any doubts about irises, the paintings of irises that Henri Matisse did in 1912 and 1913 while visiting Morocco will settle them for good. The same goes for calla lilies, mimosas, and baskets of oranges—to say nothing of the Casbah in Tangier, the view from Matisse's window at the Hôtel Villa de France, and the dusky blues, taupes, pinks, and greens that he unveiled to register these scenes. About the inhabitants of Tangier some doubts may linger, even if a few of Matisse's portraits of a Moroccan woman named Zorah approach the breathtaking allure of his landscapes and still lifes.

"Breathtaking" and other superlatives came easily when contemplating "Matisse in Morocco: The Paintings and Drawings 1912–1913", the traveling exhibition that made stops at the National Gallery in Washington, D.C., the Museum of Modern Art in New York, as well as at the State Pushkin Museum and the Hermitage in Russia in 1990–1991. Though relatively modest, comprising twenty-odd paintings and about sixty drawings, the exhibition inspired a tendency to gush. For one thing, it contained several masterpieces that have not been seen in the West since Matisse's Russian patrons, Ivan I. Morosov and

Sergei I. Shchukin, acquired them in the Teens. Then, too, "Matisse in Morocco" marks a signal moment in Matisse's development. Some see in Matisse's Moroccan paintings the end of his Fauvist period; others regard them as the culmination of tendencies that first crystallized in Fauvism. But there can be little doubt that the experience of Morocco was, as the Matisse scholar Pierre Schneider notes in the title of his catalogue essay, a "hinge" for Matisse's aesthetic development.

It was at this period that the painter whom Clement Greenberg later called "the brush-wielder and paint manipulator *par excellence*" turned decisively toward the refined and highly sensuous palette that was to dominate his canvases in the succeeding decades. John Elderfield comments in his catalogue essay, "Matisse in Morocco: An Interpretive Guide," that "Fauvism had begun as a way of responding more directly to nature, but turned out to have withdrawn Matisse from nature." Morocco provided him with both a sense of immediacy before nature and the occasion for heightened aesthetic refinement.

Although the term is freighted with all manner of ambiguous (not to say undesirable) resonances, we may also say that Matisse's paintings become more luxuriantly *decorative* as a result of his exposure to Morocco. But it is a luxury of composition and color, not detail. The Moroccan paintings are in fact great acts of distillation in which subject matter is absorbed ever more fully into what are essentially painterly ends. Matisse's colors become at once drier and more complex—more Southern—as primary colors gave way to blotted pastels. He begins applying pigment in thin washes that give his canvases an air of translucence.

In 1941, Matisse wrote that "the chief goal of my work

is the clarity of light." The intense, pearly light of Morocco was a great source of the illumination that Matisse drew on in pursuing that goal. "The trips to Morocco," he later recalled, "helped me to accomplish the necessary transition and enabled me to renew closer contact with nature than the application of a living but somewhat limited theory such as Fauvism had turned into had made it possible." Always an inveterate traveller, Matisse had considered going to Morocco in 1906 when he had been in Algiers. But it was not until January 1912, when he was in his early forties, that he first went to Tangier. He stayed about three months, returning to France for six months in mid-April. He embarked on a second and final trip to Morocco the following October, staying until mid-February 1913. Schneider suggests that "It might be preferable to regard Matisse's Moroccan experience not as consisting of two trips, but as one voyage interrupted by a parenthesis of five months in France." And indeed whatever differences one can discern among the paintings executed on the two trips, the similarities they exhibit are more profound.

The revelation that "Matisse in Morocco" was for us may have something to do with the revelation that Morocco itself was for Matisse. He arrived in the rainy season, and his correspondence is filled with despondent reports on the unending rain. "Shall we ever see the sun in Morocco?" he plaintively asked Gertrude Stein in a postcard. "Since Monday at three, when we arrived, until today, Saturday, it has rained continuously. . . . It's impossible to leave our room." We owe a substantial debt to that Moroccan rain, however. For while it corralled a Matisse impatient for the fabled glories of the Moroccan sun, it was the occasion of *Le Vase d'iris* (1912), which was purchased by Shchukin and is now at the Hermitage. If this

still life is one of the great paintings in the exhibition, it is also one of the most unusual. The palette—with its browns and blues and cobalt grays—is uncharacteristically somber.

The weeks of rain seem also to have concentrated Matisse's powers. When the sun finally broke through, he enjoyed a tremendous burst of productivity. The half dozen portraits Matisse painted in Morocco are themselves extraordinary pictures; but the *aesthetic* essence of his Moroccan experience—the play of light, the aggressive simplification of form—seems epitomized most fully in the still lifes and landscapes. The still lifes, especially the pictures of flowers, possess a simply mesmerizing lushness; they are perhaps the most straightforward and sensuously pleasing paintings in the exhibition. Yet it is in a handful of landscapes that Matisse really outdid himself. Perhaps the single greatest painting in the exhibition is his depiction of the Casbah Gate, which Matisse probably painted on his second trip to Tangier and which is now in the State Pushkin Museum in Moscow. The picture is a perfect harmony of blues and greens offset by a bold strip of buffed brownish-red running from the lower right of the picture. *Porte de la Casbah*, the right wing of the so-called Moroccan triptych—the other panels being *Paysage vu d'une fenêtre* (which forms the left wing) and *Sur la terrasse*—manages to communicate both the relentless heat of the Moroccan sun and the oases of coolness in the shadows beside the gate.

A very different masterpiece that grew out of Matisse's Moroccan experience is the Museum of Modern Art's large abstract canvas called *Les Morocains*, which was painted in 1915–16 as a kind of "souvenir" of Morocco. Closely related to a painting called *Café morocain*, the largest and most abstract of the paintings Matisse did in Morocco and

which, unfortunately, is on view only in Leningrad, *Les
Morocains* is an abstract recapitulation of a typical
Moroccan scene. It depicts, as Matisse wrote in a letter
describing the picture, "the terrace of a small café with the
languid idlers chatting toward the end of the day." *Les
Morocains* is important not only as an instance of
Matisse's move toward increasing abstraction but also, as
Schneider points out, as "the first instance of Matisse's
practice of using memory as a laboratory for decanting
reality into abstraction."

OF THE MANY art historical issues that "Matisse in
Morocco" raises, one of the most complex concerns the
question of what the catalogue calls "orientality": the ex-
tent to which Matisse's Moroccan paintings represent a
turn away from Western art toward Asian and Islamic in-
fluences. We know that Matisse had long been influenced
by Muslim art, especially its decorative textiles and
ceramics. An exhibition of Muslim art in Munich in 1910
made a deep impression on him and his tour of Moorish
monuments in Spain helped make up his mind to visit
Morocco. "Revelation thus came to me from the Orient,"
Matisse recalled in 1947.

But it is one of the chief accomplishments of John
Elderfield's highly accomplished catalogue essay to have
pointed out the extent to which Matisse's Moroccan period
really represents a return from the exoticism of oriental art
to a new commitment to the fundamental formal concerns
of European painting. For despite the subject matter of
Matisse's Moroccan painting, his increasing concentration
on aesthetic issues—especially color patterns and composi-
tional "flatness"—underscores a characteristically Euro-
pean pursuit of artistic autonomy. In other words, Matisse

appropriates exotic subject matter as a felicitous occasion for aesthetic exploration. In this sense, Elderfield argues, Matisse's Moroccan experience marked the end of his exploration of non-European art and a "reengagement with topical European culture in the so-called experimental period that followed." Hence, Elderfield concludes, though the exotic may be said to show itself again in "domesticated" form in his Nice period (1916–1930), the encounter with Morocco basically signals "the end of the exotic" in Matisse's art.

In the United States, "Matisse in Morocco" was far better served at the National Gallery than at the Museum of Modern Art. Both museums felt an unaccountable obligation to tart up the exhibition with some atmospheric props: a few horseshoe arches, a bit of exotic flora at the entrance. But the National Gallery did much better by the works of art, especially the paintings, which were hung closely together in three relatively small and warmly lighted galleries in the East Building. (At both museums, the drawings were given a large room of their own at the beginning of the exhibition, but, in truth, they were pretty much overpowered by the paintings.) The Museum of Modern Art, by contrast, hung all but one of the paintings (*Les Morocains*) in two large, box-like and anonymous-feeling galleries. This effectively cancelled the ensemble effect that had been achieved in Washington: the feeling that these paintings were deeply related to one another and belonged together. The paintings survived in New York—one has the feeling they would look stunning even in a basement—but the exhibition seemed less coherent and less intimate than it had at the National Gallery. But perhaps one shouldn't complain: "Matisse in Morocco" may have been poorly installed, but at least the museum had given us

a collection of masterpieces and a thoughtful, well-written catalogue. What was up in those same galleries as I wrote this essay was the widely denounced exhibition "High and Low: Modern Art and Popular Culture," an exhibition that travesties modern art and panders to popular culture. It was enough to drive one to Tangier.

1990

Thomas Eakins in London

THE UNITED STATES has had little problem exporting McDonald's hamburgers, MTV, and Madonna; it has not always done so well with its best artists. Consider Thomas Eakins. Born in Philadelphia in 1844, Eakins is one of America's few indisputably great painters. His friend Walt Whitman insisted that he was not so much a painter as a "force" (high praise from the cosmic bard). Today, many critics conclude that his later portraits—searingly frank yet also gentle, respectful, affirmative—have earned him a place alongside such nineteenth-century masters of psychological realism as Courbet, Manet, and Degas.

Eakins died in 1916. But to date only one of his works has found its way into a foreign collection (a portrait called *Clara* is in the Musée d'Orsay in Paris). It is even more surprising to learn that "Thomas Eakins and the Heart of American Life," which was on view in London at the National Portrait Gallery in 1992, was the first exhibition devoted to his work outside the U.S..

Despite the omission of some important paintings—the two most notable being *The Swimming Hole* (c. 1883) and *Portrait of Dr. Gross (The Gross Clinic)* (1875)—the fifty-

nine works in the London show provided a good overview of Eakins's development. The exhibition opened with some student work: a strikingly accomplished perspective drawing of a lathe that Eakins did in his last year at Philadelphia's famed Central High School and a few painstaking anatomical studies; it concludes with a handful of experiments in photographic portraiture. (In later years, Eakins did pioneering research in serial photography.)

Bracketing the main body of the exhibition, these works usefully remind us of Eakins's lifelong devotion to anatomical science and the laws of optical representation. If it was insight and intuition that made Eakins a great artist, it was a passion for exactness and technical precision that allowed him to realize his intuitions on canvas and in the darkroom. It is no accident that some of his most famous pictures are of men of science, especially surgeons.

Like all genuinely original artists, Eakins was deeply traditional. That is to say, his originality issued from his fertile assimilation of certain artistic conventions and techniques. In 1866, after studying briefly at the Pennsylvania Academy of Fine Arts, Eakins departed for Paris, where he studied with Jean-Léon Gérôme at the Ecole des Beaux Arts. Excursions to Madrid and Seville brought him into contact with the work of Velázquez and Ribera, the two old masters whose tenebrist palettes and unflinching exploration of character most decisively influenced the aesthetic temperature of his work.

Because Europe was the inescapable source of artistic tradition in the 1860s, Eakins apprenticed in Paris. But unlike such popular society portraitists as John Singer Sargent, who became a professional expatriate in London, Eakins found his vocation as a distinctively American

painter. "If America is to produce great painters," he wrote late in life, young artists should "remain in America to peer deeper into the heart of American life." In 1870, Eakins returned to Philadelphia, never to set foot in Europe again.

It was in the matter of peering "deeper into the heart" that Eakins differed most profoundly from painters like Sargent and William Merritt Chase, whose slick technique and tendency to flatter their clients made them both rich. Eakins never flattered his sitters. He preferred to explore the truth of what he saw, which is not to say that he did not discover beauty or dignity in his contemplation. Some of his portraits—*Maud Cook* (1895), for example—are positively ravishing; none lacks dignity.

Yet the critic who observed that Eakins was an "annihilator of vanity" was right. Even when he preserves a facade, Eakins glimpses the human melancholy behind it. Many clients complained that he made them look older than they were. In fact, Eakins painted very slowly and tended not to talk much while painting. This often lulled his sitters into a meditative repose, bereft of the rejuvenating sparkle that full attention brings. Some of his most penetrating portraits—of his wife in 1900, of the singer Edith Mahon (1904), of his friend Amelia Van Buren (*c.* 1891)—discreetly exploit tokens of aging to suggest the pathos of mortality.

All this made Eakins a specialty taste. Although respected by other artists and a handful of critics, he never had a wide following. Consequently, many of his portraits are of friends, family, or students. There was also some mild scandal. In 1885, for example, when he was director of the Pennsylvania Academy of Fine Arts, Eakins sought to illustrate a point of anatomy by removing a loin cloth

from a male model in a mixed drawing class: he was promptly dismissed.

Nor did his unsentimental treatment of certain subjects recommend him to established taste. The surgeon's blood-spattered hand in *The Gross Clinic* led the squeamish jury to reject it for the Centennial Exhibition of 1876. It was finally sold to a medical school for the insulting sum of $200. In 1894, an embittered Eakins wrote that "My honors are misunderstanding, persecution, and neglect, enhanced because unsought." It was not until 1902, when he was in his mid-fifties, that he was finally invited to join the National Academy of Design.

In this context, it is instructive to contrast Eakins's portraits with those of such recent stars as Francis Bacon and Lucian Freud. Both happened to have small exhibitions of portraits up in London as I wrote. In a curious way such painters have become the Sargents of today: they are facile purveyors of expected images to the chic and well-connected.

The difference of course is that establishment taste is now cheerfully "anti-establishment." While Sargent idealized his subjects, Bacon and Freud diminish them. Bacon systematically smudges and distorts the faces of his sitters, Freud saddles them with a ghastly dermatological emergency. The announced intention of these procedures is greater honesty and psychological depth: they are supposed to be keys to authenticity, revealing humanity in all its wretchedness if not, indeed, its depravity. But the result is a dehumanizing art that depends for its effect on a handful of visual clichés.

How different things are with Eakins. When he was invited to join the National Academy of Design, Eakins painted a bust-length self-portrait as a "diploma picture."

Both his preparatory oil sketch and the finished portrait are included in this exhibition. The sketch, which Eakins completed in a single session, shows him head-on, half swallowed by shadows. Everything below the neck is lost in a scumbled darkness. The artist's face is full of weary sadness, resigned but unconquered.

In the finished portrait, Eakins brought himself forward into a warm, invigorating light and accoutered himself in coat and tie. His head is cocked to the right, his gaze is even, sure, assessing. The sadness is still there, but so is a dignified humanity. Such robust humanity is conspicuously missing in the work of Freud, Bacon and many others today. The reasons for this are no doubt many and complex, but we can be grateful that it perseveres in Eakins. As this fine exhibition demonstrates, Eakins's portraits tower above art-world fads: they are the real thing, a permanent cultural possession and sustaining inspiration.

1993

Paul Klee

IS PAUL KLEE one of the greatest artists of the twentieth century? One has tended to assume as much, habitually placing the Swiss-born artist in the company of Matisse, Kandinsky, Picasso, Miró, and the half dozen other artists whose achievements constitute the vital center of modern art. A huge touring retrospective of Klee's work in 1987 offered an apt occasion to reconsider that assumption. Having opened at the Museum of Modern Art in New York, the exhibition was also seen at the Cleveland Museum and ended with a stint at the Kunstmuseum Bern in Switzerland.

Organized by Carolyn Lanchner, curator in the department of painting and sculpture at the Museum of Modern Art, the retrospective was nothing if not comprehensive. Including some three hundred of Klee's paintings, etchings, drawings, and collages, many rarely seen outside Switzerland, it generously represents every stage of the artist's career—indeed, it may be said to represent more than his career, since it also includes several examples of Klee's juvenilia, whose charm is clearly more historical or biographical than aesthetic.

Klee was born near Bern in 1879. Both his parents were

musicians, and Klee himself displayed considerable musical talent—as well as prodigious skill as a draughtsman—from an early age. He had even contemplated a career in music, but by the late 1890s had settled his vocation, throwing himself with rare determination into art. In 1898, he moved to Munich, where the following year he met the pianist Lily Stumpf, whom he married in 1906. Klee's art began to attract considerable public attention after 1911 when he met Wassily Kandinsky and Franz Marc and became affiliated with the Blaue Reiter group. Together with Cubism—especially the sensuous, rhythmically colorful Cubism of Robert Delauney—the abstract spiritualism of the Blaue Reiter was perhaps the greatest contemporary influence on Klee's mature work. In 1920, Klee joined the Bauhaus at Weimar at the invitation of Walter Gropius, teaching there until 1931 when he accepted an appointment at the Düsseldorf Art Academy. His tenure at Düsseldorf was cut short by the ascension of Hitler in 1933; Klee soon found himself branded a "decadent" artist and was dismissed from the faculty. Shortly thereafter he moved to Bern with his wife, where he lived until his death from a debilitating skin disease, scleroderma, in 1940.

Klee's wit, his edifying—and voluminous—writings on artistic creativity and spontaneity, his interest in the occult, and the urbane literary references with which he was wont to load his works have all helped make him an artist dear to the hearts of intellectuals. But as this exhibition reminds us, these same qualities invest much of his work with a rarefied, cerebral aspect that detracts from its aesthetic vigor. Too often one has the sense that, as Klee himself put it in his 1920 "Creative Credo," "the idea may be regarded as primary."

This is perhaps one reason why Klee's early etchings and

drawings—in which his wit was largely unencumbered by theory—are among his most successful, if not his most ambitious, works. One thinks, for example, of his 1906 etching *Two Men Meet, Each Believing the Other to Be of Higher Rank*, which is as exquisitely satirical as its title suggests, and his series of etchings for *Candide* (1911–12), which are perhaps the most witty and insightful illustrations that Voltaire's melancholy comedy has yet received. But the truth is that this illustrational impulse also marks an important limitation in Klee's art. It was seldom that he could manage to free himself from illustration, even if (to quote again from his "Creative Credo") the subject of his illustration increasingly was the nebulous "reality that is behind visible things."

Many critics have rhapsodized about the strength of Klee's line; there is indeed something calligraphic, almost hieroglyphic, about the way Klee draws. When everything works—as it does, marvellously, in the well known *Tree Nursery* (1929)—the effect is indeed magical. In fact, though, many of Klee's best works are resolutely more painterly than linear. For example, the 1929 paintings *Fire at Evening* and *In the Current Six Thresholds* are surely among his most beautiful creations. And here what matters is not Klee's line but his sense of rhythm and instinct for balancing mass and color, an instinct culled in part from Delauney.

BUT FEW OF KLEE'S WORKS achieve this level of aesthetic excellence. And it must be said that many of Klee's most famous works—*Actor's Mask* (1924), *Cat and Bird* (1928), *Mask of Fear* (1932), and *Arab Song* (1932), for example—emerged from the exhibition sharply diminished, hardly stronger than the ubiquitous poster-images in which

they have been enshrined. The same, alas, must be said of the celebrated *Ad Parnassum* (1932), often considered one of Klee's greatest masterpieces.

In part, this is because so many of Klee's signature tricks and techniques have been absorbed into the vocabulary of modern advertising, graphic design, and illustration; walking through the exhibition, one at times felt, anachronistically, that one was viewing the work of a talented disciple of Saul Steinberg. Then, too, there is the question of taste—a faculty that was always uncertain in Klee and one that deteriorated markedly in his last years; consider, for example, *Landscape with Two Who Are Lost* (1938), where the inept drawing and clumsy placement of the figures seriously mars the entire composition. In general, Klee's work from the late Thirties is, as Clement Greenberg observed, "extremely disappointing"—a judgment that the great number of works on view in the exhibition from this period unconditionally confirms.

Like the exhibition itself, the accompanying catalogue is handsomely produced, but is in the end a disappointing affair. Ms. Lanchner's own essay on "Klee in America" is no doubt the most accomplished of the volume's four pieces; it traces with scholarly competence the pioneering efforts of figures like Alfred H. Barr, Katherine Dreier, and Emmy Scheyer to spark interest in Klee's art in the United States in the Twenties. Unfortunately, the catalogue's lead essay, "Klee and the Avant Garde: 1912–1940," is rather a pedestrian attempt to review the connections between Klee's art and various "advanced" artistic trends, notably Dada and Surrealism, while the disquisition on "Klee and German Romanticism" succeeds mostly in embroidering both with a ponderous, pedantic academicism.

Yet by far the most egregious contribution to the

catalogue is O. K. Werckmeister's manifesto "From Revolution to Exile," the main purpose of which is to enlist Klee as a *bien-pensant* leftist and anti-fascist crusader. To this end Professor Werckmeister scrutinizes Klee's use of the term "revolution" in his correspondence and titles, informs us that his droll 1905 etching *Aged Phoenix* "personifies the revolution aborted," and offers us an interpretation of *Revolution of the Viaduct,* a whimsical 1937 oil portraying a dozen arches marching, as an anti-Nazi statement. About the aesthetic substance of Klee's art there is nary a murmur; instead, we are treated to observations like this: "By projecting into the historical perspective of eternity the modern artist's imaginary triumph over the dictator who had just come to power, Klee retracts such a triumph into the hypothetical." One has of course grown accustomed to this sort of opaque, politicized drivel—regrettably, it has become the staple of much academic art criticism these days—but practiced on an artist as essentially private and apolitical as Paul Klee, the result is absurd. It is perhaps also worth pondering what it means that the Museum of Modern Art should countenance—if not, indeed, encourage—the inclusion of such blatantly politicized screeds in its official exhibition publications.

IN HER INTRODUCTION to the catalogue, Ms. Lanchner tells us that the "principal goal" of the retrospective and catalogue is "to clarify Klee's place in the history of modernism." In this, she and her colleagues have in large part succeeded—though not perhaps in quite the exalted way they intended. One need only consider the way the term "intimate" has habitually been employed to characterize Klee's art. Already in 1941, Clement Greenberg spoke of the "intimate atmosphere" and "generally small

format" of Klee's work. It is, Greenberg wrote, an "extremely personal," even a "provincial," art—qualities he saw as contributing greatly to its appeal, but at the same time limiting its scope. Similarly, Klee's relentless wit and sense of irony undoubtedly helped rescue his art from what would otherwise have been a stultifying intellectual solemnity; but they also tend to rob it of dignity, softening, one might say, even as they lighten. Ms. Lanchner and many others would have us view Klee as an artistic giant and "index of the century." But as her ambitious retrospective makes abundantly clear, Klee's talent was a smaller, more circumscribed possession. He was, to adapt W. H. Auden's excellent category, a major minor artist—no small thing, certainly, but not everything either.

1987

Kazimir Malevich

O F THE GREAT PIONEERS of abstract art in the early
twentieth century, Kazimir Malevich may be said to
have embodied more fully than anyone the conflicting
imperatives of the moment. Kandinsky and Mondrian both
may finally have been more important artists, but Malevich
was in some ways the more typical. The intoxicating com-
bination of revolutionary politics, occult spiritualist
ruminations, and radical artistic experimentation that
accompanied the development of abstract art found an
especially congenial host in Malevich.

The retrospective exhibition that opened at the National
Gallery in Washington, D.C. in 1990 was far and away the
most comprehensive showing of Malevich's work ever
mounted in the United States. Based on an exhibition that
made the rounds in the former Soviet Union and Amster-
dam in 1989, "Kazimir Malevich, 1878–1935" included
170 oil paintings, works on paper, and architectural
models from collections in Europe, America, and the
former Soviet Union.

While it lacked a few important paintings, this well-
selected exhibition provided a generous sampling of works
from every period of the Russian artist's mature career. It

traced the circle of Malevich's development from con-
firmed naturalist to ardent Cubist to proselytizing abstrac-
tionist and back, in the late '20s and early '30s when
Socialist Realism was regnant, to a quirky, sardonic
naturalism.

Malevich is probably most famous for his radically
abstract paintings, especially for the notorious paintings
Black Square and *White Square*, which took painting to a
limit of simplicity and abstractness that in many respects
has never been surpassed. But like most important Russian
painters at the turn of the century, he was deeply in-
fluenced by Post-Impressionist French art.

The gallery devoted to his early work is provides a
veritable catalogue of French influences. The fauvist color
of Matisse, the compositional innovations of late Cézanne,
the idealizing flatness of Puvis de Chavannes, the exotic
rawness of Gauguin: they are taken up one after the next
by Malevich—though always with a distinctively Russian
inflection. If Malevich's early work lacks the elegance of
his French influences, it displays the robust, earthy ex-
uberance characteristic of Russian folk art, another abiding
influence on his work.

Many of these early works are extremely accomplished,
quite daring even in their indebtedness. But Malevich does
not really come into his own until after 1910. His associa-
tion with the vanguard artists Natalia Goncharova and
Mikhail Larionov in Moscow began around that time, as
did his encounter with Cubism. Some of Malevich's Cubist
paintings from the Teens that are on view here are ex-
traordinary works. For example, *Knife-Grinder/Principle
of Flickering* (1912) and *In the Grand Hotel* (1913) are
truly great paintings, as exquisitely poised and balanced as
anything Picasso or Braque did. Another impressive pic-

ture, *An Englishman in Moscow* (1914), has the additional virtue of being extremely witty—a quality not generally in great evidence in Malevich's art or pronouncements.

By 1914, Malevich had more or less abandoned Cubism (or "cubo-futurism," as he liked to call it) for the radically non-representational art he dubbed Suprematism. In December 1915 he exhibited thirty-nine totally abstract works in a landmark show called "0.10. The Last Futurist Exhibition." Several of these works (somewhat yellowed with age) are on view here and, even though geometric abstraction has become as familiar as apple pie, they still seem strikingly fresh and original.

Malevich praised modern art for having divested itself "of the ballast of religious and political ideas which had been imposed upon it," but he seems to have been as eager as anyone to burden art with political and religious "ballast." Indeed, in addition to art, Malevich's ruling passions were politics and spiritualism. The former made him a naive and enthusiastic partisan of the Revolution and "collectivity" in art, the latter led him to treat—or at least talk about—Suprematism as an instrument of achieving "the blissful sense of liberating nonobjectivity," the "white state of mind," he identified with salvation.

Malevich was forced to recognize some of the consequences of these passions when Stalin began his campaign against modernist art. He was summarily relieved of employment, interrogated, and tyrannized into abandoning abstract art. There was little place for "liberating nonobjectivity" in the world of Socialist Realism. Some of Malevich's late works—faceless peasant figures suspended in an anonymous space—are grim tokens of the brutalizing political system he had been cheering on only a few years before.

THERE ARE SEVERAL LESSONS that may be adduced from this panoramic exhibition. One concerns politics. Like many artists—as much now as in the Teens and '20s—Malevich enthusiastically embraced the slogans and surrendered to the euphoria of revolutionary politics. Perhaps his frenetic artistic collaborations of the early 1920s suggest that politics can sometimes have a quickening influence on art; the censorship and indignities that Malevich later suffered certainly stand as a warning against enlisting art as a servant of politics.

A second lesson concerns what we might call the theosophical aspirations of Malevich's art. I suspect that the occultist rhetoric with which he embellished his pursuit of artistic abstraction was partly just that: rhetoric, designed more to garner attention than to solicit belief.

Yet there can be no doubt that Malevich—like Kandinsky, Mondrian, and indeed like most other pioneers of abstract art—invested his art with an earnest load of spiritualist ambition, however nebulous. The "blissful sense of liberating nonobjectivity" that he discerned in those white squares was central to both the emotional and the intellectual climate out of which abstract art developed in the opening decades of this century. Similar occultist sentiments abound in the pronouncements of later abstract artists, from Mark Rothko to Barnett Newman.

But it is not at all clear that the potpourri of spiritualist doctrines that embroider abstract art are also central to its distinctively *aesthetic* achievements. My own sense is that, whatever personal investment artists may have in the occult, their primary claim on our attention has always been an artistic claim: we care chiefly about the beauty of their art, not its theology.

Spiritualism was undoubtedly a catalyst for Malevich, as

it was for many others. Revolutionary politics provided him—for a few years, anyway—with a rallying cry. But Malevich's art continues to speak to us not as a disguised spiritualist catechism, still less as a goad for social reform. Like all important art, his best works—above all, the abstract paintings and pencil drawings from the Teens— speak to us because they are beautiful. This, in fact, is one of the main virtues of this memorable exhibition: to remind us that beauty—not mysticism, not revolution— remains the fundamental touchstone of art.

1990

Alberto Giacometti

P AUL VALÉRY once remarked that a poem is never finished, only abandoned. It would be difficult to name an idea more characteristic of Romanticism. With the advent of Modernism, what changed was the mood, not the situation: incompleteness more and more became the end as well as the condition of artistic creativity.

The work of the Swiss-born sculptor and painter Alberto Giacometti (1901–1966) is a case in point. In his mature years, anyway, hardly any work of art left his studio in a state he considered finished. "That's the terrible thing," he confessed late in life: "the more one works on a picture, the more impossible it becomes to finish it." A painting or sculpture would be started, labored over, abandoned, picked up again, given up in despair, suddenly rediscovered, just as suddenly put down. As one critic observed, "Giacometti made a whole art out of pentimenti." Only time and the exigencies of exhibition schedules called a halt to the process. It is curious, therefore, that "likeness" was ever the name of Giacometti's artistic desire. Again and again he insisted that all he wanted to do was to "copy" what he saw: "to give," as he told one critic, "the nearest possible sensation to that felt at the sight of the subject."

As this well-chosen and sensitively installed overview of Giacometti's work at Montreal's Museum of Fine Arts showed, he was not talking about producing snapshots. In fact, Giacometti was an accomplished natural draughtsman. Some of his early work proves that he was well able to turn out traditional, academically accomplished representations. But the effort to achieve "likeness," to capture the sensation that the visible inspires, involved something more, something different. Achieving "likeness" was for Giacometti a struggle of Sisyphean dimensions: ineluctable and unending, a process as imperative in its demands as it was elusive in its fulfillments.

The struggle is evident throughout Giacometti's signature work. In sculpture, one thinks above all of the haunting elongated figures: the walking men, the women standing at hieratic attention. These painstakingly molded and remolded figures—some over-life-sized, many no more than an inch tall—are bulletins from an emergency, expressive souvenirs snatched from a pool of silence, nudged into articulate presence by the sculptor's dexterity. The works not only bear the scars of their creation: they also seem to exist fully only in the evidences of those scars.

Something similar can be said of Giacometti's portraits. They are not easy works. Dark and full of occlusions, they are like stage sets upon which the sitter's humanity is patiently coaxed to reveal itself. In some ways, Giacometti's method is like that of a stone rubbing. The quick scratchings of his brush or pencil register the hard cavities and reliefs of the sitter's features—and what lies behind the features. Hence the ambivalence or ambiguity of Giacometti's portraits. The artist's markings are gestures of effacement that also serve as opportunities for revelation. Giacometti's deftness in this regard is perhaps most clearly

seen in his simplest portraits: his quick pencil portrait of Matisse (1954), for example, or his late etching of Rimbaud (1962), in which the poet's countenance suddenly crystallizes from a skein-like tangle of lines.

The eldest son of a successful painter, Giacometti was brought up in the Val Bregalia in south-eastern Switzerland near Italy. His artistic interests blossomed early and were encouraged by his family. In 1922, Giacometti went to Paris where he studied at the Grand Chaumière with Antoine Bourdelle, a successful, somewhat pompous student of Rodin. Whatever Bourdelle had to teach him, the young sculptor clearly owed much more to Brancusi, Lipchitz, and Henri Laurens, as well as to Cézanne and Cubism.

Like many of his contemporaries, Giacometti was also deeply impressed by the expressive simplicities of African and Oceanic art. The works with which he first came to notice—e.g., *Spoon Woman* (1925–27), *The Couple* (1926), *Torso* (1925)—are primitivist fantasies inflected by Cubism. As with many of Giacometti's sculptures, these early pieces come with halos of allegory. They seem like displaced relics from exotic, half-remembered ceremonies: dark and often unpleasantly sexual.

It was of course this element in Giacometti's work—its adumbration of violence and sexuality—that attracted the attention of the Surrealists. In 1930, Giacometti met Louis Aragon, Salvador Dalí, and the Surrealists' chief minister of propaganda, André Breton. For three or four years, he was a conspicuous member of their circle, producing—if the phrase is not an oxymoron—several Surrealist classics, including *Suspended Ball* (1930), *No More Play* (1932), *The Palace at 4 a.m.* (1932), and *Disagreeable Object to be Thrown Away* (1931).

Surrealist art works—when it works—by conveying sug-

gestions of significance that never quite snap into focus. Most surrealist art depends heavily on the existence of widely shared conventions—moral and social as well as artistic conventions—which it then regularly and predictably violates. The expected frisson comes as much from the counter-pressure of convention as from the violation. This is one reason that most Surrealism quickly becomes boring. The works that Giacometti produced in his Surrealist phase have had such a long shelf-life precisely because their primary interest is visual, not ideological. Whatever erotic or "transgressive" charge they may have, it is their striking formal presence—their presence as made objects—that accounts for their chief hold on our attention.

Giacometti soon parted company with the Surrealists—his return to sculpting heads from a live model was unforgivable apostasy to Breton—and later referred to his years in their camp as a "transitional exercise" and a "Babylonian captivity." But his art continued to be fodder for extra-artistic ideologies. The most important of these was undoubtedly Existentialism. This association was codified as dogma—or cliché—in 1948 when Sartre wrote an essay called "The Search for the Absolute" to accompany an exhibition of Giacometti's work in New York.

In truth, just as there was much about Giacometti that invited appropriation by Breton and the Surrealists, so there was much that invited his association with the gloomy histrionics of Existentialism. "If I were true to myself," Giacometti once said, "I'd bury all my sculptures so that they wouldn't be found for a thousand years." Naturally, such statements were catnip to writers like Sartre, who were bent on elevating human futility into a badge of moral heroism. In the end, however, Existentialism, like Surrealism, has been more of a distraction

than an illumination when it comes to Giacometti's art. In part, this is because his art is simply too complex to function easily as an illustration of any "philosophy of life." There is also the fact that, as Giacometti's biographer James Lord noted, "Seeing, not believing, is what he cared about."

One was reminded of this again and again as one made one's way through the elegant galleries of Moshe Safdie's addition to Montreal's Museum of Fine Arts. They provided the perfect backdrop for Giacometti's art: cool and self-effacing, these barrel-vaulted pavilions have exactly the right expressive neutrality for his crisp species of Modernist art. Giacometti is clearly an artist who inspires a great deal of thought. So it is hardly surprising that many of his more vocal enthusiasts have been blinded by their own ideas from attending to the much more engaging objects that Giacometti has made for them to see. This splendid exhibition (if not, alas, the lackluster catalogue accompanying it) provides an excellent opportunity to redress the balance.

1998

Picasso as Portraitist

WHAT MORE CAN ONE SAY about Picasso? Long before his death in 1972, he had passed into the realm of hyperbole. The extraordinary talent, the unstoppable energy, the prodigious, amazingly protean output: all have been memorialized—by enemies as well as admirers—a thousand times, as indeed have the megalomania, the erotic fury, and the misanthropy that are also signature Picasso commodities.

Yet the commentaries, especially the tributes, have continued. William Rubin, who organized both the mammoth 1980 Picasso retrospective and a 1989 exhibition of Picasso and Georges Braque's Cubist innovations for the Museum of Modern Art, returned again to Picasso in 1996, this time to assay Picasso's lifelong confrontation with portraiture.

Mr. Rubin assembled 221 objects for this exhibition at MOMA, beginning with some portraits of Picasso's family and friends from the 1890s and ending with a selection of self-portraits. The bulk of the exhibition was grouped according to what was the chief "external" organizing principle of Picasso's art, his women: two wives and a succession of mistresses. (One of his mistresses, the photogra-

pher Dora Maar, famously observed that when Picasso changed mistresses, he changed everything, including his style of painting.) Along the way, there were tender, often sentimental portraits of his children, and numerous pictures of friends and acquaintances, including the art dealers Ambroise Vollard, Wilhelm Uhde, and Daniel-Henry Kahnweiler, the writers Max Jacob, Paul Eluard, and Guillaume Apollinaire, and the famous 1906 portrait of Gertrude Stein, which was one of the highlights of the exhibition.

Although less than a quarter the size of the 1980 retrospective, "Picasso and Portraiture" seemed very big indeed. It contained a handful of delightful items. Picasso was a master caricaturist—it may have been his greatest artistic endowment—and some of his dashed-off caricatures (of Apollinaire, for example) are extremely droll. Then, too, some of the early, pre-Cubist portraits are haunting, as, in a different register, are some of the self-portraits.

Nevertheless, this exhibition was a serious disappointment, and it is interesting to ask oneself why. It is impossible to see any number of Picasso's works without being impressed by the display of raw artistic talent. Whether he was the greatest draughtsman since Leonardo, as Mr. Rubin suggests, is open to doubt. But no one can doubt that he was dazzlingly proficient as well as stunningly original. Looking back on Picasso's work, however, the interesting question arises whether talent and originality—often thought to be the very marrow of artistic accomplishment—are themselves sufficient for achievement of the first rank. This exhibition reminded us that the answer must be "No."

Picasso himself was notoriously suspicious of virtuosity

—not least his own. He early on realized that it could be a trap, a prescription for superficiality, as well as a strength. The same is true of "style," which easily degenerates into mannerism when unenlivened by compelling experience. I believe that Mr. Rubin is right to suggest that Picasso's artistic restlessness—his endless search for innovation, and above all his embrace of radically simplifying pictorial devices (primitive art, Cubism, Brutalism)—stemmed largely from his effort to escape from the seductions of technical facility. The precipitousness with which he took up and discarded styles, however, may bespeak not creative abundance but the lack of an organizing center.

MANY CRITICS have commented on the aggressiveness that characterizes much of Picasso's work, in particular the distortions that he visits on the human form. "Obviously," he once noted with calculated melodrama, "nature has to exist so that we may rape it!" In fact, Picasso's art tends to oscillate between extremities of rage and a cloying sentimentality, both of which are abundantly present in his portraits. Often, indeed, some of the most furious pictures seem to be mere inversions of a highly sentimentalized counterpart, as if Picasso's fury were first of all the failure of sentimentality, sentimentality gone sour. The middle register, in which admiration and desire mingle to produce respect, is largely absent. This is especially true in his portraits of women. As his mistress Françoise Gilot reported, Picasso regarded women in one of two ways, as "goddesses" or as "doormats," with predictable results in his art as well as in his life.

In *Picasso's Mask* (1974), André Malraux spoke of the "never-ending war [that] Picasso picked with nature," a war that led him to reject the world of outward ap-

pearance and attempt to replace it with his own creations. "God is really another artist like me," he once said. "I am God, I am God, I am God." When such a god turns his hand to portraiture, the result is bound to be odd.

Dusting off a term from his old teacher Meyer Schapiro, Mr. Rubin spoke in this context of Picasso's "transformation" of the portrait. In the catalogue for the exhibition, he referred often to "conceptual" or "transformative" portraits, distinguishing them from the more traditional variety in which verisimilitude is high up on the list for success. Well, OK; but even Mr. Rubin notes that "defining what constitutes a 'portrait' in Picasso's work is not a simple matter." In what sense, for example, is the menacingly distorted assemblage *Seated Bather* a "portrait" of Olga Khokhlova, Picasso's first wife?

Mr. Rubin acknowledges that many of Picasso's portraits are "not at all 'portraits' in the received sense of the word." Indeed. But one then naturally wonders in what other sense they *are* portraits? Basically, Mr. Rubin offers two, somewhat opposing, suggestions. The first is that all of Picasso's portraits are really a species of self-portraiture. To support this, he reminds us that Picasso was fond of quoting Leonardo to the effect that "the artist always paints himself." It seems to me, though, that Leonardo is an unreliable source for understanding Picasso. For if he said that "the artist always paints himself," he also insisted that "that painting is most praiseworthy which is most like the thing represented"—a dictum that does not easily cohere with Picasso's more daring experiments.

Mr. Rubin's second suggestion is that Picasso, working in an age when photography began to compete with portraiture, helped to transform the portrait from an "objective" into a "subjective" enterprise—that is, one in

which the artist aims not to "memorialize" his subject but rather to express his "personal response to the subject." In this sense, he says, Picasso "redefined" the genre of portraiture in much the same way that Renaissance and Baroque artists redefined it in their own eras.

All this makes for a thicket of complications. It is certainly true that, as Mr. Rubin puts it, "the emergence of the transformed portrait subverted almost all of the assumptions on which the traditional portrait commission had been based." Yet Mr. Rubin, like many other critics, wishes to stress the centrality of the "human image" in Picasso's work. It is an image that is, often as not, distorted beyond recognition. What does that mean? I think Mr. Rubin is on safer ground when he suggests that, like the poet Stephane Mallarmé, Picasso aimed to describe "not the thing itself but the effect it produces." It would seem that for Picasso the effect produced was often distinctly unpleasant.

IT IS NO DOUBT unfortunate, but one of the first things that came to mind while looking at "Picasso and Portraiture" was Evelyn Waugh. Readers of Waugh's letters will remember that there was a time in the 1940s when he regularly included the exhortation "Death to Picasso!" as a kind of valedictory to cheer up—or to irritate—his correspondents. Naturally, Waugh spoke mostly in jest. But his campaign against Picasso—and by extension, all of modernism—had a serious as well as a philistine dimension. Waugh acknowledged Picasso's talent, especially his comic genius. What he objected to, finally, was Picasso's megalomania. His painting, especially his portraiture, is not so much a "transformation" of nature, as Mr. Rubin would have it, but a revenge exacted upon it for having the

effrontery to elude him. Many critics argue that Picasso's fury is an ineluctable reflection of the modern spirit. But there is much in his life and work that suggests that his violent distortions are less a *response* to modernity than the product of a willed dehumanization. Perhaps this is what Picasso meant when he said that people who liked his paintings "really had to be masochists."

1996

Fernand Léger

"THE MOTOR-CAR," Edith Wharton declared in 1908, "has restored the romance of travel." How things change! I thought of Wharton's comment—redolent with pleasures lost to us—as I made my way through an invigorating exhibition of paintings and drawings by Fernand Léger at the Museum of Modern Art in 1998. Léger's best work, executed from the Teens through the early 1940s, is full of the optimistic energy of high modernism. The critic and painter John Golding captured this quality in the title of his fine essay "Léger and the Heroism of Modern Life." "Never," Golding wrote, "has the poetry of the first machine age been so grandly and proudly exalted."

It was still OK for left-wing artists, like Léger, to regard science and technology as friends of mankind. Modern life may have been bright, noisy, vulgar, but it was unaccountably vital, which was unanswerable. "Beauty is everywhere," Léger observed in the 1920s, "in the arrangement of your pots and pans, on the white wall of your kitchen, more perhaps than in your eighteenth-century salon or in the official museum." One inhaled the smoke of a thousand cigarettes and felt nothing but cheerfulness: the health police had yet to blight that indulgence. The

airplane was marvellous, likewise the skyscraper and the electric light. At the touch of a finger, an elegant cut-glass siphon delivered sparkling water into a tumbler of Campari: happiness. Like Wharton's motor-car, these things infused everyday life with heady romance. It couldn't last. But while it did, it was as new and careless and intoxicating as youth itself. Léger was one of its chroniclers.

The last few decades have not been kind to Léger. There was a time, from the 1920s through the early 1940s, when he was regularly counted among the giants of French modernism, spoken of not perhaps as an equal to but nevertheless in the same breath as Picasso, Braque, Matisse, and the rest. Since his death in 1955, however, and especially in the last few decades, neglect has been slowly eating away at Léger's stature. Enthusiasm retreated to respect and then, occasionally, to unconcern. This exhibition, a larger version of which was on view in Paris and Madrid, refocuses attention on Léger's achievement and allows one to reconsider his place in the pantheon of modernist masters.

Although Léger began painting seriously in 1903 when he was 22, he first emerges *as* Léger around 1910. (The artist helped to designate his own beginning by destroying most of his juvenilia in 1908.) Léger's early works, well represented in this exhibition, are a cross between Cubism and a Boccioni-like Futurism. In paintings like *Nudes in a Forest* (1909–10), *The Wedding* (1911), and *The Smokers* (1911–12), Léger animates what are essentially Cubist compositions with a sense of movement and acceleration. The hapless critic Louis Vauxcelles, whose rage against modernist art gave us both "Cubism" (he referred dismissively to painting of "le petit cube") and "Fauvism," scored another, though less well-known, bull's eye when in

1911 he employed the term "tubism" to describe Léger's fondness for elongated cylindrical forms.

Vauxcelles was unreceptive but not unperceptive. He didn't like what he saw, but he observed clearly. There *was* something "wild" about the colors of Matisse circa 1906, just as "Cubism" now seems the inevitable term to describe those canvases by Picasso, Braque, and Picabia. Similarly, Vauxcelles picked up on something central in Léger's visual vocabulary. There is something "tubular" about his forms, from the early Cubist-inspired canvases of the Teens through the monumental tableaux of the 1920s through the late paintings of construction workers. It is as if in his effort to achieve compositional harmony Léger pressed harder and harder on the surface of his pictures. The result, especially in his work through the 1920s, is a dual sense of fullness and flatness, as if every square millimeter had been squeezed full of emotion.

"Contrast" was one of Léger's favorite words and ideas. It was, he thought, a quality that spoke to the essence of modernity. In *Contrast of Forms*, a series from the Teens, Léger exploited contrasts of form, shape, orientation, color, and texture to make some remarkably beguiling and animated abstract pictures. They are visual memoranda of Léger's experience of modern life: a chaos that is nevertheless a harmony. It is also worth remarking on the intricately nubbled texture of these paintings. For viewers who, like me, have tended to think of Léger as a painter primarily of hard-edged forms of almost billboard-like flatness, this exhibition will be something of a revelation. It shows that Léger was, as Carolyn Lanchner notes in her informative catalogue essay, "a painter in love with paint."

The exhibition is a revelation in other ways as well. Perhaps the first thing one notices about Léger is his humor.

"Deadpan" is the term that crops up again and again in reviews. And Léger's humor is deadpan. But it is also totally without calculation. In this, Léger's work is utterly unlike Pop art, with which it has sometimes been compared. Pop art is a species of marketing; Léger was after something deeper. He somehow managed to capture the incongruity that lurks wherever man troubles nature with his probings.

The son of a Normandy butcher, Léger was about as down-to-earth as a painter could be. And yet there is an almost metaphysical quality about his humor. It depended not on making jokes but revealing—as Léger himself might put it—certain essential contrasts: between, let us say, the way things are and the way we would like them to be. Léger had a special knack, a genius, even, for ferreting out and expressing such contrasts. Or perhaps "ferreting out" implies too much deliberation for insights that seemed entirely intuitive. In any event, such contrasts are what imbue even Léger's most abstract paintings with an air of inexplicable drollery. Sometimes the humor is deliberate, as in his Surrealistic spoof *Mona Lisa with Keys* (1930). In his greatest paintings—*The City* (1919), *Composition with Hand and Hats* (1927), and above all in *Three Women* (1921), his masterpiece—Léger manages to infuse the humor with a stateliness that verges on melancholy.

Léger grew into this special humor, gradually. He also gradually grew out of it. His greatest period is from 1919 through the 1930s. Some paintings from the early 1940s—the splendid *Gray Acrobats* from 1942–44, for example—still pulse with it. But as Léger grew older he somehow lost touch with his special well of feeling. He went through the motions, but, increasingly, there was something forced about his work: sad with yearning rather than accomplish-

ment. Clement Greenberg may have overstated it when he noted, in 1941, that "by force of repetition Léger's painting has become facile and empty, almost a matter of formula." Nevertheless, he discerned a tendency in Léger's work that would become more pronounced as the years went on.

1998

Mark Rothko

HAMLET: *Do you see yonder cloud that's almost in shape of a camel?*
POLONIUS: *By th' mass and 'tis—like a camel indeed.*
HAMLET: *Methinks it is like a weasel.*
POLONIUS: *It is backed like a weasel.*
HAMLET: *Or like a whale.*
POLONIUS: *Very like a whale.*

THE ONLY SURPRISING THING was how long it took: I was well into the third or fourth gallery at the big 1998 retrospective of Mark Rothko's painting and works on paper at the National Gallery in Washington, D.C., before the expected words floated up. "It's so . . . *spiritual,*" said one woman in hushed tones. "It's very Zen," agreed her companion, looking about reverently at the dark, abstract paintings.

Mark Rothko has always inspired a lot of spirit-talk: indeed, he assiduously cultivated it, and his death by suicide in 1970 added fuel to the fire. Rothko's signature paintings—which he started making around 1950—are closely modulated washes of color, one band hovering delicately on top of another. The best of them are

sumptuous symphonies of color. But they are symphonies of a Philip Glass variety: the execution is fastidious but the means are minimal. The effect, when it works, is hypnotic.

As this retrospective makes abundantly clear, Rothko's one real talent as a painter was as a colorist. His early representational work from the 1930s is partly embarrassing, partly just pedestrian. His "symbolic" abstractions from the 1940s—when the influence of Miró, Milton Avery, and de Chirico is written like a label on his work—is clumsy and forgettable. What Rothko could do, and do very well, was to balance one color against another to striking effect. He wrung a wide spectrum of emotion from his misty blues and greens and grays, his tense yellows and brooding reds.

That never seemed to be enough, though. Rothko famously denied that he was a colorist. But then he also denied that he was an abstract painter. This is one reason that people have always felt licensed to import their own little stories into Rothko's paintings. Rothko's best paintings are immensely, and immediately, likable. They are so popular because they are so easy. Their appeal—simple compositions that they are—is almost purely aesthetic: people respond to the pleasing color harmonies. Writing in 1955, the critic Clement Greenberg observed that Rothko was an artist whose work "asserts decorative elements and ideas in a pictorial context." The question such art raised, Greenberg noted, was "where the pictorial stops and decoration begins."

Of course, "decoration" and "decorative" are fearsome words for modern artists, especially modern abstract artists. They are diminishing words. They lack the gravitas one wishes to claim for one's art. From its very beginnings, in the early years of this century, abstract art has had a bad

conscience about the "merely" aesthetic. It has soothed that bad conscience with a rich and sometimes comic verbal filigree imputing all manner of religious, philosophical, and even political significance to its art. Mondrian's neo-Platonism, Kandinsky's theosophy, Malevich's geometrical mysticism: this is art that came armed with an alibi.

It is the same with Rothko. I won't say that more nonsense has been written about his art than about the art of the other Abstract Expressionists: the competition for that distinction is too ferocious for one to be confident about declaring a winner. But Rothko has certainly inspired a powerful lot of nonsense. Back in 1961 when the Museum of Modern Art mounted an exhibition of his work, the art historian Peter Selz provided a typically embarrassing essay for the catalogue. Rothko's paintings, he told his readers, "can be likened to annunciations," "the metaphor of the creation of some universe becomes paramount. . . . [T]hese 'shivering bars of light' assume a function similar to that loaded area between God's and Adam's fingers on the Sistine ceiling." And so on.

It would be interesting to know what Rothko thought about this when he first read it. We do know that he became incensed when the essay was brilliantly sent-up by the sculptor and art critic Sidney Geist in his short-lived art paper *Scrap*. Rothko demanded that Selz's essay be replaced when the exhibition traveled. But the truth is that Rothko's painting has continued to attract such silly religio-sentimental musing. Thus Professor Anna Chave, writing in *Mark Rothko: Subjects in Abstraction*, tells us that "those images of Rothko's that parallel the pictorial structure of a pietá, such as *White Band (Number 27)*, . . . might be said at the same time to parallel the structure of a conventional mother and child image."

Well, anything "might be said." The painting to which Anna Chave refers is included in the National Gallery's exhibition. It is a blue rectangle, 81 by 86 inches; in the center of the rectangle there floats a narrow gray-white band; above it sits a wider blue-gray band, below a band of charcoal-gray. You might say that it parallels "the pictorial structure of a pietá," but then you might say that it is almost like a camel, backed like a weasel, or very like a whale.

The catalogue accompanying this new retrospective is full of the same sort of thing. Item: "Whatever such speculations about the pre-tragic, Rothko, having abandoned the romantic aporias of the tragic, moved also to the only available post-tragic territory, the absurd." Indeed.

The National Gallery went to a lot of trouble with this exhibition. They produced an exquisite, if largely unreadable, catalogue, and took great care in the installation of the pictures. I very much doubt, however, that this exhibition will do anything to enhance Rothko's reputation. There are, to be sure, some marvelous pictures from the 1950s (the exhibition opens with one of the best, *No. 61*). But there are not as many success stories as one would like. And the long run up to those pictures everyone associates with the name "Rothko" is a big disappointment, as are the several extremely poor paintings with which the exhibition concludes.

Most of the really bad paintings are from the Rothko family collections, and their presence here makes one wonder whether a certain amount of attic-cleaning isn't going on. I should be very surprised if many of these pictures did not turn up on the art market soon after this exhibition concludes its tour and its effort to bolster Rothko's stock among collectors.

Enemies of abstract art generally assume that any given group of abstract pictures is pretty much the same and that it is bootless to pretend that one picture is better than another. One valuable lesson of this exhibition is to show how mistaken that view is: all you have to do is look. Rothko at his best was a deeply seductive painter. It is in the nature of seductions, however, that when they fail they leave their prey not indifferent but repelled.

1998

Part Three

The Whitney Biennial, 1997

S OME EXHIBITIONS are born bad; some achieve badness; and some have badness thrust upon them.

For as long as anyone can remember, the biennial exhibitions of recent American art at the Whitney Museum have somehow managed to be bad in every way possible: festering biopsies of American cultural pathology.

It was not always thus. When Gertrude Vanderbilt Whitney, the museum's founder, began an annual series of such exhibitions in 1932, soon after the museum opened, the result was often merely mediocre. (Well, sometimes. The critic Clement Greenberg found the 1944 Annual "more disheartening than ever," the 1945 installment a "new low." In 1947 he discerned "enormous improvement," but then things sunk back to their "old mediocrity" the next year.)

It was not until the mid-1960s that the Whitney's signature survey exhibitions—by this time they were biennials —had become something of a joke. By the mid-seventies the joke had soured. And for the last twenty years or so, the Whitney's biennial exhibitions have traced that accelerating downward spiral we associate with the action of certain large, porcelain plumbing fixtures.

Anyone familiar with desperate posturings of the art world will not find this surprising. For the Whitney Museum, like most institutions devoted to contemporary art—the London's Tate Gallery is another good example— long ago abandoned any pretense to collecting and exhibiting works whose primary distinction was aesthetic merit. Surrendering instead to the sordid imperatives of the "cutting edge," the Whitney now trades almost exclusively in the politicized, sexually perverse rubbish that substitutes for art wherever the words "deconstruction" or "transgressive" are used as terms of endearment. Every now and then, it is true, an exhibition of what used to be called art—"art" in the old sense: you know, pictures you enjoyed looking at, that sort of thing—still finds its way into the exhibition galleries of the Whitney. Several years ago, I remember, the Whitney sponsored a fine exhibition of watercolors and paintings by Charles Demuth. Similar things continue to happen even at the Tate. But such events are posthumous afterthoughts, like the twitchings of a frog's leg during dissection. The patient is dead even though some familiar motions can still be observed.

There is nothing like that in the 1997 Biennial. The Whitney's PR department says that "some of the most significant American art created during the past two years is on view in this historic exhibition." But trust me: while things are bad in the American art world, they are not *that* bad. Indeed, if this year's Biennial has any claim to distinction, it is the negative achievement of being an art exhibition completely, one-hundred percent devoid of aesthetic interest. I know, I know: that seems excessively generous. I readily admit that many recent Biennials have offered stiff competition. To be sure, some were more rebarbative, featuring instances of sexual perversion or hectoring left-

wing political animus even more lurid or repulsive than what is on view this year. And some managed to combine the visually repellent with the aesthetically soporific in ways that prescription drug companies can only marvel at. It is also true that many recent Biennials have required the critical equivalent of the electron microscope to discover anything certifiable as art. But there was always something—a stray photograph, perhaps, or a sculpture or a collage—that revealed some trace of aesthetic interest. Maybe it was—as we are told life is on Mars—exceedingly rudimentary: pre-protoplasmic virus-like slime. But it was something.

In this Biennial—the fifth she has helped to organize—the Whitney curator Lisa Phillips has finally done it. Perhaps it was the help she received from her co-curator, Louise Neri, the U.S. editor of an art journal called *Parkett*. Perhaps it was merely Phillips's own perseverance. Whatever the explanation, the 1997 Whitney Biennial must be recognized as a cultural—or perhaps I should say "anticultural"—landmark of sorts: the first totally art-free Biennial exhibition on record.

It's a remarkable achievement. According to a press release, Phillips and Neri have spent two years working on this exhibition. They looked at thousands of slides. They visited nearly five hundred studios, criss-crossing the United States. They traveled to Europe. They traveled to Brazil. They deliberated and sifted and culled. They settled finally on some two hundred items—"selections" the press release rightly calls them, not "art"—by seventy artists. How did they do it? Two hundred "selections"—"drawings, paintings, sculptures, film and video works, photography, installations, printed media, dance, performance, and sound"—by "artists" ranging in age from 22 to 85 and hailing from

all over the United States as well as Chile, Mexico, India, Italy, Pakistan, Puerto Rico, Russia, and the United Kingdom (these curators interpret the term "American art" very broadly). Two hundred "selections" and not a jot, not a scintilla, not an iota of aesthetic interest. It really is an astounding feat.

Astounding—and, if by some chance you happen to be interested in art, profoundly depressing. There is no point in attempting to "review" such an event. It is un-review-able. It would be like trying to review a heap of old clothes—no, more than that: it would in fact be reviewing a heap of old clothes: Louise Bourgeois's old clothes, as it happens, which have a room to themselves at the Biennial, clothes that this seasoned artistic huckster "collected over a lifetime and arranged provocatively."

WHAT ELSE? There are Annette Lawrence's "obsessive drawings in her own blood, based on the Mayan calendar," Shashwati Talukdar's "mock-umentary, which uses images of popular film stars to critique issues of cultural representation," Kristin Lucas's "personal adventures in technological pathology," Abigail Child's "haunting double narrative addressing the alienated self in the environment of a homeless encampment," Tony Oursler's talking heads "combining ceramics, glass, and a filmed performance of perversely distorted childrens' rhymes." Lisa Phillips summed it up well: "It's the idea of something really strange becoming normalized." True enough: and when the really strange becomes "normalized" the inevitable result is intractable boredom. We are told that most of the pathetic cultural detritus on view at the Whitney is being seen for the first time in the United States. Can we hope, too, that it will be the last?

The exhibition catalogue and all the press material accompanying the Whitney Biennial gratefully acknowledge the support of Beck's Beer. Beck's, it transpires, has been supporting this sort of thing at least since 1985, when they sponsored an exhibition of Gilbert and George, England's most prominent artistic charlatans, at the Hayward Gallery. As a rule, I am against getting the government involved in such matters: I detest, for example, the burgeoning practice of festooning cigarette packages and alcoholic beverages with warning labels. But exhibitions like the Biennial are another matter. There is something cynical, not to say manipulative, about a brewery sponsoring such events. At the very least there ought to be some sort of warning that upon leaving the exhibition the first thing most people will need is a drink. Those with weaker stomachs will need the plumbing fixture I referred to earlier.

1997

Wrong Turns at the Whitney

*Dada was an extreme protest against the physical side of
painting. . . . It was a sort of nihilism to which I am still
very sympathetic.*
—Marcel Duchamp, 1946

INANE *adj. Lacking sense or substance; empty.*
—*The American Heritage Dictionary*

THE MOST DELICIOUS news to emerge from the art
world in 2001 came in October, courtesy of the BBC.
Under the gratifying headline "Cleaner Dumps Hirst In-
stallation," the world read that

> A cleaner at a London gallery cleared away an installation
> by artist Damien Hirst having mistaken it for rubbish. Em-
> manuel Asare came across a pile of beer bottles, coffee cups
> and overflowing ashtrays and cleared them away at the
> Eyestorm Gallery on Wednesday morning.

I hope that Mr. Asare was immediately given a large raise.
Someone who can make mistakes like that is an immensely
useful chap to have about. In fact, I would hereby like to

suggest that he be taken on by some eminent London newspaper—*The Times*, say, or *The Daily Telegraph*—as an art critic. The military has special and covert forces, why not the world of criticism? As a model of concision and effectiveness, Mr. Asare's brisk critical intervention is hard to beat.

Unfortunately, his good work was soon undone. Mr. Hirst reportedly found the episode "hysterically funny." And why not? The gallery owners—spurred, possibly, by the "six-figure-sum" that the work was expected to fetch—instantly set about putting his opus back together. Thank goodness they had "records of how it had looked." Imagine the loss to world culture otherwise! Actually, I suspect that the task of reconstruction was not all that arduous. This is not Humpty Dumpty we are talking about. The BBC report carried a photograph of the work. (The original? Or the reconstruction? Perhaps we will never know.) It looked exactly like what it was: a tray of "beer bottles, coffee cups and overflowing ashtrays." That description cannot be improved upon. Let us pause to recall the phrase "six-figure-sum": that means at least £100,000—$150,000, more or less. For a tray of "beer bottles, coffee cups and overflowing ashtrays." I for one do not blame Mr. Hirst for finding the whole thing "hysterically funny." Doubtless his banker did, too.

A "spokesperson" for the gallery suggested that Mr. Asare's salutary sense of order might have "a positive outcome, by encouraging 'debate about what is art and what isn't, which is always healthy.'" Here is my second suggestion: that an immediate moratorium be called on the "debate about what is art and what isn't." As I observed above in "Minimalist Fantasies," far from being healthy, it is one of the great intellectual debilities of our day. It isn't a

debate, it is a dead end. When critics catch the what-is-art-and-what-isn't bug, you know they are utterly bored by art. When artists catch that bug, you can see clearly why the critics are bored.

The great thing about the Damien Hirst/take-out-the-trash episode—apart from its entertainment value—is that it vividly demonstrates one of the major wrong turns art took in the twentieth century. Damien Hirst didn't originate that wrong turn. Far from it. He is merely one of the many casualties—or, depending on one's point of view, beneficiaries—of that detour.

Almost all of the artistic wrong turns with which we are now living had their origins in the early decades of the twentieth century. But what began as an elite indulgence with the appearance of Dada, Surrealism, and figures like Marcel Duchamp became a national pastime in the 1960s. It was then that the wrong turn became a superhighway, when (to alter the metaphor) a rare affliction became epidemic.

The most important culprit in this story is undoubtedly Andy Warhol.† It was Warhol—aided and abetted by such figures as Robert Rauschenberg and Jasper Johns—who injected the streak of sinister levity that made Pop Art and its offshoots such a creepy, Janus-faced phenomenon: one face all smiles and Campbell Soup cans, the other a grim underworld of drug abuse, sexual predation, and nihilistic self-absorption. Pop Art enjoyed such enormous success largely because its practitioners managed to hold those opposing elements together in their art: sugar coating around a poison pill. For susceptible souls—and their number was legion—it was an addictive combination.

† See "Drunk on Andy Warhol," pages 212–221 below.

Artists like Damien Hirst and the other professional transgressors who populate the art world today are the heirs of Warhol's sinister levity. No serious contender for the Turner Prize can be without it. The Whitney Biennial exhibitions are full of it. And virtually all of the big-name star artists of the last few decades have been heavily endowed with that corrosive pathos. It is more a psychological than an artistic endowment, but the deliberate fusion or confusion of those faculties has been one of the distinguishing features of most trendy precincts of the contemporary art world.

Anyone interested in observing the crystallization of the sensibility that made artists like Damien Hirst possible should have stopped by the Whitney Museum of American Art to walk through the exhibition "Into the Light: The Projected Image in American Art 1964–1977," which was on view from October 2001 through early January 2002. Few people, I think, can have found it a pleasant experience. Film and video installations are almost by definition monuments of pretentious tedium. And even by the stringent standards of the field "Into the Light" excelled in creating an atmosphere of irritating nullity.

The Whitney's press information described "Into the Light" as "a major exhibition of works that had a transforming impact on art." That is partly right. The works from the 1960s and 1970s on view in the exhibition did have a transforming impact on art. But it was not an *aesthetic* impact. The Whitney speaks of that period as "'a golden age' that produced some of the most significant moving image installations ever made." In fact, it was a time of decadence and collapse, as will be immediately evident to anyone who revisits that slice of history. There are nineteen installations in the exhibition. None is of even

minimal artistic interest. But taken as a case study, "Into the Light" was, well, an illuminating event. Its value is educational, not aesthetic. Like a trip to a madhouse or hospital ward, it helps us become better epidemiologists, furnishing examples—some brutal, some merely pathetic —of something gone dreadfully wrong.

It might seem odd to link artists like Damien Hirst to an exhibition devoted to film and video. As far as I know, Hirst has never trespassed into those genres. But although "Into the Light" consists entirely of film and video works, its significance lies in the attitude toward art and culture it embodies. It is an attitude that Hirst and his peers have deeply imbibed.

THE BEST WAY to understand that attitude is to ponder some of the catalogue descriptions of the works on view. Bruce Nauman's *Spinning Spheres* (1970), for example, is described as an attempt "to destabilize the viewer's perception of physical space." The summary comes in two parts: exposition, which is admirably accurate, and interpretation, which is preposterous.

> Four looped film projectors show a small steel ball, placed on a glass plate in a white box and blown up large scale, spinning fast for three minutes. Every time the ball comes to a halt, an image of the white cube can be faintly seen, reflected in the spinning sphere's surface. The enlarged, abstract surfaces obscure all sense of scale, creating a dizzying vortex that pushes the viewer outwards, back into the gallery space. *Spinning Spheres* demonstrates Nauman's interest in using repetition and ambiguity to create a new sculptural language, in which optical perception is explored through altering the parameters of physical space.

Is it necessary to point out that Nauman's work has nothing whatsoever to do with sculpture or "sculptural language"? That simply being repetitious is not the same as having "an interest in" (or insight into) the phenomenon of repetition? That filming a spinning ball does not count as "exploring" optical perception?

Exasperation is an emotion that gets a heavy workout in this exhibition. Here's what the catalogue has to say about Yoko Ono's *Sky TV* (1966):

> A camera is placed on the outside wall or roof of the gallery, trained on the sky. Live images of the sky are relayed to a television monitor in the gallery, projecting the exterior world into an interior space. . . . Significantly, the camera is aimed not at the viewer but at the sky, implying the necessity of considering an infinite world beyond the ego and the hypnotic pull of commercial television.

Again, one has to admire the clinical accuracy of the exposition—Ono's piece really is just a film of the sky—followed by the interpretive nonsense.

Most of the descriptions follow this pattern. They start deadpan and then wax fanciful. We know where we are when we read that William Anastasi's *Free Will* (1968) is

> a video sculpture that engaged the space of the gallery, focusing on one of its most mundane, ignored features: the corner. A camera fixed on top of a monitor is trained on a corner, whose image is related live in black-and-white on a monitor screen.

A video of a corner. Great. I am sure you can imagine it. It supports the curator's talk about exploring "The con-

ceptual implications of autism." But then what about this grammatically challenged flight: "This self-reflexivity evokes the Buddhist admonition of the individual's search for external answers, and the importance of looking into our own internal selves."

Complete rubbish, of course, and not even accurate about Buddhism. But you can still admire the effort to cloak aggressive banality with a scaffold of higher significance. That, in fact, is a procedure one must master to thrive in the world of art film and video. Consider Peter Campus's *aen* (1977). You walk into a darkened room. There is nothing to see until you turn around and come face-to-face with a television monitor on which is displayed an image of yourself upside down. Probably you've seen something similar a hundred times when walking by an electronics store with a camera trained on the passersby. But in that case you are merely being filmed. In the recesses of the Whitney you find that *aen* "belongs to a group of seminal closed-circuit video installations. . . . Campus's shadowy projection operates on the one hand as a formal enquiry into space, surface, and scale, and on the other as a ghostly nocturnal reflection, which brings us into an existential confrontation with our own inner selves."

MOST OF THE INSTALLATIONS on view in "Into the Light" have the look of a grade-school science project. But instead of making sense of and illustrating some natural phenomenon, they glory in breakdown, futility, or simple inanity. In Anthony McCall's *Line Describing a Cone* (1973),

> A film showing a large circle being drawn is projected onto the wall of a darkened room. A thin mist is introduced into the space, which makes the beam from the projector

visible, as it gradually develops from a line into a large cone and the drawn circle is complete.

Which is about as gripping as watching grass grow. We are told that in *Shutter Interface* (1975) Paul Sharits "explored his rigorous analysis of the material properties of film and of the mechanics of cinema in spatial terms." What we actually see, however, are three colored rectangles pulsing and flickering on a wall while some unintelligible noise ("an abstract soundtrack") is piped in. Viewers are warned that the "strobing effect may be harmful for those with an epileptic condition." But what about people allergic to overbearing pseudo-artistic doodling dressed up in half-digested fragments of scientific jargon? Where is the health warning about that obvious danger?

Many of the installations have a political component. In Vito Acconci's *Other Voices for a Second Sight* (1974), for example, one hears the artist broadcasting "a pastiche of communiqués from twentieth-century left-wing revolutionaries, such as Che Guevara, Frantz Fanon, and Abbie Hoffman, articulating the loss of direction and integrity that he and other artists felt had taken place during the Vietnam era." Of course, there *was* a loss of direction and integrity at that time, but it was a loss not detected but exemplified by artists like Vito Acconci.

While the political undercurrent is never far from the surface in exhibitions like "Into the Light," even more prominent is the pretense that the boundaries or conventions or languages of artistic practice are being "redefined," "interrogated," "transgressed," or "challenged." We have seen how Bruce Nauman's silly film was said "to create a new sculptural language." It is the same with every second work in this exhibition. Joan Jonas's *Mirage* (1976/2001)

supposedly "redefine[s] the parameters of both sculpture and film." Simone Forti is credited with creating "iconic works that defined a new language of movement." Robert Morris "and others" are said to have created "a new language of art, in which our perception of the work became a central aspect of its meaning." Andy Warhol's double-screen films purportedly "dismantle . . . linear cinematic time." And so on. You would think, from the vast number of artists credited with redefining the conventions of their art, that it was the work of a moment to accomplish such transformation. In fact, redefining or creating a new language of art is something accomplished once in a century, if that.

"Into the Light" is hardly unique in broadcasting such pretentious nonsense. On the contrary, it is wholly typical of the contemporary art world. The idea that so much art succeeds in questioning its own conventions is partly a function of confusing word and deed. It is one thing to say "I am redefining the language of my art and creating a new sculptural vocabulary." It is something else to do that in fact. Nature abhors a vacuum. Confronted with work of striking nullity, human ingenuity populates the void with alibis of significance. It is a good rule of thumb in the contemporary art world that the level of pretension is inversely proportional to the level of artistic achievement. Accordingly, one *expects* the pretension level of "Into the Light" to be high. Nor is one disappointed. In the catalogue for the exhibition, Thomas Zummer ("a scholar, writer, curator, and artist") winds up an essay called "Projection and Dis/embodiment: Genealogies of the Virtual" with the observation that

Again and again, the promissory structure of a Deleuzian

"pure repetition," occluded by its own constant iterations, punctuates the spaces of media, modelling the play between the phenomenal and epiphenomenal that structures the work. The idea of deictic extension—of the body into space, over time, into other spaces, over generations—and deferral of the body has been a constant variable in media. In the resulting *méconaissance*, the body is seen arrested for a moment, everything is uncovered, *mise-en-scène* shifts into *mise-en-abîme* and we aren't even ourselves anymore.

No indeed.

Prose like Mr. Zummer's is an unmistakable warning sign that something has gone dreadfully wrong. Like a shooting pain down one's arm, it should prompt us to seek emergency relief. That is where stalwart fellows like Emmanuel Asare might be invaluable, if only there were enough of them. The works commemorated in "Into the Light" helped codify an attitude toward art and culture that finds its contemporary redaction in artists like Damien Hirst and all the many other partisans of sinister levity. Andy Warhol did as much as anyone to popularize that wrong turn. But the origin of the catastrophe lies earlier. In her essay for the exhibition catalogue, Chrissie Iles mentions Marcel Duchamp many more times than any other artist. This is entirely appropriate. For if Warhol is the father of sinister levity in the art world, Duchamp is the grandfather, the real paterfamilias. The spirit of Duchamp is such an abiding influence in the art world that we are tempted to forget that Duchamp did not attempt to revolutionize art, he attempted to destroy it. No one was more surprised by the absorption of Dada into the canon of art than Duchamp himself. "I threw the bottle rack and the urinal into their faces as a challenge," he noted con-

temptuously, "and now they admire them for their aesthetic beauty." I used to think that Duchamp's many heirs had fundamentally misinterpreted him, that they were perpetuating, albeit in a grotesque and perverted form, precisely the kind of artistic activity that Duchamp had set out to explode. Artists like Damien Hirst and exhibitions like "Into the Light" make me wonder, though. There are many ways to destroy an institution. Duchamp opted for savage parody followed up with abandonment. (Why make art when one can play chess?) His heirs are less scrupulous. But perhaps they are no less effective. Inanity, leavened by unremitting pretentiousness, has certainly taken its toll.

When I finished picking my way through the dark corridors of "Into the Light," I decided to take the stairs rather than the elevator down from the fourth floor. On the landing of the third floor is a long bench, and on this bench—curled up and apparently fast asleep—was a young woman. She seemed so carefully poised that I stopped short: was it . . . could it be . . . a work of *art*? A performance piece, perhaps, illustrating the crushing effects of the capitalist-patriarchal juggernaut on female sexuality? Although sorely tempted, I refrained from rousing the sleeper to ask and continued downstairs. Imagine my surprise when I got to the landing of the second floor and discovered, curled up and fast asleep on the bench, the virtual twin of Sleeping Beauty on the third floor. This *must* be "an installation," I thought, and far more fetching than anything I had encountered on the fourth floor. It even occurred to me that it might be an ironical commentary on "Into the Light," underscoring the fact that it was an exhibition calculated to drive one into the arms of Morpheus. I hurried downstairs and asked a guard whether the sleepers were part of an exhibition. He gave me a blank

look. Then I asked a passing administrator. She produced a worried look and went to consult the guard. Together they started upstairs to investigate. I made my way outside. I was sorry to have interrupted so much slumber. But at least, I reflected, the Whitney does not employ Emmanuel Asare: who knows what he might have tidied up.

2001

Drunk on Andy Warhol

Artists who aren't very good should become like everybody
else so that people would like things that aren't very good.
It's already happening.
—Andy Warhol

I T IS DIFFICULT to suppress a sense of amazement when one first visits the new Andy Warhol Museum in Pittsburgh, Pennsylvania. Located in a splendidly renovated 1911 industrial warehouse just off the Allegheny River, the museum is a monument to modern artistic celebrity. Who would have thought it possible? Press material informs us that this is "the Most Comprehensive Single-Artist Museum in the United States." It is easy to believe. The museum, which is officially part of the Carnegie Institute, opened in May 1994 under the directorship of Tom Armstrong, former director of the Whitney Museum of American Art in New York. It owns some three thousand works by Warhol, approximately five hundred of which are on view. Its six floors of galleries provide about fifty-thousand square feet of exhibition space for the display of objects from every phase of Warhol's life.

It's all here: the early commercial drawings and adver-

tising layouts; the pop icons that catapulted Warhol to
fame in the early 1960s—the Brillo Boxes, the Campbell's
Soup cans, the silkscreened images of Mao and Marilyn
Monroe and Elvis Presley and Jackie Kennedy and an
electric chair; in a darkened theater, one of Warhol's silent
films from the early Sixties runs continuously—e.g., *Sleep*,
a five-and-a-half-hour shot of a man sleeping ("an epoch-
making experiment in the aesthetic of the blank stare"), or
Empire, eight hours of the Empire State Building. (The
museum is billed partly as a family attraction, so
presumably some of Warhol's other films—*Fuck*, for ex-
ample, or *Blow Job*—are not publicly screened.) There are
several of his so-called Oxidation Paintings—tawny-
colored blotches made from synthetic polymer paint and
urine on canvas—as well as examples of his late
"religious" paintings: mural-sized canvases blending fig-
ures taken from Leonardo's *Last Supper* with various bits
of pop iconography.

Above all, there is paraphernalia from Warhol's life, in-
cluding scores of items from his childhood in Pittsburgh
when he was still called Andy Warhola. We learn such
riveting facts as that Warhol, "around age nine, developed
an interest in photography and took pictures with the
family's Kodak Brownie." There are snapshots and letters,
magazine and newspaper clippings, invitations, handbills,
school certificates, and some of the ceramic cookie jars he
collected when he was an adult. There are pictures of War-
hol shaking hands with the Pope, of Warhol talking on the
telephone, of Warhol hanging out with the Velvet Under-
ground, the rock band he produced in the 1960s. There are
scrapbooks and tee-shirts, paint cans and old clothing.
Among the quantities of biographical material there is
news of his nose job and hairpiece. There are also miles

and miles of audio tape: Over six thousand hours of rambling conversations between Warhol and whomever he happened to be with—or talking on the telephone with—at the moment.

The catalogue for the Andy Warhol Museum comes with a compact disk embedded in its cover. This little bonus provides an hour or so of "sounds from the life of Andy Warhol," recorded tidbits from his daily life spliced together and explained by a voice-over narrative. At some point, Warhol got into the habit of saving the minutiae of his life in cardboard boxes. He called them Time Capsules, and the Andy Warhol Museum has hundreds of them, carefully preserved and docketed, set aside in a special study room. One of the curators at the museum estimated that it will take an archivist twelve years to sort through and catalogue all the objects in the Time Capsules.

WHAT IS GOING ON here? It's a question that one will often ask oneself while peregrinating through the galleries of the Andy Warhol Museum. It is an experience that is bound to call forth all sorts of associations and memories. One of the first things I thought about was an episode of a late-night talk show I saw on television many years ago. It featured the usual roster of actors, musicians, and comedians. One chap—who I suppose was both a musician and a comedian—entertained the television audience by squeezing his hands together to produce a crepitous melody: "Happy Birthday" or some such tune in a series of squeaky little pops. I marveled both at the man's perseverance—it cannot have been easy to master that technique—and at the show's producer: why would anyone want to be subjected to this display of fatuousness?

Nothing that Andy Warhol ever did exhibited quite so

much skill as that man on television displayed; but as a purveyor of fatuousness he is hard to beat. By the time that Warhol died, in 1987, he was—as was often observed at the time—famous mostly for being famous. Although he continued painting until the end of his life (some of his late paintings are collaborations with Jean-Michel Basquiat or Francesco Clemente), Warhol had long since migrated from the world of art to the world of art celebrity. By the 1980s, he was famous primarily for going to swish nightclubs and snapping pictures of his fellow celebrities.

Which brings us back to those nagging questions: What is going on here? Why is there such a thing as an Andy Warhol Museum in the first place? Why have presumably intelligent people raised millions of dollars to renovate an old warehouse and equip it as a shrine to to one of the most notorious art hucksters of our time? (And what care went into the renovation! The architect, Richard Gluckman, did a superlative job. Everything is top drawer, from the galleries to the recreation of the original cornice on the period building. The storage facilities are the best I have seen in any museum.) Andy Warhol, of course, would have revelled in it. What he wanted above all was celebrity. He got plenty during his life, and now this! What better assurance of posthumous celebrity than an entire museum consecrated to the memory of oneself?

Naturally, having gone to the expense and trouble of creating the Andy Warhol Museum, its superintendents have been tempted to disseminate some large claims for Warhol's cultural importance. The Andy Warhol Museum has not been negligent in this area. Its press material makes some very large claims indeed for Warhol's importance. He is said to be "one of the 20th century's defining figures" who was "at the center of developments in art and Ameri-

can culture for nearly 30 years" and who, moreover, "revived a function of art that had been moribund for over a century—its ability to address the public at large, creating icons of their living beliefs." Elsewhere, we read that "the Andy Warhol Museum is essential to understanding one of the most influential American artists of the second half of the twentieth century. It is also a primary resource for anyone who wishes to gain insights into contemporary art and popular culture."

The catalogue for the museum reinforces these themes. One essay is by the American philosopher Arthur Danto, who for many years has been an ardent champion of Andy Warhol, both as an artist and—a more provocative claim—as a thinker. In the essay he contributed to the catalogue, Professor Danto reaffirms his high opinion. It all started in 1964 when he saw the exhibition of Warhol's Brillo Boxes at the Stable Gallery in New York. Since then, he writes, he has felt that Warhol possessed "a philosophical intelligence of an intoxicatingly high order." "Intoxicating," indeed. Professor Danto is a clever and erudite man; but what does it mean when a clever and erudite man concludes, as Professor Danto did in another essay on Andy Warhol, that the creator of the Brillo Boxes and the silkscreens of Campbell's Soup cans is the nearest thing to a "philosophical genius" that the twentieth-century art has produced? Admittedly, the competition has not been all that stringent. But still: Andy Warhol a "philosophical genius"?

Professor Danto has long been preoccupied with the epistemological problem of defining art: What makes an object a work of art? Why are some pieces of canvas with paint on them works of art, while others are merely pieces of canvas with paint on them? He has had some ingenious

things to say about this question. Unhappily, it turns out that his insights tell us more about the perils of philosophical puzzle-mongering than they do about art. Professor Danto observes that "Warhol violated every condition thought necessary to something being an artwork, but in so doing he disclosed the essence of art." "The essence of art"? It's as if a chef were to attempt to disclose the essence of dinner by cooking something completely unpalatable. It might be clever; it might violate every condition thought necessary to something being dinner; but so long as we possess taste buds and stomachs, it won't be much of a meal.

Professor Danto thinks that Warhol's Brillo Boxes overturned "two millennia of misdirected investigation" about the nature of art. In fact, they merely displayed the credulousness of the art-buying—and art-theorizing—public. The cynical line attributed to Warhol—that "art is what you can get away with"—brilliantly sums up the situation. The Brillo Boxes may in some technical sense be art, just as an unpalatable mess may still be dinner. But as is usually the case when it comes to art, the more interesting questions occupy the realm of experience and evaluation, not definition. Granted that the Brillo Boxes are art: do they count as *good* art? Do they provide the sort of aesthetic pleasure and spiritual refreshment we look for in art? These are the sorts of questions that Pop Art attempted to short circuit. For those suffering from aesthetic dyspepsia, artists such as Andy Warhol, Jasper Johns, and Robert Rauschenberg were godsends: artistically, they were pretty thin gruel, but they went down easily. And of course they had the added advantage of inducing feelings of nausea in those whose digestion was unimpaired.

Difficult though it may be to imagine, Professor Danto's

claims for the importance of Andy Warhol seem positively modest in comparison to those put forward by Mark Francis, the chief curator of the Andy Warhol Museum. Mr. Francis's catalogue essay is partly an act of homage to those individuals and institutions who have donated works by Warhol to the Museum, partly an encomium on the theme of Warhol's unsurpassed talent, influence, accomplishments, and spiritual significance. *Spiritual* significance? Andy Warhol's *spiritual* significance? I'm afraid so. After Mr. Francis concludes telling us that "in terms of their quality, cultural and historical significance, scale, and value, the donations to The Andy Warhol Museum are among the greatest gifts made to an American museum," he moves on to expatiate on Warhol's enormous aesthetic and religious achievement. Having walked through the Andy Warhol Museum, you already failed to recognize the grave philosophical implications of the Brillo Boxes. Professor Danto set you straight about that. Having gazed upon the images of Elvis Presley and Jackie Kennedy, you probably also failed to realize that "Warhol's work was about beauty." Mr. Francis is here to enlighten you about that—and a good deal more.

It would be hard to think of a more important artist than the fellow Mr. Francis conjures up. Are we impressed by artists who are prolific? According to Mr. Francis, in terms of productivity Warhol was "matched among artists in this century perhaps only by" Picasso. Do we care about draughtsmanship and technical skill? Mr. Francis assures us that Warhol's schoolboy drawing of a male torso "links him with a Western artistic tradition dating back to Dürer and Leonardo." How about composition? Quoth Mr. Francis: "There is a formal similarity between Matisse's and Warhol's figure drawings." Naturally, we expect that

important artists rise above frivolousness, so Mr. Francis also underscores what he describes as Warhol's "gravitas." (Yes, really.)

But it is when he comes to the "religious dimension" of Warhol's work that Mr. Francis really takes off. A great deal is made, by Mr. Francis and others, of Warhol's Catholic background. "Many of Warhol's closest associates were Catholic," Mr. Francis tells us—a fact, if it is a fact, that may strike the uninitiated as irrelevant but that means a great deal to Mr. Francis: "Seen in this light, Warhol's spectacular productions of music, film, and dance become a kind of epiphany."

> One means of preventing Warhol's work from being seen merely as an ephemeral form of social commentary is to consider it within the terms and traditions of Catholic iconography. Warhol was brought up in the Eastern Rite of the Catholic Church, and he remained a practicing communicant in his later years. In the 1960s, however, he publicly signaled how much of his work was fueled by amphetamines and other controlled drugs, and his gay sexuality and amused tolerance of license and excess in his films were not hidden, and Warhol put a distance between his lapsarian world and that of organized religion.

I suppose what the tortured prose of that last sentence means is that the Catholic Church—Eastern or Western Rite, no matter—would have had difficulty granting the old *nihil obstat* to works like *Blow Job* or *Fuck*. This reservation notwithstanding, Mr. Francis speaks enthusiastically of Warhol's "long held aim" of generating a "secular communion" and tells us that "his *Marilyn* paintings have been viewed as the equivalent of icons, and it

could be argued that his *Jackie* paintings are images of a mourning Madonna, the *Electric Chairs* a crucifixion scene, the *Skulls* his version of *vanitas*, the *Last Suppers* a superimposition of his collaborative work practice on Leonardo's image of Christ and his disciples."

A bit later he tells us that the Oxidations, the works that Warhol produced by peeing on canvas smeared with paint, "continued to refer to his preoccupations with the human body, the exchange of value between money and objects, and what can only be described as a religious desire for communion and human interaction." It should perhaps be mentioned that Mr. Francis's enthusiasm for the *Oxidations* leads him to make some dubious theological statements. In the museum, a wall panel informs viewers that "The *Oxidations* are metaphors for transubstantiation, the transformation of base materials into precious objects." Given the context, the statement may be blasphemous; in any event, it certainly is wrong, for the doctrine of Transubstantiation refers specifically to the mystical transformation of consecrated bread and wine into the body and blood of Christ. Andy Warhol's urine does not come into it.

In their different ways, Professor Danto's and Mr. Francis's essays are part of the effort to endow the work of Andy Warhol with enough significance to justify the creation of the Andy Warhol Museum. Intellectually and aesthetically, it is a bootless task; commercially, however, they may be on firmer ground. All indications are that the Andy Warhol Museum is a resounding public success. This is perhaps only appropriate, given that Warhol's true genius was for commerce and publicity, not art. It is notable that the museum is an especially big hit with school children.

This, too, seems appropriate, since it is perfectly understandable that children should like cookie jars, wallpaper stenciled with the head of a cow, and a room in which helium-filled silver-colored pillows are kept floating in the air. Among much else, then, the Andy Warhol Museum reminds us that Pop Art represents an infantilization of art and culture. The dark side of Andy Warhol—the drugs, the sex, the thoroughgoing decadence of his world view—makes only a few explicit appearances in the museum's exhibitions, though of course it is implied everywhere. Warhol represents the smiling, camp side of 1960s radicalism, and in this sense the museum devoted to his *oeuvre* may be described as fun but not wholesome.

For adults who have any serious interest in art, I suspect that walking through the Andy Warhol Museum will be much less fun. There is nothing of any aesthetic substance to claim their attention; the memorabilia, at first amusing, soon becomes trite and cloying. Moreover, adults will constantly be reminded of the pretentious grandiosity of having a museum devoted to Andy Warhol. And they will find it much more difficult to ignore the aura of narcissistic decadence that imbues all of Warhol's work. In the end, the Andy Warhol Museum is like MASS MOCA: a funhouse in which something has gone awry. The faces that at first seemed to be grinning happily more and more compose themselves into a rictus of despair. The most dispiriting thought is that the sensibility that Warhol represented is not an isolated perversity. The curators of the Andy Warhol Museum are right that he profoundly influenced art and popular culture. But that, alas, is the problem.

1995

Francis Bacon:
Another Genius on Parade

If you stay out of the galleries and museums and listen long enough to the reviews and press releases, you might just start to believe that we are living through some super-Renaissance of the arts. Seldom a day passes when we are not presented with a new genius for our delectation. When have we had so many of 'em?

We have seen that Andy Warhol—the man who brought us the Brillo Boxes and the endless campy images of Marilyn Monroe—was widely glorified as a genius on the occasion of his retrospective at the Museum of Modern Art in New York last year. The extravagant skimpyness of Warhol's aesthetic—as distinct from his public relations— achievement makes his apotheosis emblematic of the current craving for new geniuses at any price.

But Warhol is hardly the only genius on parade. On the contrary, we are awash in genius. Another figure who soaked up more than his quota of celebrity was the Irish-born English painter, Francis Bacon (1909–1992). A traveling retrospective of some 60 paintings by Bacon made the rounds in 1990, stopping along the way at the Hirshhorn Museum in Washington, D.C. Bacon was showered with almost universal praise, here and abroad—

especially in England—and notices of his retrospective were entirely according to form. When the reviewers were not busy comparing Bacon to Titian, Raphael, and Velázquez, they loudly proclaimed his "old master" touch and, of course, his genius. Indeed, "genius" is the very first word in Sir Lawrence Gowing's catalogue essay, and that's only a warm-up.

Not that this was Bacon's first taste of the limelight. The then eighty-year-old painter (who is a collateral descendent of his namesake, the great Elizabethan essayist) has been collecting elaborate bouquets from the critical establishment for over four decades. In fact, Bacon had been painting sucessfully since the early-1930s, when he was said to have been much under the influence of Picasso's biomorphic abstractions. He subsequently destroyed as much of his early work as he could, however (none of it is on view in this exhibition), reinventing himself in the mid-1940s at the age of 35 as the premier Anguished Existentialist of modern painting.

What I suppose we must call Bacon's "mature" painting is difficult to describe. The work that many consider his breakthrough, *Three Studies for Figures at the Base of a Crucifixion* (1944), is a triptych, each panel of which depicts a grotesque, vaguely humanoid form alone in a room. The influence, and the spirit, of surrealism is prominent. Two of the figures feature menacing, teeth-baring orifices (a recurrent image in Bacon's painting) on tortured, snake-like protuberances. This work, now at the Tate Gallery in London, was judged too fragile to travel, but Bacon obligingly painted a second, much larger, version of the triptych in 1988, and this later version is included in the exhibition.

It would be as impolite to ask what either version of this

triptych has to do with a crucifixion as it would be to ask what works like *Triptych Inspired by T. S. Eliot's Poem Sweeney Agonistes* (1967) or *Triptych Inspired by the Oresteia of Aeschylus* (1981) have to do with their celebrated literary references. As in so much of Bacon's painting, it's impossible say exactly what is going on—the mangled, suggestively unrecognizable figures never quite snap into focus—but we know that, whatever it is, it is extremely unpleasant.

Bacon himself has remarked that "I would like my pictures to look as if a human being had passed between them, like a snail, leaving a trail of the human presence . . . as the snail leaves its slime." Since many of Bacon's paintings remind one of nothing so much as a trip to the butcher's shop or abattoir, we can readily grant him the slime. But I suspect that most observers who remain unswayed by the hype surrounding Bacon will have their doubts about the human presence.

Something similar must be said about the depths of existential significance often claimed for Bacon's painting. A great deal is made of the way his work courageously faces up to The Void and expresses "the isolation and anguish of the late twentieth century"—to take one characteristic statement from the foreword to the exhibition catalogue. Grisly as many of Bacon's paintings undoubtedly are, though, there is something calculated, even coy, about the horror, the anguish, the isolation. It all has a predigested, automatic feel to it. Above all, Bacon shows us that Mannerism is not dead: it is dwelling in expensive squalor somewhere in London.

But what about Bacon's technique, his vaunted "old master" touch? It's all on view here: the famous *Study After Velázquez's Portrait of Pope Innocent X* (1953), in

which a sketchy pontiff in bright purple sits rigid, his mouth wide open in mad laughter; the *Study for Portrait of Van Gogh III* (1957), which takes off from van Gogh's *The Painter on the Road to Tarascon*; and several other examples of Bacon's talent for outrageous mimicry. There is, to be sure, a certain slickness in evidence in his work. But do his paintings remind one of Velázquez's courtly mastery? Do they recall van Gogh's powerful Romantic Expressionism? One might as well ask whether every tipsy adolescent with pencil and paper reminds one of Arthur Rimbaud.

1990

Grotesque

THIS BEING THE SEASON of Lent, it seems appropriate to step back for a moment in an attitude of stock-taking. It is not an encouraging activity. For when it comes to the art world there is plenty to make one feel penitential. Indeed, if you confine yourself to the official precincts of the trendy galleries and museums devoted to contemporary art, it sometimes seems that the entire lot has descended to the realm of the depraved, the moronic, the grotesque.

I thought about this recently when a press release from an obscure New York gallery crossed my desk describing a group exhibition proudly devoted to the grotesque: "Sex, politics, pigs, and food all mixed together in a very grotesque exhibition." Among the advertised attractions were a photograph (by Andres Serrano of *Piss Christ* fame) depicting a man having sex with a dwarf, a photograph of a naked women in bondage with her nipples pierced, a "Herculean wax sculpture the color of ground meat," a painting of "pigs and nudes feasting on each other with hotdogs everywhere," and "masks in plexi-boxes symbolizing the atrocities being committed in Africa and other third world countries." Yawn.

It is depressing enough, of course, when you consider

high-profile events like "Sensation" or the fiasco of the Turner Prize at the Tate Gallery. But in those cases there is perhaps some consolation in the thought that philistines will always be with us, and that today, as in nineteenth-century Paris, they control most of the prominent cultural establishments. The only difference is that today's philistines wrap themselves in the rhetoric of the avant-garde whereas their counterparts in 1850 rejected it. The deadening attitude of absolute conformity remains.

It is when this philistine attitude trickles down to the ordinary gallery owner and aspiring artist that you begin to feel that things are irretrievable. I am not saying that the exhibition devoted to the grotesque was bad. It was not good enough or substantial enough to be judged bad. It was unpleasant, the way a nasty smell is unpleasant; but mostly it was just boring: a tired agglomeration of the tedious and futile, depressing the way a ragged homeless person is depressing.

I am not, I think, alone in finding myself vacillating between feelings of pity and and feelings of irritation when confronted with such sorry spectacles. There is something terribly sad about exhibitions like "Grotesque," just as there is something sad about Gilbert and George, the Chapman brothers, about what has happened to the Tate Gallery, and about the preposterous travesty of "Sensation" at the Royal Academy. There is a sense, I suppose, in which all of the above can be considered victims of their own fatuousness. But they are not innocent victims. Their studied perversity besmirches not only themselves but our culture as a whole.

The truth is that the prevailing situation is one that is good for cultural hucksters but bad for art—and for artists. It is especially bad for young, unestablished artists,

who find themselves scrambling for recognition in an atmosphere in which the last thing that matters is artistic excellence. When we look around at the contemporary art scene, we are struck not only by its promiscuous nature—by the fact that it is a living illustration of the proposition that *anything* can count as art today—but also by certain telltale symptoms. There is, first of all, its obsession with novelty. For those in thrall to the imperatives of the art world, the first question to be asked of a given work is not whether it is any good but whether it represents something discernibly new. The irony is that the search for novelty has long since condemned its devotees to the undignified position of naively re-circulating various clichés: how little, really, our "cutting edge" artists have added to the strategies of the Dadaists, the Futurists, the Surrealists.

A second, related, symptom is the art world's addiction to extremity. This follows as a natural corollary to the obsession with novelty. As the search for something new to say or do becomes ever more desperate, artists push themselves to make extreme gestures simply in order to be noticed. But here, too, an inexorably self-defeating logic has taken hold: at a time when so much art is routinely extreme and audiences have become inured to the most brutal spectacles, extremity itself becomes a commonplace. Without the sustaining, authoritative backdrop of the normal, extreme gestures—stylistic, moral, political—degenerate into a grim species of mannerism. Lacking any guiding aesthetic imperative, such gestures, no matter how shocking or repulsive they may be, are so many exercises in futility.

It is in part to compensate for this encroaching futility that the third symptom, the desire to marry art and politics, has become such a prominent feature of the con-

temporary art scene. When the artistic significance of art is at a minimum, politics rushes in to fill the void. Indeed, in many cases what we see are nothing but political gestures that poach on the prestige of art in order to enhance their authority. It goes without saying that the politics in question are as predictable as clockwork. It's the political version of painting by number: AIDS, the homeless, "gender politics," the Third World, and the environment line up on one side with white hats, while capitalism, patriarchy, the United States, and traditional morality and religion assemble yonder in black hats.

The trinity of politics, novelty, and extremity goes a long way toward describing the complexion of the contemporary art world: its faddishness, its constant recourse to lurid images of sex and violence, its tendency to substitute a hectoring politics for artistic ambition. It also helps to put into perspective some of the changes that have taken place in the meaning and goals of art over the last hundred years or so. Closely allied to the search for novelty is a shift of attention away from beauty as the end of art. From the time of Cubism, at least, most "advanced" art has striven not for the beautiful but for more elliptical qualities: above all, perhaps, for "the interesting", which in many respects has usurped beauty as the primary category of aesthetic delectation.

Not for nothing are "challenging" and "transgressive" among the most popular terms of critical praise today. In part, our present situation, like the avant-garde itself, is a complication (not to say a perversion) of our Romantic inheritance. The Romantic elevation of art from a didactic pastime to a prime spiritual resource, the self-conscious probing of inherited forms and artistic strictures, the image of the artist as a tortured, oppositional figure: all achieved

a first maturity in Romanticism. These themes were exacerbated as the avant-garde developed from an impulse to a movement and finally into a tradition of its own.

The problem is that the avant-garde has become a casualty of its own success. Having won battle after battle, it gradually transformed a recalcitrant bourgeois culture into a willing collaborator in its raids on established taste. But in this victory were the seeds of its own irrelevance, for without credible resistance, its oppositional gestures degenerated into a kind of aesthetic buffoonery. In this sense, the institutionalization of the avant-garde spells the death or at least the senility of the avant-garde. Many of these elements came together in that protracted assault on culture we sum up in the epithet "the Sixties." It was then that the senility of the avant-garde went mainstream: when a generalized liberationist ethos and anti-establishment attitude infiltrated our major cultural institutions and began forming a large component of established taste. And this is where we find ourselves today, living in the aftermath of the avant-garde, when photographs of a man having sex with a dwarf or a painting of pigs and nudes feasting on each other is business as usual. It is, as I said, a situation that inspires both pity and irritation. But, as with a Lentan meditation, one may hope that reflection will spark not only recognition but also reform.

1998

Robert Rauschenberg:
Today's Golden Dustman

S EEING THE HUGE retrospective of works by Robert Rauschenberg in 1997 involved a mini-tour of Manhattan. One started at the Guggenheim Museum at Fifth Avenue and Eighty-ninth Street, where hundreds of objects made or at least signed by Rauschenberg were arranged in roughly chronological order, from the beginning of Rauschenberg's career in the early 1950s up to about fifteen minutes ago. One then trekked downtown to the Guggenheim's SoHo outpost at Broadway and Prince Street, where Rauschenberg's technology-based and multimedia works were on view, along with more paintings, sculptures, collages, and "combines" from the last year or so. Then one traveled across town to Spring and Hudson Streets, where the Guggenheim Museum at Ace Gallery is showing *The 1/4 Mile or 2 Furlong Piece*, as of 1997 still a work-in-progress that began in 1981 and, when I saw it, consisted of 189 parts that consumed some 1000 feet of wall and floor space.

After making these rounds, a friend and I wearily decanted ourselves into a taxi and headed back uptown. We were stopped at a traffic light when a car pulled up beside us and an Airedale in the backseat began barking

furiously through a half-opened window. When I turned to look at the dog, he suddenly stopped barking, yawned broadly, and lay down. "He doesn't know whether to bark or yawn," my friend observed. Which more or less sums up my reaction to this biggest-ever travelling road show of works by Robert Rauschenberg.

There are worse things celebrated as great art today: things, anyway, that are more aggressively repellent. But I cannot remember an exhibition that left such a melancholy aftertaste. A press release claims that, in his nearly fifty-year career, "Robert Rauschenberg has redefined the art of our time." There is, alas, a sense in which this is true. Not that there is anything original or innovative about Rauschenberg's art. On the contrary, his work is primarily a highly commercial version of what Marcel Duchamp was doing in the Teens and Twenties with his "ready-mades." In essence, it is a window-dresser's version of Dada: Dada (slightly) prettified and turned into a formula—Dada, in short, for the masses.

Like Andy Warhol, Rauschenberg's chief genius has been for celebrity. His works are props in a gigantic publicity campaign whose purpose is to foster a species of brand-name recognition. In Rauschenberg's case, the brand in question is generic: it's art-in-general. What we are meant to admire is not the aesthetic achievement of Rauschenberg's work—that, indeed, is a question that scarcely arises—but rather the fact that it somehow managed to achieve the status of art in the first place. Like Dr. Johnson's dog prancing on its hind legs, it's not how well it performs but the fact that it performs that way at all that inspires wonder.

Writing in 1967, the American critic Clement Greenberg noted that many contemporary artists were exploiting "the

shrinking of the area in which things can now safely be non-art." Rauschenberg, whom Greenberg described as a "proto-Pop" artist, has again and again proved himself extraordinarily adroit at this game, ready at a moment's notice with an old bathtub, a crumpled cardboard box, a wooden frame filled with dirt and mold, or simply a blank canvas to offer an eager art market. All of which is to say that by the time Rauschenberg came on the scene the area that could "safely be non-art" had already been collapsed nearly to zero. Rauschenberg's talent—again like Warhol's (and like that of his early collaborator Jasper Johns)—was to look back on this collapse with a knowing, eminently packageable smirk.

Much of the smirk, especially in Rauschenberg's early work, was directed at the art of his older contemporaries. This is part of what made Rauschenberg such a hit among intellectuals, for whom the spectacle of artistic self-reference is irresistible. It reminds them, just barely, of having discovered something. Rauschenberg offers them a battered wooden box into which he has hammered a bunch of rusty nails and tossed a few pebbles: they think "Joseph Cornell, sort of," and are happy.

You can tell a lot about Rauschenberg's work simply from its list of ingredients. Consider *Monogram* (1955–59), which the Moderna Museet in Stockholm actually paid good money to acquire. This typical "Combine" consists of oil paint, paper, fabric, printed paper, printed reproductions, metal, wood, rubber shoe heel, and tennis ballon canvas, with oil paint on an Angora goat (stuffed) wearing an automobile tire and standing on a wooden platform mounted on four casters. It's almost enough to make one sympathize with the animal-rights fruitcakes. (It certainly makes one sympathize with the

museum conservators charged with "preserving" this stuff.)

There's a character in Dickens's *Our Mutual Friend* known as "the golden dustman," a chap who made his fortune trawling through garbage heaps. Rauschenberg is a kind of golden dustman. At least, an exhibition of his work reminds one of nothing so much as a visit to a gigantic dustbin or junk yard, and one that magically coins vast sums of money. It will be objected that there is nothing unusual about this: that many, maybe most, of the more glamorous precincts of the contemporary art world are every bit as trashy as those inhabited by Robert Rauschenberg. I readily concede the point. But there is something special about Rauschenberg. It has partly to do with longevity—Rauschenberg has been around a long time now—partly with his facileness. What Rauschenberg produces is undoubtedly junk, but he has managed to produce a mighty impressive mound of it and he has done so with buoyant insouciance.

Over the years, Rauschenberg has won just about every award and honor a cynical art world and gullible public can confer. In 1976, he made the cover of *Time* magazine, which presented a picture of the beaming artist, in open shirt and sunglasses, with the legend "The Joy of Art." What it should have said was "The Joy of Artist." That at least would have been credible.

It's the combination of celebration and unremitting trashiness that finally makes this retrospective unbearably depressing. If Robert Rauschenberg can be said to have "redefined the art of our time," it is because of the steady pressure that the growing embrace and exaltation of his work has exerted on contemporary taste. As one walks along the ramp of Frank Lloyd Wright's expanding spiral

at the Guggenheim, one follows the course of Rauschenberg's career from 1949 until now. Along the way, there is no aspect of contemporary artistic culture that is not mocked, trivialized, or turned into some sort of joke. The only exceptions are the ghostly exposed blueprints that Rauschenberg did in 1950 in collaboration with his then wife, the artist Susan Weil. These are the only two works, out of several hundred on view, that communicate any genuine aesthetic emotion. But these works are said to have been Susan Weil's idea, and they serve chiefly to highlight the poverty of everything that surrounds them.

1997

Gilbert and George:
The Psychopathology of Culture

I T IS ONE of the oddities of being an art critic today that so much of what one is called to comment upon qualifies as art only in a technical or honorific sense. The relevant definition of "art" in my dictionary refers to "the production of the beautiful in a graphic or plastic medium." How much "cutting-edge" contemporary art has anything to do with beauty? (How much even has to do with "a graphic or plastic medium"?)

To ask such questions is to highlight the fact that much of what is regarded as art today occupies a place in human experience that is not merely indifferent but downright antithetical to beauty: it is ugly, yes, and also perverse, disgusting, banal, tendentious, blasphemous, silly, and vapid. The real novelty of contemporary art—the part of it that counts as "avant-garde," anyway—is that it manages to be so many of these things at the same time: ugly *and* silly, disgusting *and* vapid, perverse *and* banal. In a way, it is quite an achievement—though not, of course, an *artistic* achievement.

I had occasion to muse about such matters recently when I went to see the exhibition of new pictures by Gilbert and George at two trendy SoHo galleries (Sonnabend

and Lehmann Maupin) in New York. I hasten to acknowl-
edge that, for anyone interested in art, too little cannot be
said about this pair of industrious self-promoters. But for
those interested in the psychopathology of culture, Gilbert
and George present a noteworthy specimen—an unusually
malignant boil or pustule on the countenance of contem-
porary art.

For those fortunate souls unacquainted with Gilbert and
George, it is enough to explain that, like so many bad
things, they emerged on the art scene as performance art-
ists in the late 1960s. At first, they proclaimed themselves
"living sculptures." Dressed in identical suits, they would
stand on pedestals pantomiming to a popular tune for
hours on end. In the early 1970s, they began to exhibit
black and white photo-montages, usually with themselves
and other young men as the main subjects.

By the mid-1970s they hit upon the formula they have
followed ever since. They create large, brightly colored
square or rectangular photo-montages by joining together
many individually framed pictures. The result is a kind of
scatological Pop Art. Images of the two men, usually
naked, sometimes in various obscene postures, occupy the
foreground of most of the pictures, some of which cover an
entire wall. The background usually consists of photo-
graphic images of bodily fluids or waste products, mag-
nified beyond recognition except when the waste product is
excrement: then the image is merely grotesquely enlarged.
Fond of using dirty words, Gilbert and George tend to title
their works after the bodily effluvia they portray.

It is part of Gilbert and George's act to pose as moralists
whose art is wrestling with deep existential and religious
questions. "We believe our art can form morality, in our
time," George tells us in one typical statement. "Our art is

based on human life. All the important subjects of existence are involved," Gilbert says in another. They act like drunken pornographers, but tell us they are engaged in a holy mission. It's what Marxists used to call increasing the contradictions.

It is a sign of the degraded times we live in that this sort of thing has been a wild commercial success. In 1986, Gilbert and George won the Turner Prize. In the last several years journalists regularly describe them as England's most famous and richest contemporary artists. Pictures in the New York exhibition were on sale for between $40,000 and $120,000.

It is hardly surprising that words like "shocking," "transgressive," and "controversial" are regularly used to describe—and to praise—Gilbert and George's work. What really is shocking, however—and I use the word in the old, negative sense—is the extent to which important critics have fallen over themselves to celebrate this latest expression of narcissistic nihilism. Already in the mid-1980s, Simon Wilson wrote that Gilbert and George had "come to be seen as being among the leading artists of their generation" and that the young men who populate their pictures are "equivalents, performing the same function in art, of the classicizing male figures of Michelangelo and Raphael."

In 1995, when Gilbert and George exhibited *The Naked Shit Pictures* in London, Richard Dorment, writing in *The Daily Telegraph*, invoked the Isenheim altarpiece as a precedent. John McEwen, in *The Sunday Telegraph*, spoke of their "self-sacrifice for a higher cause, which is purposely moral and indeed Christian." Not to be outdone, David Sylvester, in *The Guardian*, wrote that "these pictures have a plenitude, as if they were Renaissance pictures

of male nudes in action." And in the catalogue for the present exhibition, Robert Rosenblum really takes flight: "Brilliantly transforming the visible word into emblems of the spirit, Gilbert and George create from these microscopic facts an unprecedented heraldry that, in a wild mutation of the Stations of the Cross, fuses body and soul, life and death. Once again, they have crossed a new threshold, opening unfamiliar gates of eternity."

It might be tempting to dismiss this as harmless journalistic persiflage: nonsense, of course, but merely what one expects of critics these days. I cannot agree. The preposterous praise critics have lavished upon Gilbert and George is a sign of deep cultural malaise. After all, without the collusion of critics, Gilbert and George would have remained where they belong, as a footnote to late twentieth-century cultural pathology. Instead, they are celebrated as important artists. Walking up Greene Street with me after seeing Gilbert and George at the Lehmann Maupin Gallery, a friend remarked "Think of how much had to happen in our culture for Gilbert and George to be accepted as art." And not only accepted, but accepted without qualm or protest—indeed, embraced as a beneficent spiritual experiment. We have come a long way in the art world in the last couple of decades. The success of Gilbert and George provides a depressing measure of just how far we have fallen.

1997

Richard Diebenkorn

ALTHOUGH THE AMERICAN ARTIST Richard Diebenkorn enjoyed considerable commercial success and respectful critical acclaim throughout his career, his work never achieved the celebrity visited upon many other successful artists of his generation. There were several reasons for this. One was geographical. Although he lived and worked in many places, Diebenkorn, who died in 1993 in his early 70s, was widely regarded as a "Californian artist." The adjective was meant not only to identify but also to pigeon-hole: rightly or wrongly, being a "Californian artist" was regarded as a parochial activity. Implicitly, it was thought to set a cap to one's ambition in a way that being a "New York artist" never did.

It is all the more curious, then, that another reason for Diebenkorn's relative lack of celebrity cut in the opposite direction: I mean Diebenkorn's quiet seriousness as an artist. As a 1997 retrospective of his work at the Whitney Museum of American Art made clear, Richard Diebenkorn's achievement, far from being parochial, belongs firmly in the tradition of high European modernism—in Diebenkorn's case, a tradition represented above all by Matisse and, to a lesser extent, by Cézanne and Mondrian.

Indeed, that retrospective of some 150 works spanning the artist's mature career from the late 1940s through 1992, should have finally established in the public mind what some critics have been insisting on for years: that Diebenkorn's best painting places him among the four or five most important artists to come of age in the years following World War II.

Diebenkorn's evolution as an artist has struck many observers as unusual. He began as a representational painter, influenced above all by the quiet uncanniness of Edward Hopper. *Palo Alto Circle*, an accomplished student work from 1943 that is not in this exhibition, shows how fully Diebenkorn had absorbed the lessons of Hopper. ("I embraced Hopper completely," Diebenkorn once recalled. "It was his use of light and shade and the atmosphere . . . kind of drenched, saturated with mood, and its kind of austerity.") By the late 1940s, Diebenkorn had moved away from representational painting to embrace the pictorial grammar of Abstract Expressionism. He did so, however, with a distinctive twist. Diebenkorn's early abstractions—of which a generous sampling was on view in this exhibition—are clearly Abstract Expressionist works, but without the anger, angst, or aggressiveness that infuses the work of, say, Pollock. Diebenkorn's early abstractions display the tactile intensity we associate with Abstract Expressionism, but their mood is softer, brighter, more open.

Diebenkorn's work in the late Forties and early Fifties is accomplished, individual, but not out of the ordinary. He begins to come into his own as an artist in 1955 when he steps back from abstraction and begins painting in a figurative mode again. It was audacious, of course, for a successful abstract painter to turn to representation just at the

moment when the fortunes of abstract painting were so spectacularly on the rise. But Diebenkorn's turn to figuration is easy to misunderstand. It was not a bid for novelty but rather part of the unfolding logic of his art. The same is true of his re-return to abstraction in the mid-1960s with the paintings for which he is most famous, the "Ocean Park" series, which were named for a section of Venice, California, and which occupied him on and off for the rest of his life.

As one looks back over the course of Diebenkorn's career, one sees a variety of pictorial means but a deep consistency of pictorial purpose. For Diebenkorn, abstraction and figuration were both means to the end of realizing a certain artistic vision. The nature of that vision became fully articulate in the mid-1960s after Diebenkorn returned from an extended visit to the Soviet Union—in particular to St. Petersburg (then Leningrad), which meant to the Hermitage, which, for Diebenkorn, was epitomized by the great Moroccan-period paintings by Matisse.

There were two highlights in the Whitney retrospective. One was the group of pictures Diebenkorn painted in homage to Matisse, e.g., *Nude on Blue Ground* (1966), *Window* (1967), and above all *Recollections of a Visit to Leningrad* (1965), a large painting in every sense: physically imposing at six by seven feet, this marvelous painting is large in ambition and accomplishment as well. It is clearly one of the masterpieces in the exhibition.

The other, perhaps more difficult, highlight was the "Ocean Park" abstractions. If they constitute a more difficult portion of the exhibition it is partly because there are so many of them and they vary considerably in quality. When they work, Diebenkorn's "Ocean Park" pictures are among the most beautiful abstract paintings ever made.

They somehow manage to combine the clarity of Mondrian and the sensuousness of Matisse. At their best, they have a unity of feeling and exquisite balance of color and composition. Diebenkorn was generally most successful when he chose a large format—the miniature paintings that he did on cigar box lids in the 1970s, which seem like advertisements for the Ocean Park pictures, are charming but modest: bagatelles, not symphonies. It is also worth noting that Diebenkorn's "Ocean Park" paintings tend to succeed best when they are in a vertical format and are painted predominantly in a muted palette of dusky blues and grays, bleached yellows, and tawny browns. The horizontal "Ocean Parks" and those featuring more acidulous colors mostly lack finesse and (to use Diebenkorn's favorite critical term) "rightness."

Although Diebenkorn sometimes resisted the reading of his abstractions in terms of landscape, the truth is that the ghosts of landscape, especially landscape as seen from the air, seem to hover behind many of his Ocean Park pictures. Diebenkorn even acknowledged the influence of looking down on an expanse of land from a helicopter: "Many paths, or pathlike bands, in my paintings may have something to do with this experience, especially in that wherever there was agriculture going on you could see process—hosts of former tilled fields, patches of land being eroded." Indeed, reflecting on what makes the best of the "Ocean Park" paintings so moving, one realizes that they impress one not simply as abstract compositions but as compositions that bespeak habitation. That is to say, the peculiar vitality of the pictures relies partly on their suggestion of a landscape domesticated by human intervention. There is something of this uncanniness in Diebenkorn's work from the very beginning. As the critic

John Elderfield noted in his catalogue essay, "a trace remains in Ocean Park of the de Chirico-like element of unease that infects Hopper, and then Diebenkorn himself, when painting architecture and interior; the unease of silence and sharp, dark shadows in a scenography that waits for the unexpected."

"Richard Diebenkorn" was one of the most satisfying exhibitions to be seen at the Whitney Museum in a long time. Not only is it delightful in itself, but it will assuredly have the effect of reaffirming the reputation of an artist whom one suspects has tended to be more approved of than seen and appreciated.

1997

Graham Nickson and
The New York Studio School

PERHAPS THE MOST subversive art institution in New York City these days is located at 8 West 8th Street in the building that once housed Gertrude Vanderbilt Whitney's art studios and was the original site of the Whitney Museum of American Art. I mean the New York Studio School. This small art school has been around in one form or another since 1964. But its truly transgressive character really emerged only after 1988 when the English painter Graham Nickson became dean and transformed the curriculum. Emerson once said that "an institution is the lengthened shadow of one man." That is certainly true at the Studio School. Since Graham Nickson came on board, the school has regularly engaged in numerous activities certain to outrage entrenched interests in the art world even as it has challenged the reigning orthodoxies of what has become in many quarters conventional artistic wisdom.

The list of shocking practices one finds at the Studio School is long. For one thing, Graham Nickson has seen to it that drawing—you know, mastery of the skill needed to wield pencil, chalk, or charcoal effectively—occupies a central place in the school's teaching. For another, students are encouraged to look for their inspiration not to the

recent crop of celebrity artists from SoHo or TriBeCa or Cork Street but to the riches of art history back to the Renaissance and beyond. Then, too, words like "traditional" and "beautiful" are taken not as terms of ironic denigration but as terms of praise at the Studio School. In flagrant disregard of every current artistic cliché, students are taught to regard the Western artistic tradition as an immense enabling resource rather than as an impediment to the expression of their creativity.

As part of this heterodox program, the Studio School regularly mounts small exhibitions of pictures by masters old and new. The intention behind the exhibitions is partly pedagogical. They are meant to serve as models and sources of technical guidance for the students. They are also meant to be objects of aesthetic delectation in their own right. How successful they can be in this second ambition is shown by the current exhibition of some forty small works devoted to the venerable theme of bathers.

The exhibition, culled from several public and private collections, was organized to honor Graham Nickson, who is celebrating his tenth year as dean and whose own work often depicts figures on a beach. It includes lithographs by Cézanne, Boucher, Bonnard, Delacroix, and Pissarro, a pen and ink *Baptism of Christ* by Tiepolo (which somewhat enlarges our usual idea of "bather"), and a striking copy of Raphael's *Judgment of Paris* by Marcantonio Raimondi. There are also drawings by Picasso, a watercolor by Matisse, and one of the best pictures by George Bellows I have seen anywhere.

That last remark might be taken as faint praise, but the highlights of this exhibition are anything but faint. They include *The Bath*—a quiet but memorable charcoal and pastel drawing of a female figure by Degas—and a small

handful of extraordinary drawings by Balthus whose omnipresent eroticism is counterpoised by a technical mastery of Apollonian accomplishment and disdain.

Whoever selected the exhibition deserves congratulations also on some fruitful juxtapositions. Particularly striking is the conjunction of *Turkish Bath Scene*, a small, meditative oil by Euan Uglow, an important English figurative painter who is still relatively unknown in America, and *Lincolnville Beach*, a small oil by the jaunty American painter Alex Katz. These are widely—indeed, wildly—dissimilar artists. And yet these two small paintings, especially seen in a roomful of pictures of bathers, rhyme against each other with pert insistence. It is almost as if each painting represented some unacknowledged interior aspect of the other, strangely complementing and emotionally completing it.

As seems appropriate given the occasion for the exhibition, another highlight is *Bathers by the Pond, Dark Sky, Sagaponack*, an ambitious charcoal drawing by Graham Nickson and lent by the Metropolitan Museum of Art. Nickson rather specializes in dramatic renderings of inclement seaside weather. He has produced some breathtakingly accomplished drawings that feature rain, and he is able to ring almost Wagnerian effects from his depictions of lowering skies. Like many of his signature seaside works, the present drawing includes intensely observed figures disposed in hieratic attitudes. Nickson invests his figures and their props—towels, lifeguard stands, umbrellas—with a semaphoric quality. Many of his pictures have the feeling of tableaux: visual snapshots in which a procession of gestures is arrested in in a distillation of significance.

The greatly cheering thing about the Studio School is the thought that, here in this one corner of Manhattan, the

vital lifelines of Western artistic practice are not only preserved and celebrated but are also consciously passed along to the next generation of aspirants. It's not Andy Warhol; it's not Jeff Koons or Bruce Nauman or Gilbert and George; it's not even the Chapman brothers or the Turner Prize. It's simply a small group of accomplished artists and serious students devoting themselves to making the best art they can by following the exigent models furnished by the masterpieces of European art.

1998

John Dubrow

Hail holy light, offspring of Heav'n first-born,
Or of th' Eternal Coeternal beam
May I express thee unblam'd?
—John Milton, *Paradise Lost*

L IGHT IS THE PAINTER'S real medium. Paint is merely the
means. St. Augustine famously said about time that he
knew perfectly well what it was—until someone asked him
and he had to explain. Then he discovered his ignorance.

Light is a spatialization of time. Like time, light is an
indispensable prerequisite of revelation. Yet like time, light
never makes full-disclosure. Light uncovers the world but
somehow withholds its glittering kernel: no disclosure
without closure. We all know what light is—it is a condi-
tion of our common life, a companion so familiar that we
neglect its stupendous intimacy, its bewildering gifts of
declaration and concealment. What is light? The physicist
is of little help here, for he can tell us only about the com-
ponents, not the experience, of light. Really to understand
light—to understand its brash indicatives, its retiring
adumbrations—we need not analysis but art. Or the
analysis that is art.

Artists do many things. One thing is to conjugate the rituals of light's enactments. Their impossible task is the faithful repetition of absolute evanescence. We can tell at a glance whether the miracle happened, whether the impossible has once again been nudged into recognition. The subject can be anything: bars or fields of color, a human face, a random assembly of everyday objects, a street scene, a landscape, a battle, a collocation of the gods, a mythological fancy, an ancient city taken from afar.

The American artist John Dubrow is on intimate terms with light. He has registered its kaleidescope of moods, transcribed its imperatives, jotted down the subtle inflections of half-glimpsed requisitions. What is light? A few years before the terrorist attacks of September 11, from an eyrie high up in Manhattan's World Trade Center, Dubrow captured two primary urban realities that make New York New York. Looking north, the sprawling metropolis splayed out before him, Dubrow caught the crowded hubbub of ten thousand buildings packed in brazen closeness, pulsing with life, reaching for the sky. Dubrow, who began as an abstract painter and apprenticed in the solicitous light of San Francisco, brought a compositional tautness and welcoming earth-tinted warmth to his vision of Manhattan. The hard hot grittiness of the city was transfigured by a beneficent vision that enlisted color, distance, and the gentle order of perspective in a lively, humanizing play of forms. This was Manhattan as we have wanted to know it: fixed in a quiet summer moment without pressure, without the dissolutions of noise and dirt and anger.

Dubrow caught another side of the city looking south over the tip of Manhattan island and the harbor. In these canvases Manhattan's remarkable insularity—a fundamental but oft-forgotten fact of life in the metropolis—

snaps into focus. Long shadows and the beckoning expanse of water remind us of its curious isolation: at the center of the world yet somehow apart from the world. At an early morning hour the streets of lower Manhattan are almost empty. The aura of stasis, of uninhabited monumentality, imparts a quietly arresting, almost eldritch, quality to these pictures. Off in the distance, a lone ferry steams eastward, cutting a vivid white gash in the blue-green-gray field of water between the southernmost margin of Manhattan and the Statue of Liberty. One sees a sparsely populated sea- and cityscape; one senses the enormous dense busyness of Manhattan looming up behind: heavy, dark, inexorable.

What is light? Dubrow has obviously lived long with this question. Two large and ambitious park scenes from the late 1990s record some pleasing vicissitudes of life with that interrogatory. A view of Manhattan's Central Park in autumn and of Brooklyn's Prospect Park in full summer exhibit the beguiling seductiveness of Dubrow's technical mastery and decorously articulated poise. These huge pictures—*Prospect Park* is some seven by fourteen feet—are warm, likable pictures. They reach out and welcome the viewer. But do not be misled by their openness. These pictures are also canny exhibitions of artistic strength. Their play of light—their playing with light—has the seeming artlessness of confident artistry. In *Prospect Park*, for example, Dubrow has managed to combine an homage to Seurat's *Grande Jatte* with a feeling of absolute contemporaneity. He labored on and off for some four years on this painting, yet it has the glow and freshness of an extended improvisation.

Tradition functions here less as history than as a kind of artistic blood supply: an enabling current and fathomless resource. We are often told that modernity made tradition

in this sense impossible; we were supposed to be too ironical, too knowing, too faithless to make authentic use of our past, which is to say, of ourselves. Artists like Dubrow casually explode the superficiality of that contention. *Prospect Park* shows in one impressive panorama that (as William Faulkner once put it) the past isn't dead, it isn't even past.

The story of what has happened to portraiture in the twentieth century forms one of the sorriest chapters in modern art. The assault on the human form—above all the assault on the human face—has epitomized the progress of painting's dehumanization. Dubrow is one of several younger artists who have mustered the energy and courage to resist that dehumanization without falling prey to sentimentality. Dubrow's portraits reveal an artist whose empathetic solicitude for his subjects is never in doubt but whose interest in portraiture is inextricably interwoven with the aesthetic imperatives of painting. His significant accomplishment is to have kept those dimensions of his art—the moral and the aesthetic—in vital balance and communication. For example, in his 1998 portrait of a woman called Phippy, his 1996 portrait of a father and son, *Charles and Thomas Berkovic,* or his portrait of a woman sitting on a sofa in gray slacks and a blue jersey, Dubrow has achieved fetching essays in color harmony that are also gentle exhibitions of personality. Dubrow's portraits show him to be a painter of remarkable tact as well as remarkable talent: he wields his art not as a surgical instrument but as a beckoning wave. The result are portraits in which character is not exposed but is allowed to unfold delicately in casual gestures, habitual attitudes, comfortable poses.

The five pictures that Dubrow painted on a trip to Israel

in 2000 constitute both a summing up and new departure in his art. The two pictures from Tel Aviv—a street scene and panoramic aerial view of the city—show him exploring in a transplanted venue the forms and atmospherics that he developed in his Manhattan cityscapes. Dubrow's palette has become drier, his forms crisper, but there is a large unifying continuity between these pictures and their American counterparts.

The three large pictures that Dubrow painted from a hillside overlooking Jerusalem represent a step forward in ambition. These sweeping views are saturated with painterly emotion. What is light? The famous roseate opalescence that bathes Jerusalem obviously captivated Dubrow as it has captivated so many others.

The result are three magnificent canvases in which a complex interlocking mosaic of buildings, trees, rocks, and open spaces forms a breathtaking vista. This view of Jerusalem is Dubrow's Monte Sainte-Victoire. There is an iconic element to these images of the ancient, history-battered city. As in his portraits, Dubrow has managed to balance moral and aesthetic elements in these landscapes: he has extended the genre of landscape painting into the realm of human design and complication. The exquisite harmonies of form and color—greens and taupes and flinty gray-browns—are underwritten by the inescapable awareness of history. The Dome of the Rock, the first Muslim architectural masterpiece, built in the late seventh century, winks its golden eye in all three pictures, a visual but also a religious and a political exclamation point punctuating the horizon. Dubrow's handling of the sky is particularly notable. These are dimensionless blues and whites worthy of Constable, though the winds that blow here are far indeed from Hampstead.

With these pictures from Israel—particularly *Jerusalem 3*, which is a stunningly memorable picture—Dubrow has taken another step from artistic maturity to individual mastery. It is easy to be discouraged by much of what one sees in the contemporary art world. So much of it is less *au courant* than simply ephemeral. John Dubrow is one artist who reminds us that our most pertinent contemporaries are those whose roots are in the permanent realities of human experience.

2000

Odd Nerdrum

ODD NERDRUM is certainly one of the most brilliant figurative painters now working. He is also undoubtedly one of the most disturbing artists ever to put brush to canvas. The Swedish-born (1944) Norwegian artist commands a dazzling painterly technique. Although briefly a student of Joseph Beuys (who called Nerdrum's 1981 painting *Twilight* the "most radical" work he had ever seen), Nerdrum's formative inspiration comes from Rembrandt and Caravaggio.

I know that is a large claim. And I know, too, that at a time when corporate decorators like Frank Stella claim Caravaggio as a precursor, it doesn't necessarily mean very much. Unlike Stella, however, Nerdrum has absorbed Caravaggio and Rembrandt down to his fingertips. The phrase "old-master technique" is bandied about like a shuttlecock these days. Abattoir painters like Francis Bacon and wax-works specialists like Lucian Freud are always being praised for their "old-master technique." But their efforts are crudity itself in comparison to Nerdrum's masterly compositions. "The Old Masters are my guides," he said in 1967, "nature is my God." He really meant it.

Nerdrum outdoes Bacon and Freud in other respects,

too. Like many celebrated contemporary artists, Bacon and Freud enjoy their exalted reputations partly because of their unpleasant subject matter. Screaming pontiffs and cadaverous skin appeal greatly to anxious philistines eager to impress themselves. As some paintings of his family demonstrate, Nerdrum is capable of producing tender, sunny work. But his signature pieces are mythic tableaux —pitiless elemental allegories—that make Bacon and Freud's paintings seem like something out of Currier and Ives. Many of Nerdrum's recent paintings combine subject matter as horrifying as anything in Goya's *Disasters of War* with an artistic mastery of unsurpassed sumptuousness. If Nerdrum's manner is traditionalist, his matter is something else entirely. As the critic Richard Vine put it, "Nerdrum's technique is indeed highly civilized, but his content is sheer atavism." It takes only a glance at his work to see why Scandinavian critics speak of "the Odd Nerdrum Phenomenon."

Nerdrum's career is generally divided into two phases. In the first, which lasted from the mid-1960s until the early 1980s, he specialized in a kind of radical social commentary: stunningly naturalistic paintings typified by the sexually-explicit *Liberation* (1974), *The Murder of Andreas Baader* (1977–78), and *Refugees at Sea* (1979), a large canvas memorializing the Vietnamese boat people. In such works, Nerdrum pursued a melodramatic emancipatory vision informed by the anarchist politics of the 1960s.

His work underwent a profound change around 1983. His palette and sensibility suddenly became darker, less topical, more enigmatic. The ten paintings on view at the Forum Gallery in 1997 epitomized this phase of Nerdrum's career. Painting in a reddish-brown wash of Rembrandtesque tenebrism, Nerdrum populated placeless, desolate

landscapes with hieratic figures torn from a world of implacable ritual and retribution. *Release* (1996), which depicts a bare-backed man busily digging a hole to bury alive a terrified woman, was about midway up the scale of Nerdrum's creepiness. The possibility that the man is doing her a favor—that the "release" in question is release from the terror of life itself—is a typical Nerdrum accessory.

It is curious that Odd Nerdrum's work has not been exhibited (as far as I can discover) in England. His hermaphrodites and maimed bodies seem just the thing to tickle the Turner-Prize-Hayward-Gallery crowd. Perhaps his apocalyptic anti-modernism is just too much for people who think that bisecting cattle is a radical artistic gesture. Or perhaps Nerdrum's staggering technical facility counts against him among the aesthetically handicapped. I cannot really say that I am happy to have encountered Odd Nerdrum's work. I know, however, that I shall never forget it.

1997

Tom Goldenberg:
Art Without Apology

I VIVIDLY REMEMBER the first time I saw a painting by Tom Goldenberg. It was a couple of years ago when I was visiting a friend among whose many interests is collecting art. And what a collection she has: marvelous drawings by Matisse, Giacometti, Seurat, Beckmann, possibly the best Mondrian flower picture in captivity. But she does not specialize only in artists certified by celebrity. Her interest is in good art, whatever its provenance or authorship. After lunch, she took me aside to show me her latest acquisition: a small, luminous landscape by Tom Goldenberg.

That painting was similar in theme and feeling to many of the small works in this exhibition—to *Charley Hill*, for example: an exquisitely composed picture of the rolling farm fields of New York's Dutchess County in summer. (All of the paintings and drawings in this exhibition date from the last year or two and are of landscapes in Dutchess County.)

What can I say? That the balance of colors harmonizes perfectly with one's sense of what such a landscape should be? Yes. That Goldenberg has rendered the sky with an artistry not far removed from that of Constable? Yes again. And one could also point to the apparently effortless

deployment of scale and perspective, the illusion of real space created and maintained by canny and economical means. Ponder the barn-red outbuildings in the lower right-hand corner of the canvas: how casually placed they seem, but how essential to the overall effect. Consider the field of tawny grasses in the foreground. How simply it is expressed, just a quick series of hatch-like brush strokes. But how compelling that swath of golden brown is, and how it makes the symphony of greens and yellow browns shimmer in the middle distance. I was about to observe that Goldenberg is a connoisseur of greens; this is true enough, but look at what he does with red in *Turkey Hollow Pond* or *Little Hollow Pond*, his evocation of autumn's bareness in *Schultz Hill*. In Goldenberg we have a colorist of commanding power, delicacy, and control: he is just as confident and effective in large, ambitious canvases like *Schaffer Field Road* (one of the exhibition's highlights) as he is in smaller formats.

And yet, and yet . . . It pains me to say it, but there is an important sense in which, confronted with painting of this quality, all such talk is superfluous. To be sure, there is a lot one can say about Goldenberg's intuitive mastery: his sixth-sense of visual rightness, his formidable but unostentatious command of technique. Maybe Goldenberg's painterly skill in evoking three-dimensions on a two-dimensional plane—he likes to speak of "building space" in his pictures—has something to do with his early interest in sculpture. Now in his early fifties, Goldenberg began his career in the 1970s using epoxy-resin to make lovingly detailed figurative sculptures. Maybe his compositional skill has something to do with his years as an abstract painter, and the experience of balancing forms and colors without worrying about external referents. Goldenberg

notes that he moved away from abstract art after a trip to Europe and his first-hand encounters with old masters from Titian and Chardin to Breughel. The freedom that abstract art sought in abandoning recognizable objects began, he says, to seem like a limitation.

Doubtless there is an important lesson in that observation. It is part of artistic maturity (and not only *artistic* maturity) to realize that the constraints of convention offer greater real freedom than the anarchy that results from abandoning convention. Of course even the most "realistic" painting also exists as an abstract composition. But the vistas of farm fields that Goldenberg specializes in conspicuously lead double lives, as memorable evocations of rural landscape and tightly organized arrangements of abstract planes of color. They succeed equally as representational works and as formal orderings of planes of color. I was at first surprised to hear that among the artists Goldenberg greatly admires is the Abstract Expressionist Clyfford Still. The presence of Matisse in Goldenberg's patterning of color is clear, but it took a second look to recognize the echoes and resonances of twentieth-century abstraction.

Whatever the sources of Goldenberg's particular genius, it is clear that it rests on a native visual intelligence of striking sensitivity. A familiar if unfashionable word for that intelligence is "talent," an endowment as imponderable as it is unarguable. At the end of the day, *Charley Hill*, like many of the paintings in this exhibition, elicits appreciation rather than verbiage. And this is as it should be. Unadulterated aesthetic pleasure tends to produce satisfaction, not commentary. Today the art world is awash in commentary. What does that tell us?

The embarrassing truth is that most really good art

reduces the critic to a kind of marriage broker, a middleman between the viewer and the work of art. This is especially true when the work in question is distinguished more by formal excellence than by formal innovation (which often turns out to be pseudo-innovation). Bach, for example, was an artist who did not "challenge" or "transgress" prevailing conventions; rather, he worked within them with consummate mastery. The novelty about Bach is in his execution and inventiveness within a well-defined tradition. His first listeners might not have immediately caught the complexity of Bach's music. But they had no problem identifying it as the sort of thing they were used to hearing, only better. Confronted with such art the best thing a critic can do is effect an introduction and then get out of the way.

One feels similarly about Tom Goldenberg's painting. None that I have seen exhibits the shopworn advertisement of novelty. There are no broken plates, bodily fluids, or unmannerly subjects. On the contrary, Goldenberg paints familiar subjects in a familiar way. It is just that he does it so much better than most other painters now working.

The gnomic sayings of Ludwig Wittgenstein are among the most abused of any modern philosopher. But his famous advice, in *Philosophical Investigations*, "Don't think, but look!" should be taken to heart by anyone interested in art. In my view, though, Wittgenstein didn't get it quite right. His admonition suggests a false opposition between thinking and looking. In fact, the best, most fertile looking is thoughtful looking, looking instinct with thought. But Wittgenstein was right to warn us against the clutter of words unanchored by experience. The point is that words and concepts can do as much to obscure or conceal a subject as they can to illuminate it. And when it

comes to the visual arts, that warning is especially pertinent. It is often said that ours is a "visual culture." In fact, it is an advertising culture, as visually illiterate as it is verbally and historically illiterate. More of us spend time in museums and art galleries than ever before, but how much time and attention is spent in informed and careful looking? (Think, in this context, of the phenomenon of the audio-guide, sophisticated distractions provided by a thoughtful management in case the temptation to see for oneself becomes overwhelming.) Of course, much that is on view today neither solicits nor repays careful scrutiny, but that fact merely underscores the problem.

One of the most useful things that a critic of contemporary art can perfect is a facility in making excuses. So much of what critics are called to comment on requires a more or less elaborate excuse if it is to be praised. Artist "A" really cannot paint very well, but we won't mention that because he has come up with some little gimmick that distinguishes his work, albeit minutely, from the work of every second painter now exhibiting in Chelsea, SoHo, or wherever. Artist "B" can't draw to save his life, but we won't mention that either, because at least he has some skill at arranging colors on a piece of canvas. Tom Goldenberg presents us with the rare and refreshing alternative: art that needs no excuses, no apologies. This is painting of a very high caliber indeed. The art world is a noisy place today. Nevertheless I predict that in the coming years the quiet excellence of Goldenberg's work will make itself heard wherever people still have ears to hear—and eyes to see.

2001

William Bailey:
Animating Twilight

WHEN ONE LOOKS AROUND the art world today, it is easy to see why some critics have concluded that we're living in a posthumous age. Most of what is on the walls of our art galleries and museums of contemporary art is so utterly lacking in aesthetic ambition or accomplishment that predictions about "the end of art" sometimes seem almost plausible.

Of course, art isn't really at an end. It is just that the most vital art being produced today tends to exist outside the nervous glare of art-world limelight. A case in point is the superb work of the painter William Bailey. Splitting his time between New Haven, Connecticut, where he teaches at Yale University, and Umbertide, Italy, where he has been going regularly for some thirty years, Bailey has emerged as one of the most accomplished painters of his day.

An exhibition of his paintings and drawings at the late, lamented André Emmerich Gallery in New York (and subsequent exhibitions at the Robert Miller Gallery) reminded me of just how accomplished this quiet, gloriously untrendy artist is. While he has long enjoyed the admiration of connoisseurs and certain critics, Bailey, has never really been taken up by the art world. And although he has been much

honored in Italy, he has not, as of mid-2003, had a solo exhibition, let alone a retrospective, at a major museum.

Bailey began painting at a time when Abstract Expressionism was still at high tide, and he started out intending to be an abstract painter. But a trip to Europe in 1960 convinced him that painting need not abandon the observable world in order to explore the formal realities that abstract art championed. "What happened to me when I was trying to describe something," Bailey has noted, "was more abstract and carried more meaning than when I was simply trying to put something down that merely looked abstract."

Bailey makes two sorts of pictures: still lifes depicting a small assortment of old-fashioned kitchen paraphernalia—crockery, vases, candlesticks, often a few eggs—set centered on a shelf or wooden table, and portraits of one or more women, generally nude or semi-nude. They are, however, all of a piece. Sometimes it seems that his most successful nudes are really still lifes in disguise, sometimes that his still lifes are instinct with the personality of an individual sitter. Because he renders every object with painstaking exactitude, Bailey is usually denominated a "realist." The term is accurate—as far as it goes, which turns out not to be very far. You will never encounter a milk jug or salt shaker or a woman such as those you find in Bailey's work. This is not because he lacks the technical skill to delineate the objects correctly. On the contrary, the first thing one notices about his pictures is their extraordinary technical facility. Bailey is a draftsman of prodigious accomplishment; the old story about some birds swooping down to peck at a bunch of grapes that the Greek artist Zeuxis painted does not seem so far-fetched when one considers the uncanny skill that Bailey commands.

The emphasis, however, is on "uncanny." Bailey's pictures are realistic, even super-realistic; one is sometimes tempted to reach out and test the shadows seemingly cast by his two-dimensional figures. But there hovers about them an aura of ideality that transfigures their realism. This is the deeper source of their power. However accurately delineated are the objects he paints, there is nothing photographic or "transcriptional" about them. Or perhaps one should say that accuracy, even if it is the means to an end, is not itself the end or "point" of his pictures. For one thing, these pictures inhabit a world that has transcended superfluousness. There is never so much as a stray brushstroke to compromise their profound and demanding economy. And not only is everything in its place, but also everything seems to have *become* place. One is coaxed into paradox: The objects and figures in these pictures do not so much occupy given space as they seem to constitute a given space. The accidental has been made over in the idiom of the necessary.

In this context, it is worth noting how often the word "poetic" is used to describe the effect of Bailey's pictures. The tea cup and mixing bowl and eggs are as ordinary as a tea cup and mixing bowl and eggs can be, and yet . . . The real genius of Bailey's art is not its verisimilitude but its ability to hold us in ellipses of wonder: Standing in front of his pictures, one often feels "It's only an ordinary still life, but . . . " His best works seem haunted with an element of longing or pathos, as if behind the prim meticulousness of exactitude there were glimpsed some primal lack or absence. I am not sure there is a name for that lack or absence; perhaps it is the vacancy that inhabits contingency itself, that renders every visible thing incomplete because subject to the ravages of time. This all sounds terribly por-

tentous. Which is a pity. For there is nothing at all porten-
tous about William Bailey's art—unless, that is, the
realization of beauty counts as a benign form of porten-
tousness.

Bailey's art possesses a virtue that is characteristic of
much, perhaps most, really important art: it is instantly
likable yet it continually repays fresh scrutiny. At first
glance, his still lifes seem like simplicity itself. A number of
commonplace domestic objects—eggs, candlesticks, cups,
pitchers, coffee pots, salt shakers—are neatly arranged on
a table that is placed flush against a wall. The objects, like
the table on which they rest, tend to have a somewhat old-
fashioned air about them: the spirit of the work is crisp
and fresh, but bespeaks an older, quieter, simpler time. His
soft, muted colors—the rainbow of browns and oranges,
the many shades of off-white and ivory, the highlights of
blue—owe a great deal to Italy. There is a delicate frank-
ness about these pictures. The ensemble—table and ob-
jects—is almost always presented at eye level: one looks at,
not down upon, the composition.

Bailey's commitment to the intricacies of the observable
world has resulted in a remarkably consistent oeuvre. The
new paintings and drawings that were on view at the
Emmerich Gallery included the same sort of exquisitely
painted still lifes and lovingly observed nudes that he has
been making for decades. What has changed in his mature
work is not his subject matter but the richness and subtlety
with which he presents it.

There is nothing superfluous in Bailey's works: every
object is a perfect representative of its type, without chips
or cracks or blemishes. The specific gravity of each object
is rendered flawlessly in a steady, sourceless light that
might be called the light of contemplation. What we see in

his work is the commonplace viewed through a lens of ideality. Each particular is presented in such uncompromising particularity that it glows with a distinct, individualized personality. His delineation of absolute ordinariness thus transforms it into something extraordinary.

In his introduction to a book about Bailey's work (Rizzoli, 1991), the poet John Hollander speaks of the "particular meditative cast" of his painting, "the kind of twilight in which his objects and spaces are set." It is a peculiarly haunting, and distinctively modernist, space that Bailey has created. It has something of the flatness of de Chirico's dreamscapes without their creepiness, something of the sparseness of Balthus's portraits without the hint of perversion that is his trademark. Part of Bailey's achievement is to have domesticated that distilled, stagelit space. He provides a setting in which the drama of ordinary objects emerging into perfect clarity can enact itself quietly.

In the background one senses the seamless, porcelain brushwork and modeling of Ingres, one of several old masters who has exercised a conspicuous influence on Bailey's work. The spirit of Ingres is especially evident in Bailey's nudes, where the balanced, classical poise and fastidiousness of the pictures is counterpointed with an underlying current of controlled sensuousness. Many critics have compared Bailey's work to a kind of poetry. This is not because there is anything noticeably narrative about Bailey's work but because it often seems to strive for that articulate silence that is the special province of poetry.

Thomas Aquinas defined beauty as *id quod visum placet*: that which, being seen, pleases. Precious little contemporary art can be said to please in this way. Defenders of artistic trendiness will tell you that art has gone beyond the requirement of being pleasing, that it is "challenging"

in some other, more important fashion. Lately, we've even had some prominent critics suggesting that the very idea of beauty is passé.

Few of us outside the knotty precincts of the art world really believe this, though the prevalence of such views remains a depressing commentary on the staus quo. How grateful we must be, then, to those rare artists such as William Bailey who have the courage and talent to please us in the most difficult and permanent way: by making beautiful works.

1994, 2003

Index

Index

Index

Index

Index

Index

Index

Roger Kimball is Managing Editor of
The New Criterion and an art critic
for the London *Spectator*. His previous
books include *Tenured Radicals: How
Politics Has Corrupted Our Higher
Education*; *The Long March: How the
Cultural Revolution of the 1960s Changed
America*; *Experiments Against Reality:
The Fate of Culture in the Postmodern Age*;
and *Lives of the Mind: The Use and Abuse
of Intelligence from Hegel to Wodehouse*.